ICONS

D1114406

€5. 00

Photo Icons
1827–1926

Hans-Michael Koetzle

Photo Icons
The Story Behind the Pictures
1827–1926

TASCHEN

KÖLN LONDON MADRID NEW YORK PARIS TOKYO

Cover: Jacques-Henri Lartigue, *Grand Prix de l'A.C.F.*, 1912
© Ministère de la Culture, France/A.A.J.H.L.

© 2002 TASCHEN GmbH
Hohenzollernring 53, D–50672 Köln
www.taschen.com

Project management: Ute Kieseyer, Cologne
Editorial coordination: Daniela Kumor, Cologne

Translation: Sally Schreiber, Cologne
Editing: Frances Wharton, London
Malcolm Green, Heidelberg

Design: Claudia Frey, Cologne
Production: Thomas Grell, Cologne

Printed in Italy
ISBN 3–8228–1828–3

Contents

Reading pictures
Hans-Michael Koetzle

The photographic era was heralded in 1827 by a camera picture produced by an exposure lasting over several hours, using a simple asphalt-coated plate. Meanwhile, official statistics tell us that over five billion photographs are printed each year in the big laboratories in Germany. There can be no doubt about it: we are living in an age of technically produced images. Photographs, pictures from films, television, video and digital media all fight to catch our attention. They try to seduce us, to manipulate, eroticise and even at times to inform us. People talk of how we are being deluged by images, which sounds threatening, but at heart this points above all to a phenomenological problem: how do we deal with all of these images? How do we select between them? What in fact do we manage to take in? And what, on the other hand, still has a chance of entering our collective memory?

We find ourselves at the moment in a paradoxical situation. While traditional analogue photography is losing its influence in its traditional territories, such as photojournalism or amateur photography and snapshots, the conventional camera photograph is becoming increasingly the object of a public discourse. Photographic images are now an accepted fact in art galleries and museums, at art fairs and auctions. The question as to whether photographs are actually art appears to have answered itself. Six-figure dollar cheques for key works from the history of photography, or for works by contemporary photo-artists, have long since ceased to be a rarity. A young generation has discovered in photography the same thing that previously investors found in antiques. Photography is starting to reach a ripe old age, and yet is more relevant now than ever before. As a medium of the more contemplative kind, it has found – in unison with mostly flickering images – a new, forward-looking role.

The media scientist Norbert Bolz has spoken in this connection of the "large, quiet image" that grants something like a secure foothold in the current torrent of data. Where television, video or Internet at best produce a visual "surge", the conventional photographic picture – as the

"victory of abstraction" – is alone in having the power to take root in our memory and engender something akin to a memory. The doyen of advertising, Michael Schirner, put this to the test in the mid-Eighties in his exhibition "Bilder im Kopf" [Pictures in Mind]. The show simply presented black squares with captions added in negative lettering: "Willy Brandt Kneeling at the Monument to the Heroes of the Warsaw Ghetto", for instance. Or "The Footprint of the First Man on the Moon". Or "Albert Einstein Sticking out His Tongue". Photography, as the Dusseldorf photographer Horst Wackerbarth puts it succinctly, is "the only genre that can achieve a popular effect on the immediate, visible level, and an elitist one after its initial impact on a deeper, more subtle level."

Each of the two volumes *Photo Icons I* and *Photo Icons II* presents 20 photographs from some 170 years, all arranged in chronological order. And every one of them is a key image from the history of the medium: images that have pushed photography forward in terms of either its technology, aesthetics or social relevance. There is a tradition to viewing "icons" such as these by themselves, each on their own. Best known in this context is John Szarkowski's classic book *Looking at Photographs*, first published in 1973. But going beyond Szarkowski's associative, journalese style, the present volumes also provide in-depth analyses of the contents. With the history of the picture's reception, we arrive at the question of when and in what way the motif became exactly what it is: a visual parameter for central categories of the human experience. Almost every technical approach and every major field of application (from portraiture to landscapes, from the nude to the instantaneous shot) has been included here, making the two volumes simultaneously a "potted history of photography". This prompts us to read pictures critically, to look at them more attentively and with greater awareness. As early as the 1920s, Moholy-Nagy pointed to the dangers of visual analphabetism. That applied to the era of silver salts in the photographic lab. Yet it applies more than ever to the age of satellite TV, video and Internet.

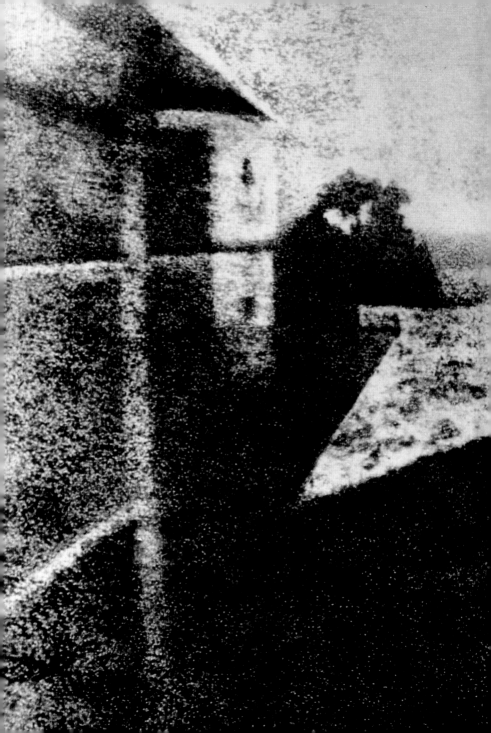

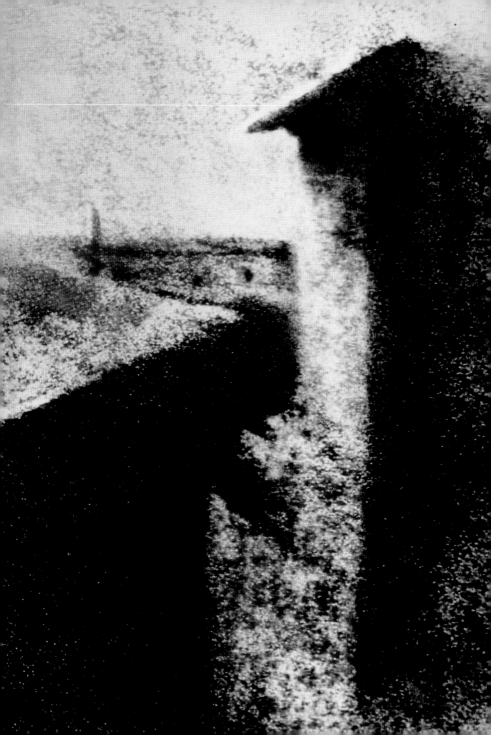

Nicéphore Niépce
View from the Study Window

Traces in Asphalt

The public announcement of Louis-Jacques-Mandé Daguerre's photographic process in August 1839 is usually accepted as the birth date of photography. But in fact, Daguerre's compatriot Nicéphore Niépce had succeeded in fixing images with a camera obscura a good decade earlier.

The view must have been very familiar to the photographer. After all, what does a thoughtful person do when the flow of ideas is blocked, and though merely spin in circles around the problem without advancing further? One looks out the window, beyond the limitations of one's own desk, and seeks new ideas and inspiration from the distance. The study of Joseph Niépce – who signed himself Niépce, but by the end of 1787 had adopted a second forename, Nicéphore – was located on the second floor of his family estate Maison du Gras, in the village of Saint-Loup-de-Varennes, just under three miles from the village of Chalon-sur-Saône in French Burgundy. Just how often Niépce must have glanced out the window of this room we can only guess, but what he saw is a matter of absolute certainty: to the right is an at least partially visible barn roof; somewhat to the left, a dovecote; to the far left, a recessed baking kitchen; and finally, in the background, the pear tree, whose leafy crown nonetheless allows a clear glimpse of the sky to show through in two places, even in the summer months. And what he saw, he captured with the camera. *View from the Study Window* at Maison du Gras, taken in June or July 1827, is in all probability the first permanent – although mirror-reversed – image in the history of photography.

Long way from permanent camera images
Nicéphore Niépce had returned to Burgundy in 1801 after a number of years spent in Italy, on the island of Sardinia, and in Nice. Now, as a gent-

leman-farmer, he raised beets and produced sugar; financially, however, he was in fact independent, for in spite of the vicissitudes of the French Revolution and the Napoleonic era, his inheritance was large enough to support him comfortably. With the years, he increasingly devoted his time to scientific experiments, busying himself as a private scholar and developing (together with his brother Claude) the so-called pyréolophore, a combustion engine meant to revolutionize human locomotion, but which in fact turned into a financial debacle. Furthermore, Niépce attempted to find a substitute for indigo, which had become scarce as a result of the Continental Blockade, invented a kind of bicycle, and last but not least, set himself the task of fixing the fleeting images produced by the camera obscura.

Niépce had already produced his first heliographs, as he called the results of his experiments, in the spring of 1816. And already at this point, it was precisely the view from the window that he attempted to depict in his 'sun drawings'. One wonders what motivated Niépce again and again specifically to aim the eye of his camera from his study down onto his property in Le Gras. Was it sentimentality? Or did the experiment of capturing precisely the view that he knew so well appeal to him because its very familiarity would make it easier for him to check its precision and accuracy – the qualities that he was most striving for? In all probability, the reason lies elsewhere: Niépce could work with his camera on the window sill at length, without interruption and without having to answer questions of the curious – and without alerting possible competitors to the progress of his experiments. For he knew that discovery was in the air. "My dear friend," he wrote in May 1816 with unusual candor to his brother Claude, now living in Paris, "I am rushing to send you my four latest test results. Two large and two small ones, all considerably clearer and more exact, which I succeeded in making with the help of a simple trick: namely, I reduced the aperture of the lens by means of a piece of paper. Now less light makes its way into the interior of the camera. As a result, the image becomes more lively, and the outlines as well as the light and shadows are clearer and better illuminated."

And what does Claude see in the pictures, insofar as he can make out anything at all? For Nicéphore has not yet found a means of permanently fixing the silver-chloride images made with the help of his home-made camera obscura. Together with Nicéphore, he gazes out the window of

Nicéphore Niépce

Born **1765** in Chalon-sur-Saône as the son of a royal tax-collector. Works as a teacher. **1792–94** lieutenant in the Revolutionary Army. From **1801** administers the family's country estate at Chalon. At the same time develops a ship engine (*pyréolophore*) together with his older brother Claude. From **1813** explores the possibilities of lithography. **1816** first experiments with a camera obscura. From **1822** on first successes with photochemical reproduction of images. **1827** meets Daguerre on his way to England. Gives a report on heliography to the Royal Society. **1829** forms a partnership with Daguerre. **1833** dies unexpectedly of a stroke

their hereditary Maison du Gras: before him are the two wings already described, the dovecote, the dominating slate roof of the baking kitchen. Admittedly, all that he sees is reversed from left to right; similarly, the shadows and light appear as negative images; and the whole is merely black and white. Niépce is still a long way from either positive or permanent camera images. At the same time, he remains confident and confides in his brother in order to convince himself of his own progress. He has no inkling that it will in fact take him another ten years to produce a permanent photographic image.

Searching for a new technology

Nicéphore Niépce, born the scion of a wealthy family in March 1765, was not the only one searching at the turn of the nineteenth century for a new technology that would produce images appropriate to the new positivistic age. It had been four hundred years since Gutenberg introduced a true textual revolution. In contrast, the development of the visual image had stagnated, at least in the technical sense. Of course Aloys Senefelder's invention of lithography (1797) signified an important flat-printing process for the graphic arts. But here also – and in this, lithography did not differ from woodcuts or copper engraving – the active hand of the artist remained necessary to the creation of a picture. Still missing was a quasi-automatic process that would be both fast and inexpensive. Above all, the new technology had to be dependable, objective, and precise in detail – in short, it must correspond to a rational age oriented to exactitude. To this end, research and systematic experiments were being conducted in almost all the lands of Europe, but nowhere more intensively than in England and France. After all, the principles behind an analogue process for producing pictures were already long familiar: the operation of the camera obscura, known from the Renaissance, and Johann Heinrich Schulze's discovery of the light sensitivity of silver salts in 1727. Actually, it was only necessary to combine the two principles – the physical and the chemical – together.

Views according to nature

In his quest, Niépce was a child of his age; his research was not at all directed toward the discovery of a new medium of artistic expression. He strove for a pictorial mass medium: quick, cheap, and dedicated to the

realistically oriented Zeitgeist of a bourgeois age. Niépce had actually begun quite early to employ various acids for etching transitory images onto metal and stone. "This kind of engraving," claimed Niépce in 1816, "would be even better than the [the silver chloride images] because they can be so easily replicated and because they are unalterable." In the end, however, his efforts, whether to obtain a direct positive image or to produce plates that could be used for printing, remained unsuccessful. Not until 1822 did Niépce discover in bitumen, an asphalt-like substance used by both copper engravers and lithographers, a medium capable of holding an image. He realized that bitumen eventually bleaches out and, more importantly, hardens under the influence of light; on the other hand, bitumen kept in the shade remains soluble and can be rinsed away. Niépce succeeded in copying a portrait of Pius VII by using oil to make the copperplate print transparent, placing it on a bitumen-coated glass plate, and laying it in the sunlight. After two or three hours, the exposed portions had hardened to such an extent that the shadowed areas could be rinsed away with a solution of lavender oil and turpentine.

Homage to Niécpe: double-page spread from Miroir du Monde, *June 17, 1933. His* View from the Study Window *had yet to be discovered.*

DIE ERSTE PHOTOGRAPHIE DER WELT

Soeben gelang es Helmut Gernsheim, die älteste Photographie – das Urphoto schlechthin – aufzufinden. Er wollte, es mußte noch irgendwo vorhanden sein. Nicéphore Niépce hat es im Jahre 1826 aufgenommen. Es zeigt den Blick aus seinem Fenster in Gras bei Chalon-sur-Saône. Vom Abzug Gernsheim übernahm sofort die notwendige Forschungsarbeit an diesem letzten und größten Fund. Gerade dabei unterscheidet sich die Gernsheims von vielen anderen Sammlern: jeder neue Schatz wird gründlich geprüft und sorgfältig dokumentiert. Daß aus diesem stark verblichenen Bild unseren Lesern zugute kommen, ist dem Kodak-Forschungs-Laboratorium zu danken, dem es in mühevoller Arbeit gelang, eine druckfähige Reproduktion herzustellen.

"The first photograph in the world". This article in Fotomagazin (May 1952) is probably the first reference to the sensational discovery in a German specialist publication.

On the advice of his brother, Niépce soon replaced the glass plates with copper or, often, tin, which reflected more light and was thus more suited to his intention of creating "views according to nature." Now, with his discovery of the missing clue, Niépce took up his earlier experiments with the camera obscura again around 1825, replacing his home-made camera in February 1827 with a 'professional' model that had double convex lenses using bitumen-coated tin plates. In the summer he succeeded in making a $6^1/_2$ x $7^3/_4$ inch direct positive image with left-to-right reversal. In the picture, the lustrous bitumen rendered the light, while the tin, washed clean with lavender oil, reproduced the shadows. His shooting point was his study in Le Gras, and experts have calculated that the exposure time must have been more than eight hours. It is for this reason that the two opposite wings of the building are both in sunlight. Clearly recognizable at the edges of the picture are the curved and out-of-focus vertical lines produced by the lenses.

What we are looking at – and here historians of photography are unanimous – is clearly the world's first photograph. Initially, Niépce left it behind in Burgundy when he journeyed to England in September 1827 to visit his seriously ill brother Claude, who was now living in Kew, near London. Among the acquaintances he made on the visit was that of the botanist Francis Bauer, who immediately took a strong interest in Niépce's heliographic experiments and proposed making a report on the process before the Royal Society. Niépce sent at once for his pictures, including *View from the Study Window*, and immediately drew up a memorandum, point-black identifying himself as the inventor of what he called 'heliography': a process of "capturing the pictures reflected in the camera obscura in gradated tones from black to white solely with the help of light."

Niépce avoided, however, giving precise information about his method of procedure, a reticence which led the Royal Society to reject the report.

Niépce returned home to France, undoubtedly disappointed, in January 1828, having turned over all his experimental pictures to Francis Bauer as a gift. The botanist was well aware of the significance of the seemingly insignificant objects: "Monsieur Niépce's first successful experiment of fixing permanently the Image of Nature," he inscribed on the back of the picture which makes its way into every history of photography as *View from the Study Window*.

After Bauer's death in 1841, Niépce's pictures and other documents passed first into the ownership of Dr. Robert Brown for a sum of 14 livres and 4 shillings, and later into the hands of J. J. Bennett, both of whom were members of the Royal Society. Bennett subsequently sold one portion of the legacy to the photographer Henry Peach Robinson, and a second to Henry Baden Pritchard, the publisher of *Photographic News*. In 1898, the 'heliographs' surfaced once again within the framework of a photographic exhibit in the London Crystal Palace. And then they disappeared without a trace into the depths of history. We would still probably be speculating about the content and whereabouts of Niépce's view of Le Gras today if Alison and Helmut Gernsheim had not set out on a seemingly hopeless search for the pictures a few years after the end of the Second World War. In April 1948, the two researchers published a brief report in the London *Times* with all their findings gathered up to that point, but the article found no immediate resonance. Two years later, they made a second attempt, and this time the aged son of Henry Baden Pritchard responded in a corresponding article in the *Observer* – without, however, offering any information on the whereabouts of the pictures, last seen in 1900. Months passed until Mr. Pritchard Jr. was heard from again at the end of 1951: tucked between books and clothing, Niépce's picture (in the meantime framed) had turned up in the family attic in a suitcase belonging to his mother, who had died in 1917. The joy at the discovery was muted, however, because the motif was hardly discernible to the naked eye, and was furthermore not reproducible. There followed long and arduous attempts by the research department at Kodak until a certain P. B. Watt finally succeeded in photographing the image in such a way that the picture – today owned by the University of Austin, Texas – became legible: the contours of the buildings at Le Gras emerge recognizably behind the initially reflective surfaces. Niépce's *View from the Study Window* had thus been exposed, so to speak, a second time.

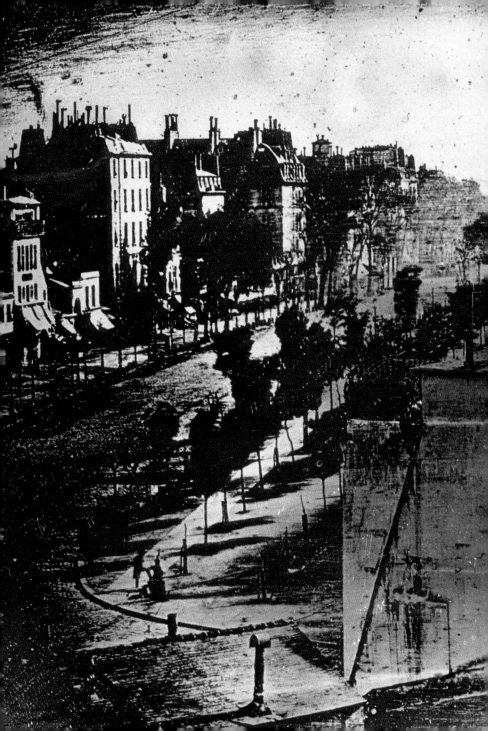

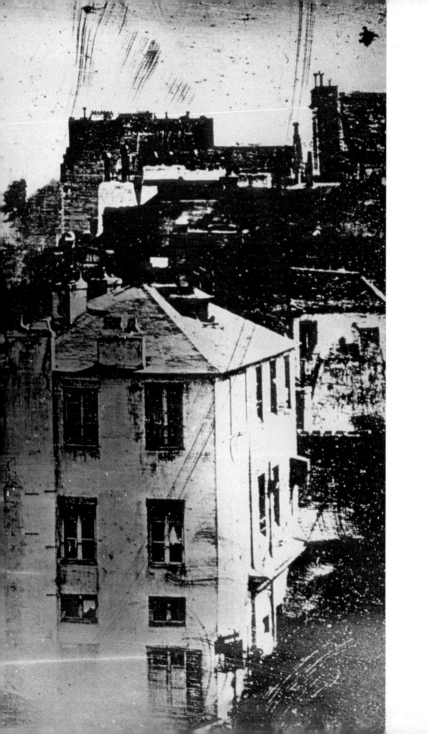

Louis-Jacques-Mandé Daguerre
Boulevard du Temple

**The Lone-
liness of
the Shoe-
shine Man**

**Around 1835, Louis-Jacques-Mandé Daguerre succeed-
ed for the first time in fixing permanent photographic
images through the process that later became known
by his name. His most famous daguerreotype, almost
certainly taken in the spring of 1838, was long thought
to be the first photographic image of a human figure.**

The image was anything but perfect – its creator realized this full well.
The painter, inventor, and diorama owner Louis-Jacques-Mandé Daguerre
belongs – together with Niépce and Talbot – to the great triumvirate of
photographic history. Of the three, however, Daguerre was surely the
most skilled tactician, possessing what we would today call a highly de-
veloped sense of PR. Ever since the 1820s, Daguerre had been looking for
a process to enable the technical production of pictures based on the
images produced by the camera obscura. Finally, in 1835 he achieved suc-
cess, and now the issue became how best to exploit the potential of the
new medium. Daguerre's view of the Boulevard du Temple was intended
to be a link in a visual chain of argumentation for his new process. Admit-
tedly, as remarkable as his picture was for the conditions of his time (or
rather, for the limitations of his process), his 5 x 6 1/2-inch format image
remained nonetheless modest in comparison with what painting, draw-
ing, or graphics could offer. In short, from the very beginning, photo-
graphy had to compete with the 'fine arts'. And in this contest, the new
medium labored under numerous disadvantages: Daguerre's photo-
graph, for example, reproduced the reality it sought to capture in very
small format – and 'merely' in black-and-white (as the early critics noted
with disappointment as early as 1839). Furthermore, the photograph,
which consisted of a single direct plate, was necessarily a reverse image,
and on top of this, the reflecting surfaces of the plate itself interfered
with viewing the image: according to how one held the daguerreotype,

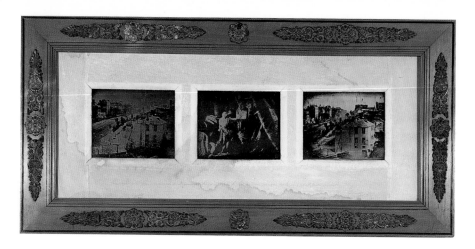

Triptych with three daguerreotypes for King Ludwig I of Bavaria

the picture flipped from a positive to a negative image. But perhaps worst of all was that nothing was to be seen of the pulsating life of the Boulevard with its trade and activity and traffic, in the form of carts and horse-drawn wagons. These were left to be imagined. The deadening effect of the daguerreotype is evident in an encyclopedia entry for "Paris" written in 1866, which describes precisely this length of the Boulevard as the former "main square for the true life of the people of Paris, ... [where] quacks, somnambulists, rope-dancers, etc., compete with lots of larger and smaller theaters, whose audiences as a rule found entertainment in such blood-curdling pieces that the street was called the boulevard du crime." Our picture, however, conveys none of this. In the left foreground is merely a gentleman in a frock coat, a tiny figure, apparently having his shoes polished – and even contemporaries suspected that Daguerre had hired two people to play the parts by maintaining a pose for the still lengthy exposure time of several minutes. As Jean-Pierre Montier once put it, their shadows were "impregnated" onto the plate. Whatever the case, this picture remains the first photographic image of a human being, or rather, two of them – if one omits the recently discovered portrait of a certain "M. Huet", dated 1837, also attributed to Daguerre.

Curious onlookers are unwelcome
A view out the window. A view from above down into a world that now existed to be photographically explored, investigated, exploited, and

recorded. Niépce had already gazed out of the window of his estate in Le Gras. Talbot, the inventor of the negative-positive process and Daguerre's true competitor in the struggle for the copyright to photography, had already bequeathed us even more than a view from a window: perhaps the most famous of his works is his calotype of the Boulevard des Capucines. As so often in the early stages of photography, the photographers here, too, consciously turned to a theme that had already been formulated by traditional panel and canvas painting. In the early days of photography, when a photographer aimed a camera out a window – whether from his house (Niépce), his room (Daguerre), or even a hotel (Talbot) – he had a completely pragmatic reason, beyond that of iconographic reverence for the traditions of painting. These early researchers feared too much publicity and sought to exclude a curious audience from taking note of their endeavors. This was one reason they searched out a photographic 'hiding place'. Furthermore, their work was easier if they could conduct it close to the home laboratory; more precisely, the lab was what made early photography possible in the first place. The French science minister Arago estimated that the preparatory work for a single daguerreotype amounted to 30–45 minutes – and Daguerre wanted always to make three exposures in a row for the sake of underlining the usefulness of his process, so to speak: one taken in the morning, one at noontime, and one in the afternoon.

We find ourselves at 5 rue des Marais. We can be fairly certain that it was from the window of his private apartment that Daguerre made his three exposures, of which only two have survived, albeit in heavily damaged condition. Anyone looking for the house today is on a fool's errand, for the rue des Marais, like so many tranquil – or, phrased negatively, dim – corners of old Paris fell victim to the colossal urban renovations of Baron Haussmann. But we can imagine the house to be approximately where the Boulevard de Magenta runs into the Place de la République, that is, in the 10th Arrondissement. In Daguerre's day, Paris housed around 800,000 inhabitants. The city limits in the west were defined by the Field of Mars, in the east by the Père Lachaise, in the south by the Montparnasse Cemetery, and in the north by today's Pigalle. This is the Paris of Balzac and Hugo, Ingres, Delacroix, and the young Dumas – the Paris in which Rodin would be born in 1840, Sarah Bernhardt in 1844. All this makes the city sound like the world art capital – which the city certainly

was in the nineteenth century. But Paris was something else as well, namely narrow, dark, close, dirty, and in this age before sewers, filled with what was then called a miasma. As the writer Maxime Ducamp pertinently remarked, "Paris as it existed on the eve of the Revolution of 1848 had become unlivable."

A pictorial diversion for the broad masses

In the spring of 1838, Daguerre tuned the lens of his camera obscura, which had been built by the Paris opticians Charles and Vincent Chevalier, down onto the Boulevard du Temple. He was not at all interested in a nostalgic look at 'Old Paris' threatened with (possible) extinction; that is a theme that such photographers as Atget would explore decades later. Instead, Daguerre, wholly in the role of a technician and inventor, sought within the panorama of his city a picture that would be at once as rich in detail, as sharp and effective, and as large as possible (in spite of the very small aperture) – and that at the same time that could function as a metaphor of the cradle of the invention. And in fact it was the many tiny objects in the picture that captivated the first viewers of the photograph. Among these was no less a figure than the American painter and inventor Samuel F. B. Morse, who looked up Daguerre in Paris in March 1839 "to see these admirable results." Morse expressed himself charmed "by the exquisite minuteness of the delineation" but noted at the same time: "Objects moving are not impressed. The Boulevard, so constantly filled with a moving throng of pedestrians and carriages was perfectly solitary, except an individual who was having his boots brushed."

The Parisian inventor, born Louis-Jacques-Mandé Daguerre in 1787, already had several careers behind him as a scenic artistic, stage and costume designer, and the creator and director of a diorama, before he developed an interest in the possibility of permanently capturing the fleeting images produced by the camera obscura. Daguerre was what we might today call a media person – someone who recognized the need of his times for pictures and sought to commercialize this need in as many ways as possible. Whereas the diorama offered an almost archaic form of the cinema – a pictorial diversion for the broad public, a spectacle produced by means of illusionistic painting united with skilled lighting effects – the new medium of photography, which still remained to be invented, sought a process of picture-making that would correspond to the posit-

Louis-Jacques-Mandé Daguerre

Born **1787** in Cormeilles-en-Parisis. **1801–03** trains in an architect's practice in Orléans. From **1803** in Paris. **1816–22** works as a scenic artist. **1822–30** builds and runs a diorama. **1829** forms a partnership with Niépce. **1839** the diorama is destroyed in a fire. Public presentation of the daguerreotype that same year. The state purchases the rights to the method. **1841** returns to the country. **1844** last daguerreotypes. Dies **1851** in Bry-sur-Marne

ivist age: a process at once fast and exact, economical and objective. Daguerre, who had worked together with Nicéphore Niépce, had realized the light sensitivity of silver iodide already in 1831, a discovery which in turn led him to an improvement in the process that bears his name. A popular anecdote claims that in 1835 it was merely by chance that Daguerre discovered the so-called latent image, which meant that the exposure time could be reduced to a sensational 20 to 30 minutes – thus raising Daguerre's hopes for the genre of picture that was of greatest interest to him, namely the portrait.

The delicacy of the contours, the purity of the forms

The daguerreotype, however fascinating, has always been termed a dead end of photography – an accusation that refers primarily to the production of a single, irreproducible plate, in contradiction to the real aim of an economical mass medium. The daguerreotype has in fact neither predecessors nor successors. All of this may be true, but nevertheless overlooks the importance of daguerreotypy as the first truly practical photographic process, which in some countries – such as the USA – remained viable until into the 1860s. From the technical point of view, the daguerreotype is a direct positive image in a (then) maximum full-plate format of $8^1/_2$ x $6^1/_2$ inches. To produce a picture, a silvered copper plate was sensitized with iodine vapor, exposed in the camera obscura, developed in mercury steam, and finally fixed in a solution of salt or sodium thiosulfate. The result was a reflective and one-of-a-kind image, whose finely chiseled lines, even down to tiny details and shadings of tone, produced a picture of the world that addressed the scientific interests of the time. Daguerre's discovery placed him on the horns of a dilemma. His process was still far from mature, especially because portraits, which at this point continued to require an exposure time of ten minutes in sunlight, remained more or less out of the question. On the other hand, the inventor was involved in an international race, and he felt intense pressure to go public with his process. Therefore, in the autumn of 1838, Daguerre appealed to leading scientists for help in interesting the government in his invention. He found his chief supporter in François Arago, the secretary of the Academy of Sciences. It would also be Arago who convinced the French Parlement to buy the rights of the process and to make it internationally available. On 19 August 1839, the two official bodies held

Enlarged section from Boulevard du Temple: the image of the shoeshine is regarded as the first successful depiction of a person (or rather: two people) in photography.

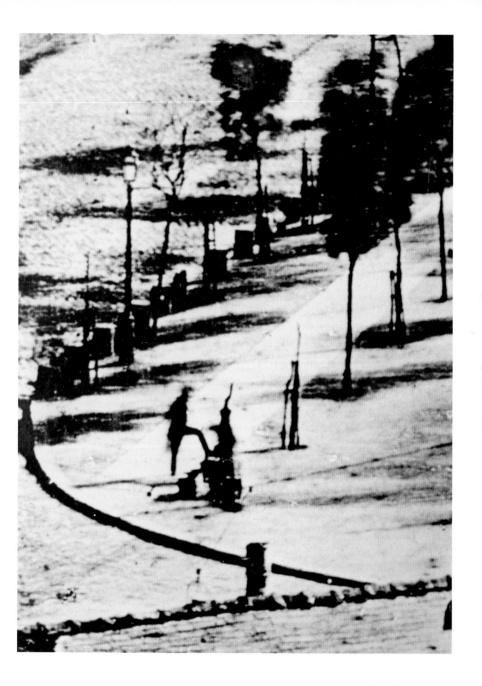

their memorable meeting in which the technical details of daguerreotypy were presented. The age of photography had begun.

The initial reports concerning the announced discovery appeared early in 1839, and the photographs of the Boulevard du Temple became the focus of amazement among contemporary scholars and journalists. The *Pfennig Magazin*, for example, announced in 1839 that in one of the pictures, a man could be seen "having his boots polished," and continued, "He must have held himself extremely still, for he can be very clearly seen, in contrast to the shoeshine man, whose ceaseless movement causes him to appear completely blurred and imprecise." What intrigued John Robinson, the secretary of the Royal Society of Arts, were the differences between the three plates caused by the changes in light. In addition, "delicacy of the outlines, the purity of the forms, and the precision and harmony of the tones, the aerial perspective, the thoroughness of even the smallest details" also earned praise (Eduard Kolloff, 1839). Daguerre's invention was clearly greeted as a sensation. Soon 'daguerreotypomania' spread throughout France and the rest of Europe.

Excitement among artists and art-lovers

We do not know precisely what moved Daguerre late in 1839 to send a sample of his 'artworks' to the ruling houses of Russia, Prussia, and Austria. Gernsheim (1983) speculates about an initiative of the French foreign minister; in any case, the list of selected monarchs included the Bavarian King Ludwig I, who received – along with a dedication by Daguerre – what were even then already the world's most famous photographs, namely two of the three views of the Boulevard du Temple and, in the middle of the framed triptych, a still life which has not survived, along with an inscription by Daguerre. "Noon" wrote the photographer in his own hand under the picture on the left. "Huit heures du matin" (eight o'clock in the morning) is legible below the photograph with the shoeshine man – information that later formed the basis of the attempt to determine the exact date of the picture. Using contemporary maps and diagrams, and taking into account the length of the shadows and the camera position of 51 1/2 feet above the street, Peter von Waldhausen has been able to date the view of the boulevard to the period between 24 April and 4 May 1838. The identity of the shoeshine man and his customer, however, remain matters for speculation.

In October 1839, the three daguerreotypes arrived in Munich, where they were on display at the Arts Association after 20 October. They immediately caused excitement, particularly among "artists and art-lovers." According to commentary in the *Allgemeine Zeitung*, the pictures were absolutely free of error and "by demonstrating all the advantages and wonder of the [new] invention, they teach us also about its relation to art." After the exhibit closed, the daguerreotypes returned to the private royal household, and after the regent's death, became part of the collection at the National Museum of Bavaria. The pictures, however, received no special attention, at times being included in the permanent exhibit. As a part of this collection, they were evacuated for storage during the Second World War, and were heavily damaged. In any case, by the time the plates were turned over by the National Museum to the Munich Photography Museum as a permanent loan, they were suffering so severely from oxidation that the still life in the center – a picture contradictorily described by contemporaries – was totally beyond recognition. An inexpert attempt at cleaning Daguerre's two remaining plates in the 1970s succeeded only in erasing their content. Thus, one hundred forty years after their creation, nothing more of the Boulevard du Temple was to be seen. The photohistorian Beaumont Newhall, however, had earlier made reproductions of the plates for an exhibit at the New York Museum of Modern Art entitled "Photography 1839–1937." Based on these plates, Peter Dost of Nuremberg and Bernd Renard of Kiel were able to produce facsimiles. Our *Boulevard du Temple* as seen on these pages is thus no more than a technical (i.e., screened) translation of the original daguerreotype based on one of the modern reproductions of the original plate. As cynical as it may sound as far as the cultural loss is concerned, photography as a technical pictorial medium nonetheless won the day.

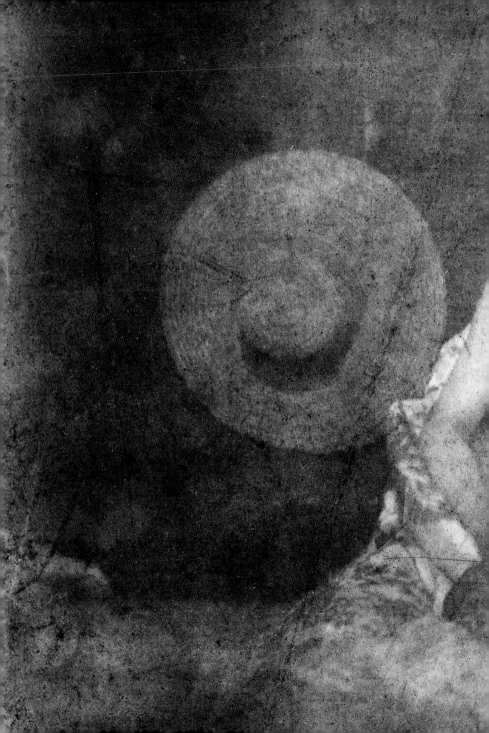

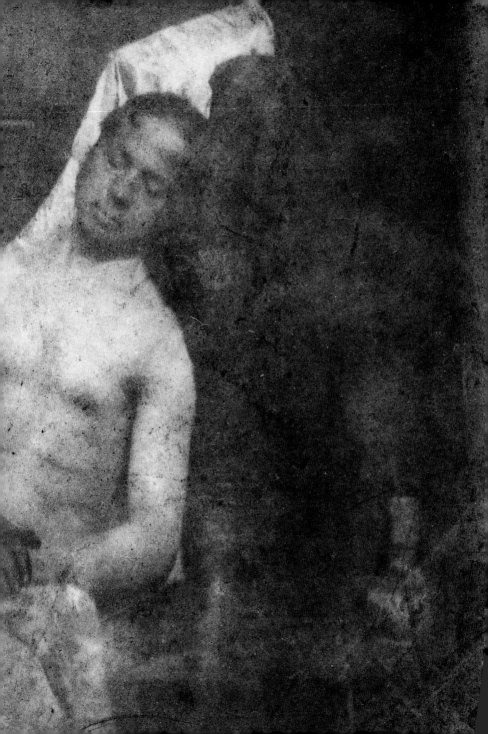

1840

Hippolyte Bayard
Self-Portrait as a Drowned Man

A Temporary Demise

Around 1830, scientists and artists alike were fascinated by the dream of finding a means of permanently preserving the fleeting image produced by the camera obscura. One of the pioneers in the effort was the Frenchman Hippolyte Bayard, who not only succeeded in producing photographic images, but who was also one of the most versatile photographers of the early nineteenth century.

In the center of the picture is a man, not particularly young but not yet marked by life, probably in his mid-thirties. His torso is naked to the navel. Hardly of athletic build, he appears rather to be someone who spends his time at a desk – but his browned hands and equally tanned face tell us that he also must spend long hours outdoors in the sun. A long, heavy, large-patterned piece of cloth serves both as a comfortable underlay for his head and back, and drapes his loins, thighs and knees to cover the lower part of his body. The nameless man appears to be lost in thought, his hands resting on his lap. Is he asleep? Is he dead? The theme and design of the picture seem at first to provide an answer to the question: this early photograph unmistakably reflects Christian iconography, which typically presents the Deposition of Christ in a similar manner. Even the traditional shroud, or burial cloth, is present and plays an important role in the composition, in this case by emphasizing the powerful diagonal running from the lower left to the upper right. This line is contrapuntally picked up by the wide-brimmed straw hat on the wall as well as by a shadowy, barely recognizable vase in the lower right of the picture.

Great deal of honor, but not a single penny

The paper print with an original format of approximately $7^1/_2$ x $4^1/_2$ inches bears an inscription on the reverse – an extensive quill-and-ink comment-

Bayard's faked fare-well letter dated October 18, 1840, facsimile

ary that seems to address the questions raised by the picture itself: "The body of the man you see in the picture on the other side," reads the French text, "is that of Mr. Bayard, inventor of the process whose glorious results you have just seen or are about to see. To the best of my knowledge, this talented and untiring scientist has been working for about three years on perfecting his invention. The academy, the King, and all those who have seen this picture, were full of admiration, just as you yourselves are, although [the artist] found the picture unsatisfactory. It has brought him a great deal of honor, but not a single penny. The government, which has granted so much to Mr. Daguerre, claimed it was unable to do anything for Mr. Bayard. As a result, the unfortunate man drowned himself. Oh, human fickleness! Artists, scientists, and newspapers have taken an interest in him for a long time, but today, after he'd been lying in the morgue a few days, no one recognized him or claimed his mortal remains. Ladies and gentlemen, let us now move on to other

matters for fear that your olfactory organs will be affected, for as you have noticed, the face and hands of the gentleman have already begun to decay." The lines are dated 18 October 1840.

Peter Weiermair has designated the picture, taken a good year after the announcement of the daguerreotype process (August 1839), as the first male nude in photography. It is wise to exercise restraint in using superlatives in the history of photography, above all in the area of erotic photography, for precisely here we may be certain that there are many pictures that have remained unpublished. What we can say about the present picture, however, is that it represents an early photographic falsification: it is a fake, so to speak, made with the conscious intention of misleading the observer, the person reading the picture and text. In short, at the time the photograph was taken, the protagonist was anything but dead. Spurred by resentment, worry, or fury at the lack of recognition for his pioneering role in the development of photography, Hippolyte Bayard staged himself in the photograph as the victim and tragic hero of a scene of his own creation – and indeed not without a touch of irony, for the accompanying text is signed "H. B.".

The history of photography accepted Bayard's self-evaluation at face value and continues to do so today. Thus Jammes terms him an "unrecognized inventor"; Newhall considers him the "most luckless pioneer," and Gernsheim sees him as an "unfortunate inventor" who moreover deserved "greater respect" than he received. In fact, none of the photographic processes bear his name. The life and work of this early photographer have given rise to more speculation than fact, and as far as the invention of photography is concerned, Bayard is rarely mentioned with the trinity comprised of Niépce, Daguerre, and Talbot. And yet Bayard discovered on his own an independent direct-positive process on paper. Furthermore, in contrast to Daguerre, Bayard left behind a multi-faceted oeuvre that made use of practically all the early processes (daguerreotypy, calotypy, albumin and collodion prints). Last but not least, he played an important role as a founding member and secretary (1861–80) of the Société française de photographie.

Milieu of painters, writers, and lithographers

The literature on the subject relates that Hippolyte Bayard, born on 20 January 1801 in Breteuil-sur-Noye (Département Oise), had come into

contact already as a youth with the 'photo-graphic' phenomena in the literal sense of the words ('light' + 'drawing'). According to legend, his father, who was a proud garden owner, was passionately devoted to cultivating peaches. Before they ripened, he sometimes pasted cutouts of his initials on the fruit, causing these places to remain white. Probably a good deal more important, and of a more lasting impression, was the milieu of painters, writers, and lithographers into which Bayard, a trained notary clerk and later tax assessor, fell after moving to the French capital. By the mid-1830s, 'photography' (the medium had as yet not acquired a universally recognized name) – in particular the experiments of Daguerre – had become the talk of interested Parisian circles, and by early 1839 at the latest, Bayard had begun his own experiments. According to the journal of his experiments, he began work on 1 February 1839. "On 20 March," he noted, "obtained direct positive image with the camera obscura." By June, his diary records that he had succeeded in taking photographs of statues using an exposure time of a quarter of an hour, and of a landscape in twenty minutes. Thus, according to his biographer André Jammes, Bayard had mastered "the principles of the technique within forty days."

Bayard's use of factory-made paper as a vehicle for the photosensitive layer shows foresight. Nonetheless, the search for a direct-positive process eventually revealed itself to be a dead end, for the future of the medium resided in the production of a negative that could in theory be reproduced an unlimited number of times. In the direct-positive approach, Bayard's process resembled Daguerre's, although the latter had already won over François Arago, the Secretary of the Academy of Sciences, and convinced the French government to purchase his process in return for a lifetime pension. "Until today," protests Bayard in a declaration addressed to the Academy of Sciences, "I have postponed the publication of the photographic process which I invented because I wanted first to make it as perfect as possible. But because I was not able to prevent some information from leaking out, I believe I dare not postpone the announcement of the process any longer, in order to prevent anyone from disputing my rightful claim to the discovery or possibly profiting from my work." Bayard published these lines on 24 February 1840. By then, the detailed publication of daguerreotype process had already been a matter of history for half a year.

Hippolyte Bayard

Born **1801** in Breteuil-sur-Noye as the son of a justice of the peace. Tax official in Paris. Early **1839** first photographic experiments: daguerreotypes, calotypes, later also wet-plate collodion and albumin exposures. **1840** publication of own photographic methods. **1851** becomes a founder member of the Société héliographique and **1854** of the Société française de photographie. The latter also came to be entrusted with his estate of 900 exposures. Dies **1887** in Nemours

Hippolyte Bayard:
Self-Portrait in Studio,
after 1850

Advantageous on long journeys

Thus, in Hippolyte Bayard, we meet an inventor who arrived too late – who introduced his process after the political die had long been cast in Daguerre's favor. Technically, however, Bayard's procedure was not intrinsically more complicated than Daguerre's. Bayard exposed his blackened silver chloride paper to natural light, dipped it in a potassium iodide solution, and then exposed it in the camera obscura. The treatment caused the paper to bleach out at the appropriate places during the exposure period. Afterwards, he fixed the image in a solution of sodium hyposulfate. Raoul Rochette, secretary of the Academy of Arts, particularly stressed in his evaluation of Bayard's process the importance of the fact that the photography paper could be prepared ahead of time – as it were, manufactured: "how advantageous it might be during the course of a longer or shorter journey always to have at one's disposal a supply of these prepared sheets that are ready for use at any time." Nonetheless, in the end the field was won by the daguerreotype process, whose finely chiseled details unquestionably appealed to the precision-oriented positivistic age. An exhibition in June 1839 containing approximately thirty photographic samples produced by Bayard's method probably mark the high point of Bayard's work as scientist and inventor.

Hippolyte Bayard died a natural death in Nemours on 14 May 1887. Popular histories of photography commonly skip over his name and role in the early, pioneering phase of the medium. To this day, Louis-Jacques-Mandé Daguerre is celebrated together with the date of his announcement, 19 August 1839. Serious research, however, knows better. "Photography," argues Wolfgang Kemp, "is the outgrowth of a broad spectrum of energies moving along in the same direction in philosophy, art, science, and economy; realism, positivism, and materialism are some of the terms for these epochal tendencies." In other words, photography is a child of numerous fathers, and Hippolyte Bayard is one of them.

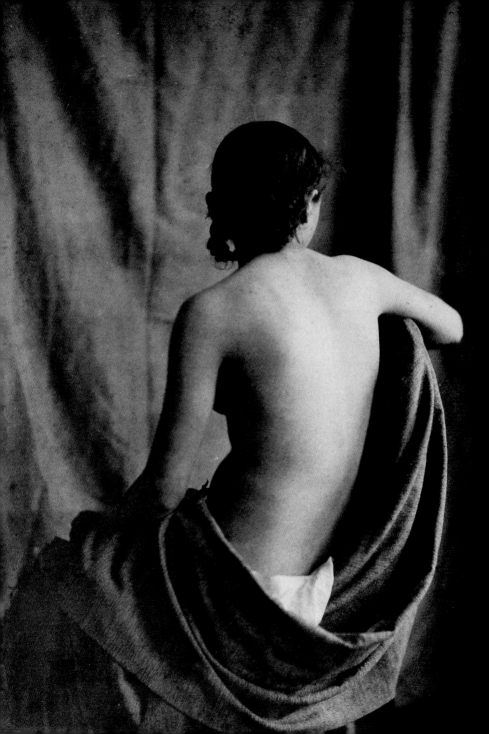

Eugène Durieu/Eugène Delacroix
Nude from Behind

ca. 1853

Paris, June 1854: working together, the painter Eugène Delacroix and the amateur photographer Eugène Durieu completed a series of nude photographs. The nearly three dozen studies that have survived constitute one of the artistic high points of early nude photography.

Charm and
Quiet
Modesty

We know neither her name nor her age. In all probability, she is a professional model. She averts her face in a movement that may be partially interpreted as calculated caution, as a conscious attempt at anonymity. Nonetheless, there are three other variations in the series in which the narrow, serious, young face is visible. The turning away from the camera is therefore part of a carefully thought-out scene. The combination of revealing and concealing, charm and modesty, lasciviousness and humility, eroticism and innocence succeed in achieving a rare balance. Even a hundred and fifty years after the photograph was made, the image seems amazingly modern: simple in concept, superb in lighting, radical in its rejection of ornamentation or typical contemporary accessories. Only a self-confident photographer, sure of his style and obeisant only to his own taste, could have created an image of such timeless validity in the midst of the nineteenth century. Eugène Durieu, so the story still goes, handled the camera, while the painter Eugène Delacroix directed the scene. This constellation would go a long way in explaining the excellence of the result. But the real ground for the photograph's success may lie elsewhere. Eugène Delacroix: the quintessential 'romantic' and antithesis to Ingres; the painter once described by Baudelaire as a volcano whose crater was artfully hidden by a bouquet – a remark that elegantly highlights the unparalleled productivity of this great nonconformist to French art of the nineteenth century. When Ferdinand-Victor-Eugène Delacroix died at age sixty-five in his studio on the Place de Furstenberg on 13 August 1863, he left behind 853 paintings, 6,629 drawings, 24 etchings, 109 lithographs,

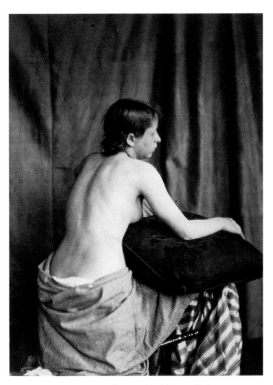

Eugène Durieu/
Eugène Delacroix:
Plate XXXII from the
Uwe Scheid Collec-
tion, albumin print,
ca. 1853

and 1,525 watercolors, ink drawings and pastels. In addition, his estate included more than 60 sketch books, an impressive number of writings important for art history, and one expressed wish: in no case, decreed the artist, should a death mask, drawing, or photograph be made of his face: "I expressly forbid it." The last testament comes as a surprise. For one thing, it was entirely customary to photograph the deceased in the nineteenth century. In addition, during his lifetime, Delacroix had done everything he could to foster his own image and guarantee himself lasting fame. As far as his own photographic portrait was concerned, by 1842 – that is, only a few years after the announcement of the photographic process –

Delacroix had himself daguerreotyped several times by Léon Riesener, only to claim subsequently in dogmatic tones that, "If we take a closer look at daguerreotype portraits, we must admit that among a hundred, not one is tolerable."

Delacroix's attitude toward the new pictorial medium was markedly ambivalent. The painter was thoroughly appreciative of photography as a handmaiden to the artist that provided a fast and comfortable process for capturing an image. Photography had, as Jean Sagne emphasizes, "enriched [Delacroix's] vision and strengthened his mode of working." But the artist was reticent in approving photography as an independent artistic form of expression. In his essay *On the Art of Drawing*, he admits, "daguerreotypy is certainly a good purveyor of the secrets of nature," but, he continues, when it comes to bringing us closer to certain truths, a photograph is nonetheless not an independent work. For Delacroix, photography was an ancillary medium, a visual lexicon – but its productions

could never be more than a cold and artificial imitation of reality.

Drawn and painted from photographs

Did Delacroix himself take photographs? In all probability, he did not; at any rate, there are no photographs from his own hand. Furthermore, the estate auction held in 1864 contained no technical equipment that would point to photographic experiments of any kind. Delacroix was too busy as a painter; why would he have additionally involved himself in the still very complicated and time-consuming pictorial medium of photography, especially when he maintained friendly contact to well-known photographers such as Riesener and Durieu, who regu-

This female nude is also attributed to Eugène Durieu. Albumin print, ca. 1855, from the Uwe Scheid Collection

larly provided him with photographs, including, often enough, nude studies? Delacroix used these photographs to sketch from and to train his hand at drawing. He clearly carried nude photographs along to the popular bathing resort Dieppe in 1854, for example – and into the Church of Notre Dame as well, where it is said he had drawn from nude photographs during the Mass. In short, Delacroix maintained a sober and pragmatic approach to the medium. He did not join the public polemic against photography, begun in 1862 when Ingres, together with such prominent artists as Flandrin, Fleury, and Puvis de Chavannes, declared war on the new medium. To the contrary, in 1851 Delacroix became the sole painter to become a founding member of the Société héliographique. A slap in the face to Ingres and his supporters? Perhaps: "Which of them," Delacroix is reputed to have asked, "would be capable of such perfection of line and such delicacy of modeling? But no one may speak about this aloud."

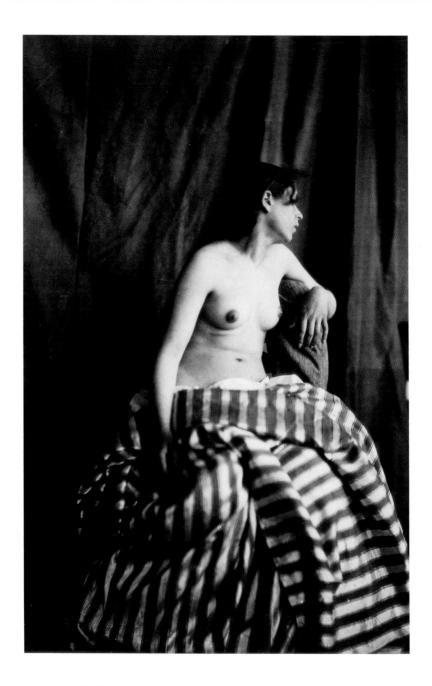

How Delacroix reacted to the sensational news of Daguerre's process in August 1839 is not known. His diary is silent on the years between 1824 and 1849; but we may well assume that the artist paid close attention to the emergence of this new, quasi automatic pictorial medium. After 1850, numerous, if scattered, entries in his journal indicate an alert, engaged, and at times amazed interest in photography, such as for 13 August 1850: "Read in Brussels that someone in Cambridge set up an experiment to photograph the sun, moon, and even the stars. They obtained prints of the constellations Alpha and Lyra [with stars] the size of pinheads. The report also includes a true but curious insight: if one assumes that the light of the daguerreotyped stars has taken around twenty years to reach us, then it follows that the beam that engraved itself into the plate had left the heavens long before Daguerre made his discovery."

Delacroix's short-term interest in the Cliché-verre process that he learned from Constant Dutilleux remained merely a passing episode. Delacroix was an avid collector of photographs, but he used them only for purposes of study. (That he had his portrait taken a number of times in the 1850s by photographers such as Pierre Petit or Nadar is noted only for the sake of completeness.) As far as Delacroix's relation to photography was concerned, what was most important was his collaboration with his friend Jean Louis Marie Eugène Durieu (1800–74), an administrative official and – beginning in 1848 at the latest – an enthusiastic amateur photographer with a studio in Paris located at 10 rue des Beaux-Arts. On 18 and 25 June 1854, Durieu and Delacroix scheduled an appointment with male and female models at the studio to take a series of nude photographs. "Eight o'clock at Durieu's," Delacroix noted in his journal. "Had them pose the whole day. Thévelin sketched, while Durieu took photographs, one or one-and-a-half minutes per picture."

The results of this early collaboration have survived in the form of an album of thirty-two photographs that the art critic Philippe Burty, whom Delacroix appointed administrator of his estate, bought from the estate auction. The note on the half-title stems from Burty's hand: "I bought the following series of photographs at the posthumous sale of the studio of Eugène Delacroix. He often used the pictures as models. And the folders held a considerable number of pencil drawings based on precisely these photographs." Today, in the Musée du Louvre, Paris or in the museums in Besançon and Bayonne, for example, one can find entire series of small-

Jean Louis Marie Eugène Durieu

Born **1800** in Nîmes. Lawyer in governmental service. Around **1845** astrophotography in collaboration with Baron Gros. From **1848** first calotypes. **1851** founder member of the Société héliographique. **1854** founder member of the Société française de photographie. **1855–58** chairman of the S.F.P. **1856** represented with his works at the World Exposition in Brussels. Dies **1874** in Paris. Works are presently in the keeping of the Bibliothèque Nationale, Paris, the collection of the S.F.P., and George Eastman House, Rochester

Eugène Durieu/ Eugène Delacroix: Plate XXXI from the Uwe Scheid Collection, albumin print, ca. 1853

format pencil drawings from these photographs. Delacroix also took inspiration for his oil paintings from the album. Apparently Plate XXIX served as the model for the small odalisque, today in the Niarchos Collection in London. Delacroix had begun to conceive the painting already in October 1854: "Painted a little on the odalisque from the photograph," he wrote in his journal, "but without much energy."

At Philippe Burty's death, the album passed into the hands of Maurice Tourneux, who in turn bequeathed the outwardly unassuming notebook to the National Library in Paris in 1899. There it was duly entered as Gift No. 9343 in the collection of the Cabinet des Estampes. On a number of occasions since the 1970s, portions of the series – in particular our nude from the rear – have been reproduced and exhibited. Jean-Luc Daval used the image on the cover of his work, *La photographie, histoire d'un art*, Paris (*Photography: The History of an Art*). Beyond this, the picture has appeared in almost every exhibit of the nude in photography. The complete sequence was first shown at the exhibit "L'art du nu" in 1997 at the Bibliothèque nationale de France, after the album had been disassembled by art experts. It is probably not too much to claim that the series today presents the best-known contribution to the theme of the nude in early photography – although it is likely that Delacroix's name has contributed significantly to the reception of the photographs. But what part did the painter really play in the series?

Let's take a closer look at the sequence of thirty-two photographs in various formats. The smallest is 4 x 4^1/$_2$ inches; the largest, 7^3/$_4$ x 5^1/$_4$ inches. Plates I through XXIX were processed as calotypes, that is, as waxed and unwaxed salted paper prints made from paper negatives. Plates XXX to XXXII, however, are albumin prints produced from wet-collodion negatives, a process which explains their clearly improved sharpness and brilliance of half-tones. There are eighteen male and five female nudes, with the combination of a male and a female models occurring nine times. In the first twenty-nine plates, the poses do not at all seem to be a matter of chance: we may assume they were taken at the direction of the painter to suit his concrete needs. Jean Sagne has compared the photographs with other works of Durieu, such those in an album now residing in the George Eastman House in Rochester, New York: "The props in the form of rocks or draperies constitute a well thought-out form of setting a scene. The Bibliothèque nationale has no

Plate XXIX from the total of 32 motifs in the series. Calotype, ca. 1853

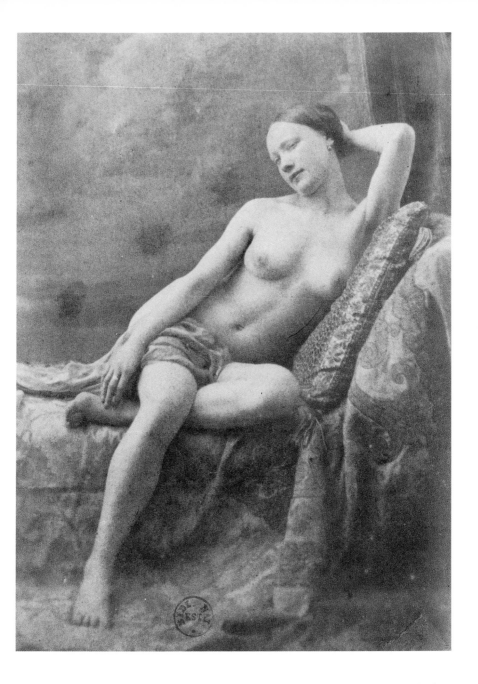

Nude from Behind **41**

Right:
Jean Louis Marie
Eugène Durieu:
Young Nude Girl,
ca. 1859, Manfred
Heiting Collection,
Amsterdam

The exposure was
made in the same
studio as for the
motifs on pp. 34, 36
and 37.

Left:
Male nude with
crate: *Plate XXII of*
the Delacroix album,
Bibliothèque natio-
nale, Paris, calotype,
ca. 1853

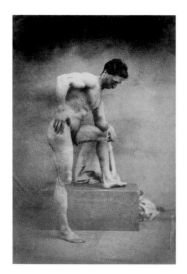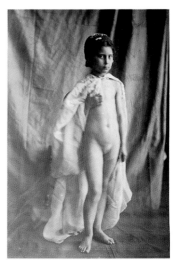

prints which compare with these. Dutilleux insists quite properly on the substantial influence of Delacroix, who may well have posed the bodies and determined the lighting. Durieu's role was certainly that of an operator, his actual contribution, that of a clever technician."

Quiet areas for the eye to rest

Beyond this, Sagne speaks of the thirty-two photographs as a series that is generally homogenous – a position contradicted by Sylvie Aubenas in a recent study. The curator of the Bibliothèque nationale argues that in terms of their technical production alone, the first twenty-nine photographs distinguish themselves from the last three. What is remarkable in this connection is that Durieu remained true to calotypy until far into the 1850s. There are also clear indications that Delacroix also preferred the glaze of the salted paper to the brilliance of the wet-plate process. Quite decidedly he adopted a position against the detailed richness of daguerreotype and glass negatives in favor of "an ineffableness, a rest zone for the eye, that prevents it from concentrating too much on individual details." What also must be not overlooked is that Plates XXX to XXXII are clearly carefully formulated, consummate images of decisively classical composition. In contrast, Plates I to XXIX are clearly 'academy photographs', that is, studies of the human body produced for artists. In

addition, the pictures possess a clearly experimental character, play with various degrees of focus, indistinct contours, and movement. Interestingly, after the last three nude photographs, whose composition is more reminiscent of an Ingres or David, Delacroix stopped drawing. In contrast, the pencil sketches based on the majority of the salted paper motifs have survived. And something else is puzzling: Durieu, the amateur, never tried to sell his photographs. Examples of his work are extremely rare, and those resulting from his collaboration with Delacroix are known only from our album – with the exception of precisely the last three, which are in the collections of the Getty Museum (Plate XXX), or of Uwe Scheid (Plates XXXI, XXXII, and variation), or of Robert Lebeck (Plates XXX and XXXI). Is it therefore possible that our rear nude is by a third, heretofore unknown, photographer? But who could have been the photographer of such a picture? The album has been only recently restored. In the process, photographs were removed from their backgrounds, but contain no stamp or signature. That contemporary nude photographers such as Moulin, Belloc, or Vallou de Villeneuve could have produced them is out of the question: their creations are too enamored of decoration and trimmings. Closest in style to the nude are the photographs of a nude from the rear by Paul Berthier (1865) or Nadar's portrait study of the actress Marie Laurent (1856), a picture which Sophie Rochard once described as a "miracle of charm."

But we are nonetheless brought back to Durieu by a child nude ascribed to him, which was auctioned at Beaussant Lefèvre in Paris in 1993. The simplicity of the picture, the reduction of accessories to a piece of cloth, the interplay between concealing and revealing all resemble our rear nude rather closely. But even more decisively, it is clear that the albumin print of $7^3/_4$ x $4^1/_2$ inches, today owned by Manfred Heiting of Amsterdam, was taken before the same neutral curtain and with the same lighting. Moreover, the folds of the background are of such astonishing similarity that one must conclude that the picture was created not only in the same ambient as our motif: if one assumes that a soft, movable curtain can hardly hold its shape for a longer period of time, the nude must have been made close to the same time as the albumin print. But the reverse of the child nude bears neither date nor signature. In the face of many questions, one point is certain: whoever the creator of our nude from the rear may be, he succeeded in creating a true "miracle of charm."

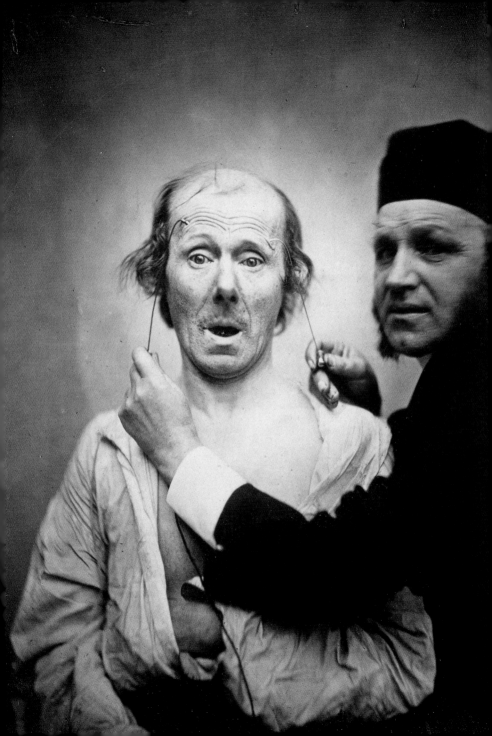

Duchenne de Boulogne
Contractions musculaires

The French medical doctor Guillaume Duchenne de Boulogne may not have been the first to seek and discover applications for the new pictorial medium in the realm of medicine. But, unlike his predecessors, he had a conceptual grasp of the medium and moreover sought to establish a bridge to the fine arts.

A Grammar of Feeling

Why is he looking at us? Why must he peer into the camera like that? Wouldn't Dr. Duchenne de Boulogne, here left in the picture, not have been better advised to concentrate on the subject of his experiment? To take care that the two electrodes maintain their contact, and thus produce the desired effect. It is of course possible that an operator in the foreground is giving him directions, but that would be possible also without eye contact, especially since this is not the first photograph that has been produced according to a certain plan and on the basis of pre-formulated guidelines. Nonetheless, this is the sole exemplar from the almost one hundred photographs of the cycle in which Dr. Duchenne is wearing this unique cap that hides his 'high forehead'. "Look at me," his face seems to say, with a trace of some amount of vanity. "Here I am: Dr. Guillaume-Benjamin-Amand Duchenne, known as Duchenne de Boulogne, medical doctor, scientist, member of the Société de médecine in Paris, specialist in the field of electrophysiology, and at this moment, conducting precisely the experiment with which I hope to change both the history of medicine and of photography."

In 1856, the year in which the photograph was supposedly taken, the technical processes of photography had already been in use for around a decade and a half. The age of the daguerreotype and the calotype was drawing to an end. With his wet-collodion process, the Briton Frederick Scott Archer had given the photographic world not only a more sharply defined process based on glass negatives, but also a technology which was

twenty times more sensitive to light than the earlier processes. Instantaneous photographs now became at least theoretically possible. Photography was being applied to more and more fields. The positivist notion of inventorying the world by means of the purely 'objective' medium of photography seemed to have taken a bold and irrevocable step forward. Photography appeared to be useful in all possible areas of life – becoming the medium of seduction in nude photography, of memory in the portrait, of inventories in ethnic studies, of reflection in death portraits, and of identification in criminal photography, to mention just a few of the ways in which photography was being applied specifically to the human body.

It was bound to be only a matter of time before the medical sciences also would take up the medium. And in fact, Duchenne de Boulogne, born in 1806, was not the first to place photography at the service of medical research. In 1844 Léon Foucault had succeeded in making daguerreotypes of human blood corpuscles. But this early exploratory attempt – moreover by means of a process whose results consisted of one-of-a-kind, saucer-sized reflecting plates – was hardly suitable for conveying the desired knowledge in a comprehensible manner. Moreover, doctors were divided over the use of photography as a pictorial medium. For a long period, many medical experts held that the traditional kind of illustration that had been in use since the Renaissance was preferable to photography because it allowed the presentation of finer distinctions and hierarchies. From this standpoint, Duchenne de Boulogne, although not the first medically trained photographer, was nonetheless the first modern doctor to use photography scientifically, in that he worked conceptually; in other words, he arranged his subjects with a view toward the medium. De Boulogne thought beyond the successful individual picture in terms of the larger connections. He thus reflected the communicative function of photography, and last but not least, he understood and accepted the medium on its own terms, including the principles of trimming, perspective, and light. In fact, his well-composed scenes and subtly illuminated pictures provide far more than merely an early visualization of certain bodily phenomena for purposes of study. Not only do his physiognomies *au repos* pass for excellent portraits, but also his experimental pictures evoke nothing less than amazement, even today, a hundred and fifty years later. One cannot help but wonder what was really going on here.

Art of reading character from facial features

Duchenne de Boulogne began his experiments, which were rooted in a combination of anatomy, physiology, psychology, and art, in the early 1850s. The way had already been pointed out by the writings of Lavater, whose *Essai sur la physiognomie* (1781–1803) – a much respected piece in its age, and praised by Goethe – described the art of reading character from facial features. In the realm of art, character typologies had existed since the seventeenth and eighteenth centuries, and were a part of the standard program in academic instruction, as is evident from painters such as Charles Le Brun and Henry Testelin. The technical basis of de Boulogne's work lay in the discoveries of Luigi Galvani, who was the first to prove the existence of electrical currents in muscles, and also in the work of Michael Faraday, whose discoveries in the area of electromagnetic induction (1831) proved directly beneficial to Boulogne's experiments. It is highly unlikely, however, that Duchenne de Boulogne would have been familiar with the anatomical studies and drawings of Leonardo da Vinci residing in the library of Windsor Castle (these would become available to the broader public only later through the carefully prepared edition of Théodore Sabachnikoff *I manoscritti di Leonardo da Vinci della Reale Biblioteca di Windsor* (1898).

A slight anesthesia in the region of the head

Joy and fear, wonder and disappointment, horror and amusement – these constitute fundamental human states of being that communicate themselves in a universally understandable manner through facial expressions. The impulses behind these expressions are provoked by certain muscles. If one stimulates these muscles systematically, one after the other, then one should be able to produce a kind of grammar of the feelings, an atlas of the emotions – thus Duchenne's hypothesis. Beginning in 1852, five volunteers stood available to the doctor as guinea pigs: two women, one younger, one older; a young anatomy student named Jules Talrich (who was also able to mime feelings without induction current); an alcoholic worker; and, as the central figure in the series of experiments, a former shoemaker, whom Duchenne himself described as "old and ugly." The man was furthermore intellectually handicapped and suffered under a slight 'anesthesia', or lack of feeling, of the head, a condition which presumably helped to make the application of electric cur-

Duchenne de Boulogne

Born Guillaume-Benjamin-Amand Duchenne in **1806** at Boulogne-sur-Mer. From **1826** studies medicine in Paris. **1831** doctorate (*Essai sur la brûlure*) and return to Boulogne. From **1842** back in Paris. **1847** embarks on his scientific researches in the field of electrotherapy. Regular publications in medical journals. **1851** member of the Société de médecine in Paris. **1857** and **1864** applies unsuccessfully for the Prix Volta. **1862** publication of his (photographically illustrated) work *Mécanisme de la physiognomie humaine ou analyse électro-physiologique de l'expression des passions applicable à la pratique des arts plastiques.* **1871** correspondence with Darwin. Numerous photographs by Duchenne included by Darwin in his *The Expression of the Emotions in Man and Animals* (**1872**). Dies **1875** in Paris

rent painless. According to Duchenne, he selected the man as a subject because the age wrinkles in his face responded well to the effects of the current, and thus provided especially clear delineation of facial expressions. The man's gauntness additionally increased the clarity of the facial creases and made the precise points for the placement of the electrodes easier.

Between two and four electrodes were used to stimulate the muscles, the source of the electric current being a generator (today in the Parisian Musée d'histoire de la médecine), which we may imagine to be located to the lower left, just outside the frame of the photograph. Duchenne's experiments, which are looked at askance by experts, are one thing; their photographic documentation, however, is another issue. Might Duchenne have been inspired to his efforts by the experiments of his colleague H. W. Diamond, who daguerreotyped mentally ill patients in British asylums? Probably not. What is certain, is that beginning in 1852 Duchenne sought the advice of respected photographers in Paris, possibly including Gustave Le Gray, Alphonse Poitevin, and even Louis Pierson. He certainly had contact with Nadar's younger brother, Adrien Tournachon.

The advancement of science

Tournachon had studied medicine for a while and might therefore have already been acquainted with the doctor. We may suppose that the young man introduced Duchenne to the technology of photography; but what is certain is that the younger Tournachon photographed some of the motifs – otherwise why would the stamp 'Nadar Jne' appear on eleven prints in the Archives nationales? Beyond this, Duchenne claimed sole authorship for most of the photographs; "I myself," he wrote in the second edition of his *Mécanisme*, "have produced the majority of the seventy-two pictorial examples in the scientific portion of the work, or was at least present [as they were made]." Proof of the claim exists also in the clearly visible (also evident in our photograph) black fingernails, revealing the ugly, but unavoidable, evidence of the professional photographer in the age of the wet-collodion process. Duchenne described the method of exposure: "The light was so placed that the creases stimulated by the electric impulse would be defined as clearly as possible... An assistant sensitized the plate with wet collodion. Before placing it in the camera, the photographer, with the help of the assistant, attempted to find a pose that

Duchenne de Boulogne: Effroi, sujet vu de profil (Fright, subject viewed in profile), Plate 42 from Duchenne's Album personnel, *1855–56*

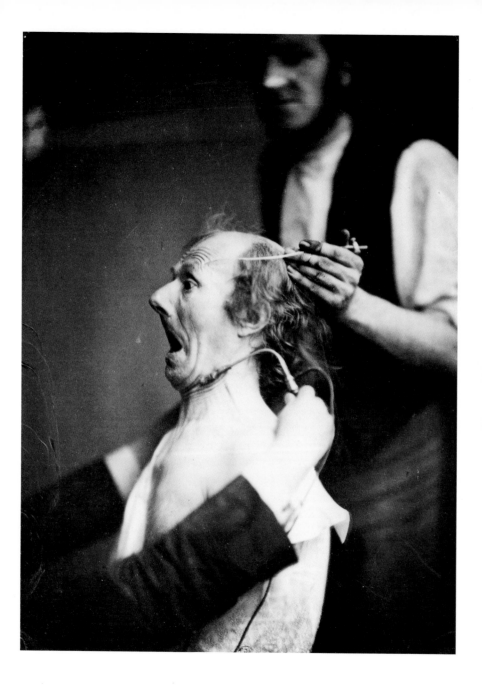

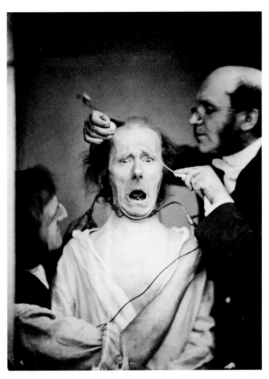

would illustrate the subject in sharp detail, without disturbing the already sharp focus of the subject ... At an agreed sign the assistant opened and closed the lens. Finally, the experimenter himself did the developing."

We have no information about where our motif was taken. In other photographs, Duchenne's private apartment at 33 boulevard des Italiens, where it is known that the doctor maintained a *laboratoire*, is recognizable. In the case of our picture, a completely neutral background provides an atmosphere at once concentrated and anonymous. The lighting indicates the direct influence of Nadar, whereas the posture of the subject, whose right hand disappears into the neck of his simple white

Duchenne de Boulogne: Effroi, mêlé de douleur, torture (Fright, pain, agony), Plate 45 from Duchenne's Album personnel, 1855–56

shirt, could be read as a reference to the Second Empire, for Louis Napoleon, the nephew of Napoleon I, had dissolved the National Assembly and had taken over the government in 1851 in the course of a coup. That the ambitious emperor was particularly interested in supporting the sciences and industry is well known, and the revival of the Prix Volta for pioneering practical research in the area of electrophysics was a result of his initiative. Duchenne de Boulogne applied for the attractive prize with its award of 50,000 francs with his works on "human physiognomy" in both 1857 and 1864, but without success.

Duchenne's investigations and his photographs – including our motif, which represented the emotion 'surprise' – appeared in a work published in 1862 under the title *Mécanisme de la physiognomie humaine ou analyse électro-physiologique de l'expression des passions applicable à la pratique des arts plastiques*; that is, they were presented in a book whose visual and educational material was primarily directed toward artists in the fine

arts. But Duchenne's pasted-in albumin prints chiefly depicting a debilit-
ated old man apparently interested the creative sector that the doctor
had in mind just as little as they impressed his colleagues in the field of
medicine. The book remained almost wholly without a public, a circum-
stance that no less a figure than Charles Darwin remarked upon in the
introduction to his *The Expression of the Emotions in Man and Animals* in
1872 when he noted that Duchenne's work had either not been taken
seriously by his fellow countrymen, or had been completely ignored. In
fact, the first French translation of Darwin's study created a certain level
of attention for Duchenne de Boulogne. In 1875, one year after the pub-
lication of the French title, the doctor died in Paris. In the context of a
questionnaire à la Proust, Duchenne de Boulogne was once asked what
he most liked to do. His answer: "To research." His photographically
illustrated *Mécanisme de la physiognomie*, which straddles a bizarre line
between science and art, is without a doubt the most original contribu-
tion to its field.

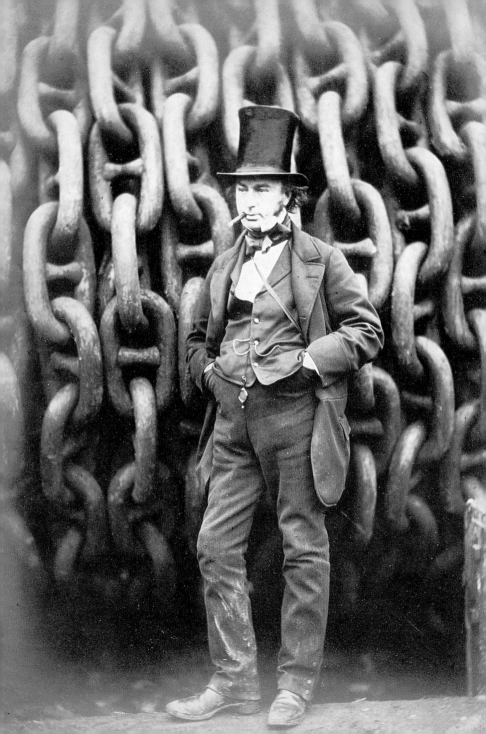

Robert Howlett
Isambard Kingdom Brunel

The Great Eastern was one of the largest steamships of the nineteenth century – a dream-turned-steel of overcoming the elements. The builder of the ship, which originally bore the name 'Leviathan', was the imaginative and resourceful engineer Isambard Kingdom Brunel, whose portrait is part of one of the earliest industrial photographic reports.

Moloch
on the
Thames

Let's not deceive ourselves: the top hat is still an integral element in the wardrobe of a British gentleman – and the same is true for the half-length frock coat, vest, and bow tie above the collar that, unlike today, would never be left open. One might almost speak of 'full dress' in the sense of the combination of matched and co-ordinated elements, if it were not for the emphatically relaxed posture of the figure – or the wrinkles in the vest, caused by the upper button, instead of the prescribed lower one, having been left open; or the hands stuffed into the remarkably high trouser pockets; or, above all else, the unmistakably filthy shoes and trouser legs. And this is not even to mention the cigar jauntily tilting out of the right corner of his mouth, which lends our protagonist a rakish air – although one must remember that the gesture of smoking together with the aura it created was considered, from George Bryan Brummel to Oscar Wilde, as the *arbiter elegantiarum*, and thus signified the complete opposite of lassitude and nonchalance. But in the role of the 'rake' or 'dandy', insofar as these terms implied a sense of self-admiring vanity, was probably not how the man here pictured, Isambard Kingdom Brunel, would have seen himself. Not that he wasn't both vain and full of self-love; however, this master builder, architect, and engineer did not define himself by his persona, but rather by the industrial 'monuments' that he had created. With these amazing productions of the capitalist age, the bourgeois world of the nineteenth century sought to link itself quasi

seamlessly to the world wonders of antiquity. Looked at from this perspective, the dirty boots and trousers can be interpreted as entirely in keeping with the required uniform expressing the ideas of making and creating. To this uniform also belonged the folded monocle and, especially, the watch affixed to a long chain: the watch, after all, was the medium that could turn human achievement into a measurable quantity.

In November 1857 the young London photographer Robert Howlett made a portrait of Isambard Kingdom Brunel. Unusually enough, he shot the portrait in the open air, and even more surprisingly flaunted the expectations of contemporary bourgeois self-confidence, which normally preferred an antiquating decor as backdrop to lend the picture a classic air. Instead, Howlett selected as background the mighty anchor chain of the ship with which the engineer Brunel was to leap beyond all norms and dimensions of shipbuilding that had held valid till that time. There is something undeniably Babylonian about the picture. The human figure, low in height, fragile in comparison to the power suggested by the rolled iron links, nonetheless stands proud in the knowledge of being the creator of all this might. The photograph, like the great ship itself, must have

Brunel as a woodcut: only via this circuitous route could a half-tone be printed prior to 1900. From The Illustrated Times, *London, 16.1.1858*

surprised contemporaries and moved them to a sense of wonder. The London *Illustrated Times*, which published an illustrated report on the completion of the floating monster, significantly named 'Leviathan', also offered original prints for sale, which presumably found a multitude of ready buyers. How else can one explain the fact that precisely this exposure, for example, is owned by the American private collector Paul F. Walter? The Gilman Paper Company also calls a particularly fine copy their own, as well as the Amsterdam collector Manfred Heiting, whose print – in the original format 11 x 8$^1/_2$ inches – we were allowed to reproduce here. The list of copies furthermore includes various British and American collections and archives, to mention just a few. In other words, the photograph numbers among the better-known incunabula of early British photography – an astonishing portrait that retains the full force of its suggestive power even today.

To be precise, the picture is part of a larger series, what we would today call a photo-report, that Robert Howlett completed under commission from the *Illustrated Times* immediately before the Leviathan – or, as the ship soon came to be popularly called, the Great Eastern – was finished. Mind you, as a technical pictorial medium, photography had been in use

for only a decade and a half. With the wet-collodion process invented by Frederick Scott Archer in 1851, glass could now for the first time be practically employed as the vehicle for the colloid. This meant that the negatives were more clearly defined than the calotype, or paper negatives that had been used up until then. Just as important was the reduced exposure time. On the other hand, because the collodion plates that were about to be exposed were wet, they required considerably more technical and logistical work. One can easily identify at least eighteen different steps in the process, ranging from the sensitizing of the plate to the completed exposure. As a result, the self-confident engineer Isambard Kingdom Brunel likely found himself facing an equally self-confident photographer. Robert Howlett would also have seen himself as a pioneer and innovator of the industrial age, albeit in the completely different area of photographic technology and aesthetics.

Leaving few, but therefore all the more impressive, traces

We know comparatively little about Robert Howlett – a surprising situation, in view of the high evaluation today accorded him and his works. Mark Haworth-Booth, for example, calls him "one of the leading professional photographers of the mid-1850s". and Waeston Neaf recognizes him as "one of the daring innovators in British photography of the 1850s". Nonetheless, data concerning Howlett remains sparse. On one hand this vagueness may result from the fact that research into nineteenth-century photography is still in its infancy; on the other hand, it may be because Howlett died at age 27, leaving few, but therefore all the more impressive, traces.

Born in 1831 as the son of a Norwegian pastor, Howlett is supposed to have been for a time the partner of the photographer Joseph Cundall (1818–75). Under the title *On the various methods of printing photographic pictures upon paper* (1856), Howlett authored a widely-used photographic text book. In addition, he developed a portable darkroom tent that was probably especially helpful to him in his work at the London docks. Most importantly, however, Howlett was open to the most various applications of the still young medium. Still extant are his portraits of Crimean War veterans, which he supposedly made at the behest of Queen Victoria; in addition, he completed landscapes and architecture studies. Howlett was also active in the area of art reproduction, and produced

Robert Howlett

Born **1831**. Makes his name in London during the **1850s** as a successful commercial photographer. Partner in the firm Cundall and Downs. Distinguishes himself by his portraits of Crimean War veterans, for instance, and interior views of Buckingham Palace. **1857–58** pictures of the launching of the Great Eastern. Portrait of its builder, Isambard Kingdom Brunel. 16 January **1858** pictorial report in London *Illustrated Times* using his photographs. Dies the same year. His photographs are to be found in the collection of the Victoria and Albert Museum, London, as well as of the Gilman Paper Company, USA.

Robert Howlett: Construction of the Great Eastern, *albumin print, 1857*

Unmistakle on the right hand side is the rolled-up anchor chain which Isambard Kingdom Brunel posed in front of for the photographer.

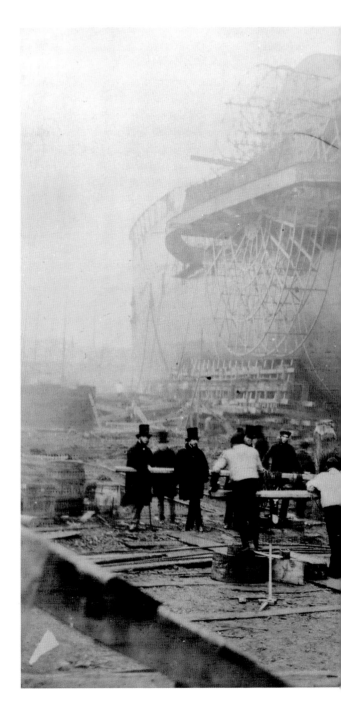

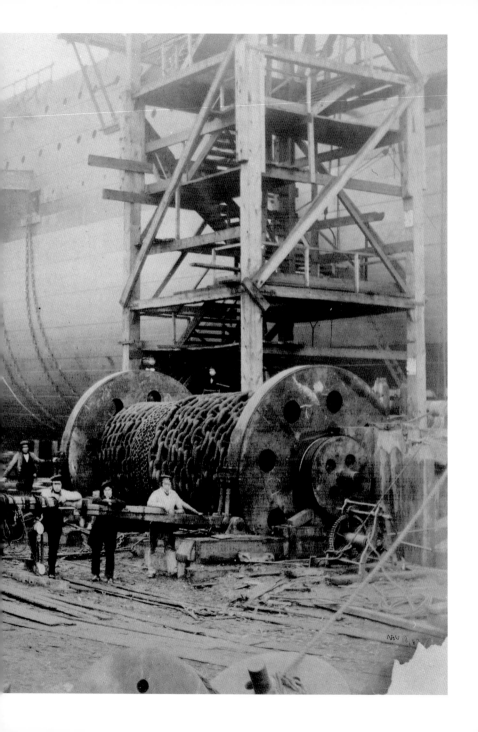

photographs meant to serve artists as models. The painter William Powell Frith, for example, is reputed to have referred to works by Howlett in the composition of his painting *Derby Day* (1858). Admittedly, however, Howlett's most famous work is his series on the launching of the Great Eastern, photographed precisely one year before his unexpected death in November 1858 – whether this was from typhus or, as is occasionally argued, from careless handling of the sometimes dangerous chemicals that were a part of these early years of photography remains an open question.

Was Robert Howlett a friend of Isambard Kingdom Brunel? It has occasionally been claimed, and if true, would explain why the engineer appears in almost every photograph in the series. At the same time, it must be stressed that Brunel was something of a star engineer, and his presence in a picture would certainly contribute to the public's interest in a newspaper article. In an age when the limits of the feasible served as a constant challenge in the struggle for progress, Brunel functioned more or less as the prototype of an uninterrupted belief in progress. With truly breathtaking speed, a society whose commerce was primarily determined by agriculture and hand-production had transformed itself into a capitalist industrial economy, a process in which England could rightly claim a leading role. New materials (above all, iron), new sources of energy (in particular coal, and the resultant steam), and new technologies now determined the rhythm of progress, which in turn lead ultimately to the creation of new way of life, new social levels and classes – as well as to the class antagonisms later described by Karl Marx and Friedrich Engels in their works.

Born in 1806, Brunel's father was the famed engineer Mark Isambard Brunel. A pure technocrat, the son had little interest in the social implications of his accomplishments: for him, the art of engineering meant the conquest of the elements, a battle which could never be pursued far enough. At Brunel's death on 15 September 1859, the *Morning Chronicle* appropriately noted: "The history of invention holds up no other example that great innovations can be so keenly conceived and so successfully implemented. Had he been less bold, he would have been less successful... Brunel was able to create an epic of engineering epic, but not a sonnet of engineering. If he could not exert power, he was absolutely nothing..."

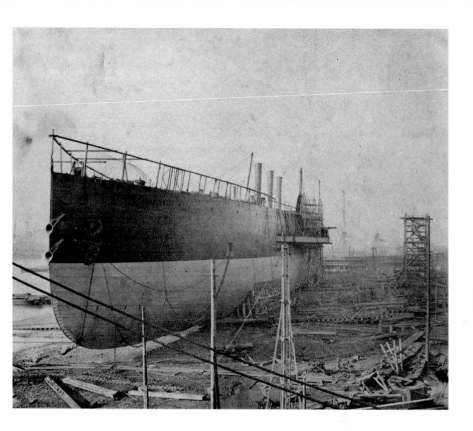

The Bourgeois hero at the focus of interest

He had built tunnels and harbors, involved himself in the railroads, and in particular, designed, financed, and built ships. British historian Francis D. Klingender begins the history of steamship travel with Brunel's Great Western (1838); five years later, his 3,000-ton Great Britain was launched – for its time, a mighty vessel, but modest in comparison to the Great Eastern, which gradually took shape on the mud banks of the Thames beginning in 1852. The records speak of a water displacement of twenty-seven thousand tons, a length of 692 feet, and a breadth of 82 feet. The ship was planned for four thousand passengers, sported six masts and five stacks. A steam engine with eleven thousand horsepower turned a paddle wheel almost sixty feet in diameter. In addition, there was stowage for approximately 15,000 tons of coal; that meant that the ship could

Robert Howlett: The bows of the Great Eastern, albumin print, 1857

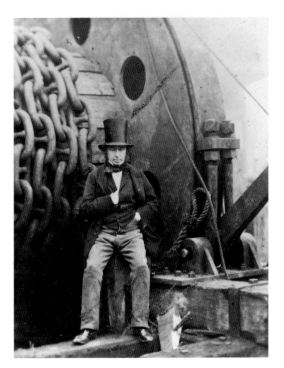

Robert Howlett:
Isambard Kingdom
Brunel, *albumin
print, 1857*

The ingenious in-
ventor in one of the
less common versions
of the photograph

cross the Atlantic without having to load fuel on route. Contemporary reports turned to the map of London to convey their readers an idea of the dimensions of the ship: "Neither Grosvenor nor Belgrave Square could take the 'Great Eastern' in; Berkeley would barely admit her in its long dimension." From the very beginning, it was the task of photography to testify to the (nearly) incredible. The mechanical, quasi automatic, aspects of the photographic process lent photographs their power as evidence, without reference to aesthetic demands that were laid upon the medium from the other direction. Although the series of pictures that Howlett made in November 1856 of the construction of the Great Eastern possesses uncontested aesthetic value – and in this sense it constitutes one of the great achievements of early photography – the photographer was primarily interested in the visualization of an event. Because of the complexity of the photographic process, instantaneous exposures were impossible. Therefore, Howlett placed the protagonists, in particular Isambard Kingdom Brunel, at the center of the striking setting provided by the powerful new ship – no doubt with the request to stand still. We do not know how many plates Howlett exposed, but in any case, the surviving images prove his skill in analyzing a theme into individual aspects in order to tell a story, quite in keeping with today's understanding of reporting that tells a story. Howlett repeatedly placed the engineer in front of imposing backdrops, at times photographing close up, at times at a distance, an approach which emphasized the size of the ship. In the collection of the J. Paul Getty Museum in Malibu, there is a particularly impressive group portrait, dated 1857, of dark-clothed men, presumably taken before the launching of the ship. Howlett must

therefore have followed the construction of the ship over a period of time. The *Illustrated Times* published a report with photographs by Howlett and Cundall in its issue of 16 January 1858. Because half-tone print could not be directly printed, the original was first copied as a wood engraving. The portrait of Isambard Kingdom Brunel was rendered fairly exactly in front of the large anchor chain. Only the dirt on his trousers and shoes fell victim to the correcting stylus of the engraver.

In particular, Marxist aesthetics has found fault with the absence of workers in Howlett's pictures. And in fact, workers, when they appear at all, are small, relegated to the background, and usually blurred. The reigning concept of the age was still that of patriarchs, to whom all industrial progress owed its being. From this standpoint, Robert Howlett's photograph of the self-confident engineer reveals the ideology of a century that saw bourgeois heroes as the focal point of historical interest. That Brunel himself did not live to see the maiden voyage of his ship is one of the tragic aspects of the picture, an image which stands almost emblematically for the technological enthusiasm of the early nineteenth century. In 1867 the Great Eastern put to sea; among the passengers was no less a figure than the writer Jules Verne. Through him the utopias of Isambard Kingdom Brunel found their apotheosis, albeit 'merely' an artistic one.

1862 Auguste Rosalie Bisson
The Ascent of Mont Blanc

**The Archi-
tecture of
the Alpine
Peaks**

The eighteenth and nineteenth centuries – the age of industry and technology – discovered nature anew. The idealized landscapes of classical painting were replaced by scenes of an environment as perceived through the analytic eyes of science, and photography came into its own as a pictorial medium suited to the needs of the age. In the new, realistic interpretation of landscape, the younger of the two Bisson brothers was a leading pioneer.

They photographed architecture – ever and again architecture. Along with Edouard-Denis Baldus, Gustave Le Gray, and Henri Le Secq, they number among the most important architectural interpreters of the nineteenth century. Their large-format photographs manifest an amazing feel for the power of light, for the modulations produced by the interplay of light and shadow. In short, the photographs of the Bisson brothers represent an attempt to convey the reality of architecture in the form of a two dimensional image. But what is it that lent their unpeopled topographies such clarity and artistic power? Was it the slowness of their large plates? The complexity of the photographic process? Or the atmosphere of an age capable of greater concentration than ours? After 1860, at any rate, the name of the firm, "Bisson frères," was known even beyond the borders of France as a synonym for the quickly growing genre of architectural pho-tography. But the brothers did not rest with views of the Louvre, Paris or the cathedrals of Chartres or Reims. They undertook lengthy journeys to Italy, Spain, and Germany. In Heidelberg they used a platform to achieve a new and unfamiliar view of the castle ruins; in Paris, the towers of Notre Dame offered the opportunity to formulate several views of the city from the airy heights. A panorama with the astounding dimensions of $17^3/_4 \times 41^1/_2$ inches, composed of three negatives depicting the interior of

the Musée du Louvre in Paris won a positive review from the photography journal *La Lumière*: one must praise the "great harmony of light, and all the fine and numerous details of this sculptural jewel," which was here "reproduced with rare harmony." For the sake of completeness, it must be noted that the brothers also produced daguerreotypes, fulfilled portrait contracts, photographed art works, and also placed their talents at the service of science. But most importantly, theirs were the first successful photographs of the peak of Mont Blanc in 1861 – an impressive achievement in terms of skill both in mountaineering and photographic technology. Their achievement not only caused much excitement at the time, but it also constituted an important contribution to the history of photography and secured the Bisson brothers a place among the six most important French photographers of the pioneer age: Bernard Marbot, Nadar, Nègre, La Gray, Baldus, and finally, the Bisson brothers themselves, who, as "diligent pilots of a large firm," were thus also intermediaries between industry and art.

Two brothers: Louis Auguste, born in 1814 and Auguste Rosalie, twelve years younger. It was intended that Louis Auguste become an architect, but in fact he worked for twelve years in the Paris city administration before turning to daguerreotypy in the early 1840s – a surprising decision from today's point of view. But we must remember, at that time, the medium, still young, was a playground for any entrants into the field who could demonstrate courage, a readiness to take risks, an interest in pictures, and the spirit of an inventor. Reviewing the original professions of the early photographers, Hans Christian Adam came up with a list that included portrait painters, scientists, lithographers, and even a coal dealer. The Bissons' father, Louis François Bisson, was a ministerial official who painted coats-of-arms on the side, before he took up the still-young process of daguerreotypy in 1841. The family was thus from the very beginning a part of that much-cited 'daguerreotypomania' that took root in France and elsewhere after 1840. It is therefore not surprising that Auguste Rosalie also soon gave up his job as an official in the Office of Weights and Measures and turned to photography. He began with portraits, but also reproduced paintings, and gave instruction in photography. By 1849 at the latest, the two brothers were working together as partners and in 1852 they opened a joint studio, initially located at 50 rue Basse du Rempart, then at 62 rue Mazarine, and finally at 8 rue Garan-

Bisson frères

1814 birth of Louis Auguste Bisson in Paris. **1826** Auguste Rosalie born in Paris. **1843** Louis Auguste and Bisson senior open up a portrait studio in Paris. **1848** Auguste Rosalie opens a studio. From **1852** the two brothers work openly together ("Bisson frères"). **1854** first presentation of large format views of monuments. Become founder members of the Société française de photographie in that same year. **1856** Napoléon III visits their studio. **1858** views of the Mont Blanc range and of Switzerland by Bisson the younger. **1860** further shots of the Mont Blanc range. **1861** views of the peak of Mont Blanc. **1862** second successful ascent of Mont Blanc. Exhibition of prints in Amsterdam and London (World Exposition). **1863** the firm goes bankrupt and is liquidated. **1876** death of Bisson senior in Paris. **1900** death of Bisson the younger in Paris

cière, where they occupied a total of twelve rooms on three stories for their private and professional needs.

Although the Bisson frères, as they were officially known as a firm after 1852, were active in all the early genres of photography except the nude, their real domain remains that of architectural photography. They advertised an impressive selection of offerings, including "photographic reproductions of the most beautiful examples of architecture and sculpture of antiquity, the Middle Ages, and the Renaissance." The photographs were pasted into books or albums, or alternatively were made available to the educated public in the form of original single sheets. In addition to all this, at the beginning of the 1850s, the brothers began to take an interest in landscape photography. A six-foot-long panorama of the Pavillon de l'Aar probably represents their first zenith as photographers of nature – and is said to have moved the Alsatian clothing-manufacturer Daniel Dollfus-Ausset to buy his way into the Bisson brothers' firm as a limited partner for a sum of one hundred thousand francs. Dollfus-Ausset took a lively interest in Alpine glaciers, and felt confident that in Louis August and August-Rosalie Bisson he had finally found a team who could guarantee him the photographic exploration of the mountain world. Dollfus-Ausset's affinity for the mountains heights must be understood in the context of the new understanding of nature. Beginning with Rousseau at the latest, the traditional, normative concepts of nature had begun to dissolve: the traditional image of the ideal landscape as found in literature and the fine arts was now being replaced by an empirical model. This approach had already entered the sciences, and by the time of the Napoleonic wars, had increasingly made its way into the military. It is no accident that fields such as geology, geodesy, and geomorphology blossomed for the first time precisely during these years of increasing nationalism and imperialism.

Photography in the cold, thin mountain air

Even before establishing his connection with the Bisson brothers, Daniel Dollfus-Ausset had already spurred other photographers on to make pictures of the high ranges of the mountains. Thus, Jean Gustave Dardel was the first to succeed in taking photographs of the Alpine landscape, producing approximately a dozen pictures in 1849. Similarly on the initiative of Dollfus-Ausset, Camille Bernabé made daguerreotypes of several Alpine

Auguste Rosalie Bisson: Ascent of Mont-Blanc *(via a crevice), albumin print, 1862*

Auguste Rosalie Bisson: Meeting point of the Bosson and Taconnaz glaciers *(abandoned attempt to ascend Mont Blanc), albumin print, 1859*

glaciers and peaks in August 1850. The midpoint of the century also found other photographers such as Friedrich von Martens, Aimé Civiale, Edouard-Denis Baldus, and the Ferrier brothers at work in the mountains. Although Auguste Rosalie Bisson was not the first to set up his camera in the high Alpine ranges, he was the first photographer to succeed in conquering the heights of Mont Blanc. Furthermore, unlike the majority of the photographers cited above, he employed the more modern, albeit more complex, wet-collodion process, which, it must be added, had not yet been tested under the extreme weather conditions of the mountain heights. What he brought back from his successful expeditions of 1861

and 1862 was more than a mere 'I-was-there' variety of proof: Auguste Rosalie Bisson's large-format negatives and prints also conform to the highest aesthetic standards.

In August 1859, Auguste Rosalie Bisson started his first attempt to ascend to the peak of Mont Blanc. It is difficult for us today to imagine the difficulty of such an undertaking. In the first place, in 1850 mountain climbing was still in its infancy, the equipment of the mountain climbers had not yet been perfected, and the participants as a rule were insufficiently trained. But even without all this, Mont Blanc represents a particularly dangerous and moody peak, which had been first conquered only in 1786, and significantly bore the nickname *montagne maudite*, or 'damned mountain'. Furthermore, the challenge facing the younger Bisson was not merely to reach the nearly sixteen-thousand-foot peak, he also wanted to take photographs there – specifically using the wet-collodion process that was as yet untested in the thin mountain air and extremely cold temperatures.

The collodion process, announced in 1851 by the Englishman Frederick Scott Archer, was the most complex of all the early black-and-white photographic processes, calling for a glass plate as the vehicle for the photographic layer. The use of the glass plate offered the advantages of considerably increased light sensitivity and a more brilliant and precise image. The disadvantage lay in the no fewer than eighteen various steps that the process required, from the sensitizing the plate with a fluid mixture of

ether alcohol, collodion, iodine and bromide salts, through the exposure of the plate in the camera, and ending in the development and fixing of the negative. Because the plates had to be exposed while still wet, a traveling photographer had to carry along – in addition to the camera, tripod, glass plates and chemicals – a complete darkroom tent. In reality, no fewer than twenty-five men accompanied Auguste Rosalie Bisson on his excursion; in addition to the necessary porters, there were also experienced mountain guides such as Mugnier and Balmat.

Milestones of early photography

On 16 August 1859, the party set out from Chamonix. Initially, the weather looked promising, but worsened considerably in the course of the day. A hut on the glacial lake served as their quarters for the night. Now it started to snow and the temperature sank to ten degrees Fahrenheit; nonetheless, Bisson and four guides reached the final rock face before the summit on the next day. Buffeting winds and whirling snow prevented the final ascent, however, and taking photographs was out of the question. Thus the first attempt was given up without result. A year later, on 26–27 July 1860, a second attempt also resulted in Bisson's retreat from the peak without pictures. It was not until the third try on 24 July 1861 that the photographer finally succeeded in climbing "the giant among mountains with his equipment," as *La Lumière* commented with admiration. Once again, the weather seemed favorable. The group set off from Chamonix on the morning of 22 July. By evening they reached the Grand Moulets at a height of more than ten thousand feet. They rested for an hour, and reached the great plateau around six o'clock in the morning. Proceeding to the Petits Moulets at a height of more than fifteen thousand five hundred feet, the group was greeted with storm winds and snow, and was forced to turn back. Some of the men began to give out; they were sent back to Chamonix, and replacements were sent up. Toward midnight of the second day, they set off again, finally attaining the peak at morning. "The tent was erected," as described in a contemporary report, "the camera placed on the stand, the plate coated and sensitized, exposed, and the view was taken. And what a view! What a panorama! As the picture was being developed, there was no water at hand to rinse it. It was assumed one could melt snow with the lamps, but in this atmosphere, the lamps burned only with a very small flame... One man was

assigned to the lamps, to keep them burning; he fell asleep. Another replaced him, but the same thing happened. Finally Mr. Bisson himself managed to obtain enough of the precious substance. He hurried to his tent, at whose door only Balmat was still standing, and completed processing his negative."

In this first successful expedition to the summit of Mont Blanc, Bisson succeeded in taking a total of three photographs. On a second ascent in 1862, he brought back six more. These were not to be his last pictures from the mountains, but they remain his most spectacular: in the technique, aesthetics, and logistics of the entire process, these stand as milestones of early photography. Whether or not Bisson used a green filter to even out the extreme differences in contrast in the negative, we do not know. Nor do we have information about the exact format of the plates, the camera, or the lenses that he used. What stands out in the pictures is their aesthetic content, undoubtedly wrung from Bisson's routine architecture interpretations; his sure sense of style; his experience with light, composition, reduction, and the golden section – from all of which he could profit. Bisson, as Milan Chlumsky rightly has said, was the first to prove that the "deserts of snow possess unmistakable aesthetic qualities. He was the first to capture the majesty of the Alps by photography." We know that the Bisson brothers had assumed they would make money from the spectacular undertaking. But ironically, more than a year after the second ascent of Mont Blanc, the firm went bankrupt and went under the auctioneer's hammer on 7 April 1864. The buyer, a certain Emile Placet, paid the ridiculously low sum of 15,000 francs for the entire inventory, the negatives, and the rights to the pictures – including the legendary photographic conquest of Mont Blanc.

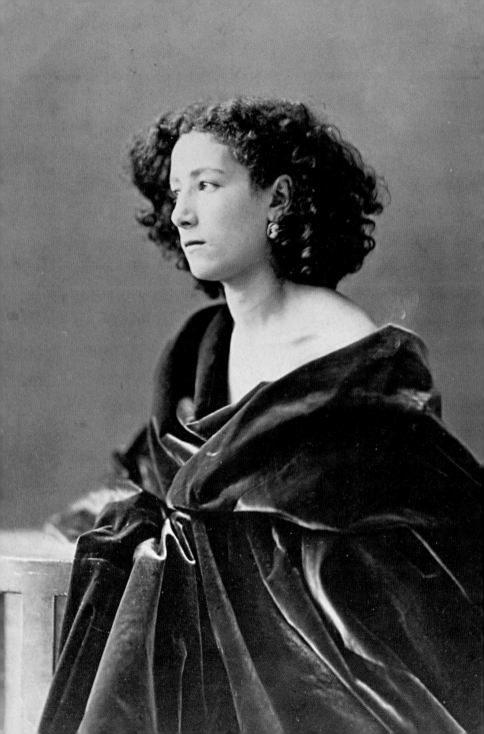

Nadar
Sarah Bernhardt

ca. 1864

She was a true child of the age of photography. Fascinated with the new pictorial medium that photography represented, Sarah Bernhardt understood how to wield photography to foster her growing fame.

Lady at Ease

At some point in the course of 1864, the young Sarah Bernhardt had her portrait taken in the studio of the Paris photographer Félix Tournachon, known as Nadar. The precise day and month have not been recorded but researchers nevertheless have agreed. At the time, Henriette Rosine Bernhardt, the daughter of a Hungarian Jewish mother, was twenty years old, and it would be an exaggeration to term her a famous actress. At this point even the word 'promising' might be too much – although she had been a conscientious student at the Paris Conservatory, and had passed the final exams as the second in her class. But even so, coming directly from school, she would never have been engaged by the Comédie Française – at that time still the leading theater in France – without the support of her mother's influential friends. One cannot speak, however, of the beginning of a brilliant career; in fact, rather the opposite. "Her debut," writes Cornelia Otis Skinner, one of Bernhardt's biographers, "was not at all sensational; it wasn't even good." In particular, the stage fright from which she was to suffer throughout her life weakened her self-confidence during her performances. Accordingly, the critics responded with restraint. Francisque Sarcey, for example, initially commented positively on the way the young actress carried herself and spoke in her first appearance in Racine's Iphegenie – but shortly afterward rescinded his faint praise. Similarly, the influential critic of *Le Temps* found her performance unsatisfactory. If she seem to have made an impression at all, then it was thanks to her appearance: "Mademoiselle Bernhardt ... is a tall and pretty young person of slender build and very pleasant facial expression. The top half of her face is remarkably beautiful; her posture is good and her

"Sarah Bernhardt after leaving the Conservatory". Article in the French glossy VU, August 12, 1931

The date of Nadar's photograph is given here as 1861.

pronunciation completely clear. More," according to Sarcey, "cannot be said at this point."

By 1864, Sarah Bernhardt had two years of stage experience behind her. She had appeared in pieces by Molière and Racine, and had also held her own in now-forgotten plays by writers such as Barrière, Bayard, Laya, and Delacourt. But until the time of the photograph, she had garnered more attention from a certain extravagance of clothing and appearance, as well as a series of moderate-sized scandals, which initially were anything but helpful to the progress of her career. A slap she delivered on the public stage in early 1863 gained her not only dismissal from the Comédie Française but the reputation of being difficult, stubborn, and arrogant. She was, and remained, without permanent engagement. On top of all this, she was now pregnant. The child – a son named Maurice – was born in December 1864 on the wrong side of the blanket. All in all, the young actress was not in an enviable position. "This young person," her teacher at the Conservatory is said to have prophesied, "will either be a genius or a disaster." In 1864, the latter seemed the more likely prognosis.

In precisely this unpromising year, the young actress determined to visit Nadar's atelier. The studio was not just any of the by-then numerous photography establishments in Paris: it was the largest and probably the best known. Opened in 1860 at 35 Boulevard des Capucines, the studio tended to draw customers of name and rank, if not precisely the power elite of the Second Empire, from whom the republican sympathizer Nadar kept a critical distance. Instead, his clientele included the members of the bohemian circles from which Félix Tournachon himself had arisen, even if his meanwhile well-developed sense for business distinguished him from the "water-drinkers," as he called them.

Pantheon of prominent personalities

Gaspard-Félix Tournachon, who began to style himself 'Nadar' in 1838, had started his career as a theater critic, writer, publisher of literary magazines, draftsman, and caricaturist. His project of creating a lithographic *Pantheon of Famous Contemporaries*, begun in 1851, won him attention, even though financial problems prevented him from producing more than a first issue. In the same year, Nadar also turned to the still-young field of photography, a decision that at first glance seems logical for technical reasons: photography was faster and cheaper than lithography, thus making it easier to construct his 'pantheon' of prominent personalities, for example. Furthermore, a new process had just become available that, although rather complicated, was many times more sensitive to light: the wet collodion process, which Félix Tournachon set to immediate use in his very first photographs. Nadar began making portraits of family members; soon, however, his artist friends were also stepping in front of his camera: Baudelaire, Champfleuri, Doré, Delacroix, Rossini, and Berlioz – a collection of simple, concentrated studies that "even today still retain their directness" (Françoise Heilbrun). Within a very short time, Nadar refined his portraiture to a remarkable level, a feat for which no doubt his familiarity with his subjects, his years of work as a caricaturist, as well as his "general curiosity about human beings" (Heilbrun) proved of great value. Nadar himself was thoroughly conscious of his abilities – of his own 'genius' – as demonstrated in a sensational civil suit against his own brother Adrien, who was in competition with him. During the trial, the self-assured Nadar declared that in photography, one could learn much for oneself, but not everything; excellent portraits, in particular, depend-

Nadar
Actually Gaspard-Félix Tournachon. Born **1820** in Paris. Studies medicine, without finishing. **1838–48** unsettled bohemian life. Friends with Murger and Baudelaire. First caricatures. **1851** preliminary work on a Pantheon of famous contemporaries. **1854** turns to photography, opens a studio. **1858** first exposures using electric light. **1860** founds Atelier Nadar on Boulevard des Capucines. **1861** pictures of the Paris catacombs. **1886** photo interview with the 100 year-old chemist Chevreul. **1887** ceases studio work. **1897–99** new studio in Marseille. **1910** dies, is buried at Père-Lachaise

ed chiefly on the talent of the artist behind the camera. This evaluation was picked up by Philippe Burty in his criticism of the photographic Salon in 1859: "Mr Nadar," as he wrote in the *Gazette des beaux-arts*, "has made his portrait photographs into unquestionable works of art in the truest sense of the word specifically through the manner in which he illuminates his models, the freedom with which they move and assume their postures, and in particular by his discovery of the typical facial expression of each. Every member of the literary, artistic, dramatic, and political classes – in short, the intellectual elite – of our age has found its way to his studio. The sun takes care of the practical side of the affair, and M. Nadar is the artist who supplies the design."

For almost a decade, portraiture seems to have engrossed Nadar's artistic energies. Afterwards, so the story goes, he became bored by photography, although not to such an extent that he gave it up entirely. In 1861 he took impressive photographs of the catacombs of Paris using artificial light, and later he also photographed from balloons. Furthermore, he remained involved in portraiture, although his large new studio which opened in 1861 was primarily devoted to the quasi-'mechanical' production of photographs that had become almost universally popular. The process introduced by Disdéri allowed the production of up to twelve saucer-size portraits quickly and cheaply. Nadar's answer to the commercial challenge was his new studio in the Boulevard des Capucines that is supposed to have cost an unimaginable sum of two hundred thirty thousand francs – of borrowed money. Rumor has it further that he employed fifty workers, who could finish up to ten portraits a day; until that time, the upper limit had been three. It is not difficult to imagine why this 'mass production' was unable to achieve the desired 'character balance' sought-after in more 'intimate portraits'. If Nadar's studio was still important in the 1860s, it was chiefly because of its size and his advertising methods, which were unusual for the age. Attached to the façade of the building facing the boulevard was the owner's name in red script, which was furthermore illuminated at night. Nadar and his young client Sarah Bernhardt at least shared the feel for the grand entrance.

New food for his lens

Sarah Bernhardt had visited Nadar's studio for the first time in 1862. The proof is a visiting card in the Bibliothèque nationale that already evinces

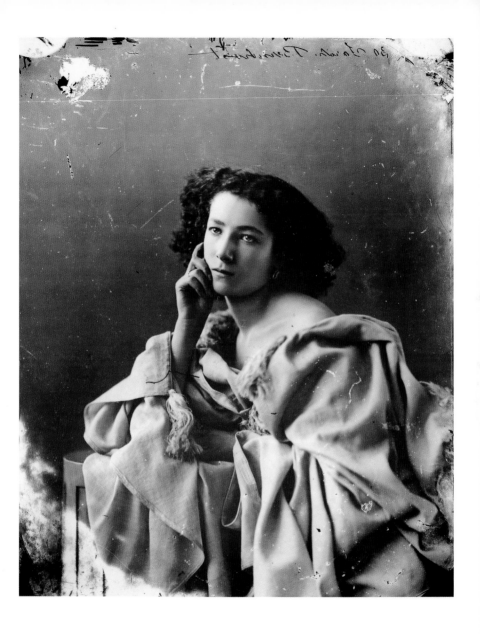

Nadar: Sarah Bernhardt,
ca. 1864

all the signs of the standardized portrait. Whereas Nadar had rejected the use of props in his early portraits, such accessories, considered indispensable accouterments in the photography studios of this age of rapid commercial expansion, now began making their way into Nadar's studio, too. The typical example of these studio props was the supposedly antique-looking stump of an ancient column, made if necessary of papier maché and left unlacquered to avoid reflections. Such a column is clearly evident in the well-known Bernhardt portrait of 1864, and was present in the photograph of 1862 as well. In the older photograph the pose is conventional, the lighting unconvincing. The picture is, in short, flat, like the scene itself. The light-colored drape across the actress's shoulders emphasizes the thinness of her arms, a 'fault' which had often been ridiculed in her stage appearance, just she had often been teased as a child for her thick, curly hair. For the portrait, the 'blond Negress', as she was sometimes called, had combed her dark hair back into a braid and bound it. If there is anything that this insignificant photograph of Sarah Bernhardt does not exude it is precisely the quality that later characterized her whole being, namely, self-confidence and pride to the point of defiance. It is no accident that her chosen life-motto was Quand même – "Despite everything."

It is highly unlikely that Nadar personally took this first photograph; on the other hand, we may well assume that it was precisely he who undertook two years later to portray Sarah Bernhardt's often-praised beauty so convincingly in a single sitting. Art critics reckon the photograph of the young, still unknown actress to be among Nadar's "most inspired" works (Silvie Aubenas), and one of his best after 1860. The background of the portrait is neutral; the stump of a column hidden behind a pose that seems purely natural. The transfigured gaze is directed into the distance; there is no jewelry to compliment her beauty – the small cameo on her left ear in the photograph is hardly noticeable. She is wearing her hair loose; the burnoose that she has thrown off emphasizes the pyramidal composition of the entire photograph. This time, the actress's slim upper torso is skillfully presented, with only the tip of the left shoulder showing, to give the picture a suggestive note. There is here both a clearer contrast between dark and light elements and a selectively sharper focus that together increase the sculptural effect of the picture. Only on a few, rare occasions, according to Françoise Heilbrun, one of the leading experts on

Nadar's work, did Nadar again achieve a portrait of this quality: in his later years, only when he was fascinated by the subject – or, more precisely, the person.

Three versions of the Bernhardt portrait have survived, and each may well be accounted successful in terms of offering a convincing image of the actress's personality. In all three, the actress is presented in a half-length portrait, leaning against the remains of a column. Her hair is loose, the burnoose is on one occasion replaced by a black velvet drape. In any case, Nadar succeeded in eliciting the touching beauty of the young actress, whether en face or in three-quarters profile, for viewers even a hundred and thirty years later. That no contemporary print (vintage print) of the photographs exists is explained by the fact that the twenty-year-old was still unknown. On the other hand, this public insignificance seems to be precisely what provided a particular challenge to the photographer. "Our photographic hero finds the greatest joy and an unimaginable enthusiasm there where his lens makes out an unknown food," wrote one of Nadar's contemporaries. Shortly thereafter, once the 'divine' Sarah Bernhardt had become a legend, she was no longer of interest to the photographer.

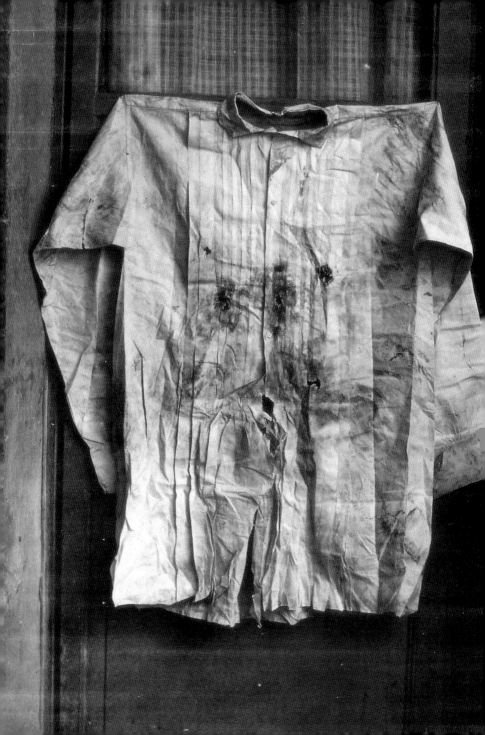

François Aubert
Emperor Maximilian's Shirt

François Aubert stood at the side of the unfortunate Emperor Maximilian of Mexico as court photographer. The photographs he made of the final phase of the "imperio" were of particular interest to many of his European contemporaries, and are even said to have served Edouard Manet in the creation of his famous historical paintings.

Decision in Querétaro

In the summer of 1867, the news broke like a bombshell in the carefree Parisian salons: the emperor Maximilian of Mexico, together with his generals Mejía and Miramón, had been executed in Querétaro. In spite of the numerous foreign dispatches that had alerted to the danger, in spite of appeals for mercy from figures like Giuseppe Garibaldi and Victor Hugo, the news came as a shock. To the nineteenth-century understanding of justice, execution was a thoroughly accepted concept, and ever since the French Revolution the violent death of a monarch was of course recognized as one of the possible outcomes of the historic process. What shook the self-confidence of great European powers, especially Austria and France, was the fact that in this case the "upstart", Benito Juárez García, was of Indio background. He had successfully challenged the Old World and had put a definitive end to at least the French attempt at hegemony in Central America. Rumor had it that Napoleon II spontaneously broke out in tears when the news reached him on 30 June. After all, it had been he who had sent Maximilian to Mexico, but then left him to his own devices, without military or political support. Prince and Princess Metternich demonstratively walked out of a fête associated with the Paris World Exhibition. The Count of Flanders and his wife did not even appear. Emperor Franz Joseph of Austria probably greeted the news with mixed feelings. He had always mistrusted the political instincts of his younger brother, but had also more or less encouraged him to undertake what

François Aubert: Max-
milian's Embalmed
Body in His Coffin,
albumin print, 1867

*The medical Dr.
Vicente Licea of Que-
rétaro was responsible
the procedure, which
involved fitting the
corpse with blue glass
eyes.*

was in any case a very risky ven-
ture.

Maximilian's doomed mission to
Mexico might be understood as a
strategic diplomatic power play for
political influence. But it was also
a personal debacle of a passionate
and emotional man, who was liter-
ally destroyed between the inter-
ests of clever tacticians working
according to different plans. And
because the fate of individuals
moves the thoughts and feelings
of contemporaries more power-
fully than abstract political config-
urations, Maximilian succeeded in
becoming one of the great tragic
figures of the nineteenth century
whose fate remained a matter of
interest, at least in Europe, for a
considerable length of time. It was
hardly by chance that Edouard

Manet, upon learning that the death sentence had been carried out, im-
mediately began working on a large-format painting of the scene – a
painting that remains not only one of his most important works but also
an apotheosis of historical painting.

Today it is generally accepted that Manet, one of the leading Impression-
ists, derived much inspiration from photographs – although it must be
borne in mind that the painter was not primarily concerned with the
simple portrayal of historic events. If we nonetheless 'read' the painting
as a document – as the title, *The Execution of Emperor Maximilian*, sug-
gests – then it is chiefly because the photograph itself does not offer us
the decisive moment. François Aubert was denied permission to docu-
ment the execution photographically. In spite of this, in the early morning
of 19 June 1867, Aubert, a trained painter, hurried off to the Cerro de las
Campanas, the so-called 'Hill of Bells', to capture the scene at least by
pencil. His small-format sketch, today in possession of the Musée Royal

de l'Armée in Brussels, offers in fact the most authentic visual witness to the moment of execution.

Born in 1829 in Lyons, France, François Aubert graduated from the local art academy, studied under Hippolyte Flandrin, and by 1864 was active as photographer in Mexico. In addition to his private work, he also served as court photographer to the Emperor Maximilian – although he hardly had to undergo the formalities that normally surrounded such an appointment in the courts of Europe. Soon after the arrival of the designated monarch in Mexico, Aubert began to make portraits of him, the court, and his staff of generals. We might well picture Aubert – a powerful figure with a broad face, bearded and with a full head of hair – more as an itinerant photographer and adventurer than as a serious courtier. Furthermore, he was a clever reporter and an instinctive businessman who well knew how to take commercial advantage of the growing public interest in photography.

Although Aubert wasn't allowed to photograph the actual execution, he at least managed to document the 'scene of the crime' afterwards: the site of execution is marked with wooden crosses and an iron-wrought 'M' with a crown. Also clearly evident on the photograph are parts of the clay wall that had been hastily erected for the execution – a backdrop that also appears in two of Manet's four versions of the scene. In addition, Aubert photographed the execution squad, and the embalmed and freshly dressed corpse of Maximilian in his coffin; nor was Aubert shy of capturing the bullet-ridden, blood-spattered clothing of the emperor for a curious public. He photographed the emperor's black frock coat, vest, and blood-flecked shirt before as neutral a background as possible. The photographs were subsequently distributed and sold internationally by the firm A. Pereire, which had presumably purchased the photographic plates and rights from the photographer.

A cosmopolitan with liberal tendencies

In the tradition of Christian reverence for relics, Aubert placed the emperor's shirt in the center of his composition, thereby making it into the determining element of his photograph. The dark door frame in the background, the window, and the curtain behind it serve to concentrate the observer's attention on the most important artifact. The photographer attached the shirt to the door with two nails in such a manner as to make

François Aubert

Born **1829** in Lyon. Studies at l'Ecole des Beaux-Arts, under among others Hippolyte Flandrin. **1851** participates in the Salon. Emigrates to Central America. **1864** opens a studio in Mexico City. **1864–69** portraits of French, Belgian and Austrian soldiers. Unofficial pictorial chronicler at the court of Kaiser Maximilian. **1867** present as photographer at the capture and execution of the Emperor. **1890** return to Algeria, where he photographs the battle fleet. Dies **1906** in Condrieu, Dep. Rhone

the pleated front clearly visible; having less interest in the presentation of the arms, he allowed them to fall rather more carelessly to the side. Clearly visible also are six circular bullet holes at chest level. According to Maximilian's personal physician, Dr. Basch, the bullets had all passed through the emperor's body, puncturing heart, lungs, and the large arteries: "From the nature of these three wounds, the death struggle of the emperor must have been extremely short." Aubert's photographs substantiate the doctor's statement and relegate rumors that Maximilian died only after receiving a *coup de grace* to the realm of legend – although it must be stressed that Aubert did not at all consider his work to be forensic. Instead, he was concerned with producing commercial icons – images that would satisfy the visual curiosity of an international public and thus allow them to participate in the fate of a young man who had failed in his endeavors.

A brilliant conversationalist, gallant social figure, talented dancer, art collector, and belletrist who expressed himself in the form of travel accounts and poetry; a cosmopolitan with liberal tendencies, who could converse in at least four languages – so runs the description of Maximilian, born the second son of Archduke Franz Carl and his wife Sophie of the noble house of Wittelsbach in 1832. Maximilian enthusiastically devoted his energies to the creation of a modern Austrian fleet on the British model, incorporating the newest technology, including steam power, screw-driven propellers, and iron hulls. In addition, he founded a marine museum and hydrographic institute and furthered the construction and fortification of a new shipyard in Pola. Appointed rear admiral at age twenty-two, he shortly thereafter was named supreme commander of the navy as well, and was subsequently designated governor-general of the Lombard-Venetian kingdom. When his sober-minded brother withdrew these important offices from him in 1859 under threat of impending war with France, Archduke Maximilian came to feel the weakness of his position at home. This made him all the more susceptible to an offer from Paris, where Napoleon III had sought a candidate for the imperial throne he wanted to establish in Mexico – by today's standpoint an absurd idea.

Walking to his death with an upright posture

The background of the Mexican experiment was the attempt of several western European powers to revive Old World influence in Central and

François Aubert: The
Place of Execution at
Querétaro, Mexico,
albumin print, 1867

*Maximilian and his
generals were exe-
cuted at this spot.*

South America and simultaneously to "balance the Protestant-republican
power of North America with the counterweight of a Latin-Catholic em-
pire" (Konrad Ratz). A unilaterally imposed moratorium on repayment of
the overdue Mexican state debt declared by President Benito Juárez Gar-
cía provided France, Spain, and England with a welcome excuse for
immediate military intervention and the establishment of Maximilian's
'imperio'. For his part, the Archduke of Austro-Hungary made his agree-
ment dependent on the outcome of a plebiscite – which Napoleon and
his Mexican vassals quickly served up. Thus Maximilian considered him-
self to have been "elected by the people," and on 10 April 1864 accepted
the crown in the palace of Miramar. Four days later he set sail from Triest
aboard his favorite ship, the Novara, headed for Vera Cruz.

What turned out in the end to be merely a short Central American re-
gency reflects the internal contradictions of a monarch who swung oddly
between court etiquette and liberal sentiments, between a zeal for re-

Edouard Manet: The Execution of Emperor Maximilian, *1868, oil on canvas, Städtische Kunsthalle, Mannheim*

form and de facto highly authoritarian decisions. In an attempt to satisfy all parties – monarchists, republicans, liberals, and the Catholic Church – he placed himself politically between various political positions without having a firm basis of his own. On top of this, he faced an increasingly hopeless military situation. The end of the American Civil War had provided Benito Juárez García – who in any case was far from defeated on his own turf – with an unexpected ally in the form of the USA. Simultaneously, Napoleon, succumbing to internal pressures, lost interest in his American adventure and withdrew his troops from Mexico. As a result, Maximilian's twenty thousand imperial troops – in part recruited by force – confronted what eventually amounted to more than fifty thousand republican soldiers. Maximilian's offer to negotiate remained unanswered. As a result, everything depended on a swift military solution to the problem.

It is 14 May 1867. Since February, Maximilian and his remaining troops have been entrenched in the small Mexican city of Querétaro, one hundred twenty-five miles northwest of Mexico City. The strategy, particularly supported by the Indio General Tomás Mejía, was to gather all forces for

a final and decisive blow to the republican troops far from the capital. In fact, however, the imperial troops had maneuvered themselves into a trap, which they now planned to break out of on the morning of 15 May. It is no longer a matter of debate that Colonel Miguel Lopez betrayed the plan from a sense of wounded honor, and allowed Juárez's troops to infiltrate the city the night before. Within a few hours, the streets of Querétaro were in republican hands, Maximilian and his officers were captured. A trial lasting several days was held, and the emperor was sentenced to death on the basis of the "Law of Punishment for Crimes Against the State," which had been decreed by Juárez in 1862. On the morning of 19 June 1867, Maximilian and his generals Miguel Miramón and Tomás Mejía faced an eight-man firing squad under command of nineteen-year-old Simón Montemayor. "I forgive all and ask all to forgive me. May the blood we lose be of benefit to the country. Long live Mexico, long live independence!" are reputed to have been his last words.

Reports by the few eye-witnesses who remained loyal to the emperor are contradictory in their details. It seems certain, however, that Maximilian approached his fate with an upright posture and amazing serenity. However self-contradictory, fickle, naive, and indecisive he may have been in the short course of his life, he now faced death with bravery and pride. He granted General Miramón the place of honor in the middle of the trio; Maximilian himself, contrary to Manet's interpretation, stood at the far right. The distance from the firing squad is said to have been five steps. To each of the soldiers he is supposed to have bequeathed an ounce of gold with the request not to aim at his head. Then, at 6:40 a.m., he turned his gaze to the heavens, and stretched out his arms. Maximilian's final gesture was substantiated by the testimony of his adjutant Prince Felix zu Salm-Salm: the emperor compared himself to Jesus Christ in the end, who had also been betrayed into the hands of his enemies. François Aubert, with his photograph of the blood-spattered shirt, bequeathed us the icon corresponding to his martyrdom.

André Adolphe Eugène Disdéri
Dead Communards

**The End of
a Utopia**

Historians are still in disagreement: Was the Paris Commune of 1871 merely an outburst of chaos and anarchy, or was it the first proletarian revolution in history? In either case, the uprising resulted in even more casualties than the French Revolution of 1789. It was a civil war, as bloody as it was brief, in which photography defined a new field for itself.

Someone had distributed slips of paper, had given them numbers. Perhaps that is what is most shocking in this picture that breaks with taboo in two senses, consciously offending against the accepted rules of decency and morality. First, it makes the wounded, desecrated, defenseless human body into a pictorial object, and second, it subjugates suffering to a cool arithmetic. But why, one asks oneself willy-nilly, were these twelve male bodies in plain coffins made of raw spruce boards laid side by side and provided with hand-written numbers? Whoever did it could not have been following any imaginable principle. One may speculate about a coded message, but such a theory is really rather improbable. It remains astonishing that the row of numbers begins with a 'six' and ends with a 'one'; 'four' was assigned twice; 'twelve' is missing. The sum amounts to 70 – but that can hardly be significant. Literature concerning the picture has sometimes claimed that the numbers could have served for later identification of the corpses. But this, too, seems hardly plausible if one considers the fate of the men: anonymous members of the Commune, presumably arrested after 21 May 1871, shot by unknown soldiers of the regular troops, quickly buried – but first provided with a 'portrait' beforehand. Who could have been interested in identifying them? And if someone were, then why don't the numbers follow some kind of understandable logic. Don't the physiognomies provide enough evidence on their own?

Hard years for the working class

The picture is beyond a doubt a document of power – the power of the living over the dead, who can no longer remove themselves from such degrading exhibition and classification. The power of the victor over the vanquished, the bourgeoisie over the defeated proletariat. "Hard years for the amputated, debt-ridden, working class, under surveillance and suspicion – these years under Thiers and MacMahon," as Michelle Perrot describes the situation in her book *Les ouvriers en grève*. "Paris had lost approximately 100,000 workers: 20,000 to 30,000 had probably been killed, 40,000 imprisoned, and the rest fled..."

Mountains of bodies round the Jardin du Luxembourg

To make it clear from the beginning: we know little about this photograph, whose original is now in the possession of the Musée Carnavalet, the municipal museum of Paris. The lightly bleached-out albumin print bearing the archive entry 9951 is $8^{1}/_{4}$ x 11 inches in size, pasted onto grey cardboard, and was a private donation, as the handwritten remark, "Legs Hauterive," testifies. Neither does the photograph provide further information on its reverse about the place and time it was taken, nor does it identify the names of the executed. Only the small stamp at the bottom right on the front puts us on the trail of the photographer: namely, Disdéri. In all probability, the photograph was taken immediately after 21 May 1871, that is, during the so-called Bloody Week during which most of the revolutionaries – or men who were held to be such – were shot by Thiers's merciless troops and buried in mass graves. The location of the picture might be the Père Lachaise Cemetery, at the time the center for the executions, or the walls around the Jardin du Luxembourg, where "mountains of bodies" were also reported. The naked torsos of the corpses one, three, four, six, and seven may be an indication that they died heroically with their chests bared. The slightly dandyish clothing of corpses two and eleven suggests that they were of the bohemian world, and in fact, there are supposed to have been an above-average number of intellectuals and artists who sympathized with the Commune. Research speaks of 1,725 members of the liberal professions who were arrested after the Bloody Week. Among them, perhaps the most prominent of them, was the painter Gustave Courbet, who miraculously survived the 'cleansing', but was fined an annual sum of 10,000 francs in the course

André Adolphe Eugène Disdéri

Born **1819** in Paris. First dedicates himself to painting and theatre. **1847** turns to photography. Initially active in Marseille, Brest, Nîmes. **1854** sets up a studio in Paris. In the same year files a patent for a fast and reasonably priced form of portrait (known as *carte de visite*). **1855** founding of the Société du Palais de l'Industrie. **1860–62** portraits of prominent contemporaries for a *Galerie des contemporains*. Branches in Nice, Madrid and London. **1871** takes photos during the Commune. **1877** sells his business. Moves to Nice. **1889** returns to Paris. **1889** dies in the Paris Hôpital Sainte-Anne, deaf, blind and totally impoverished

Shot Communards,
*Gernsheim Collection,
The University of Texas
at Austin*

*This picture from 1871
is also attributed to
Disdéri.*

of a sensational trial. The money was used for the re-erection of the column damaged by the Commune on the Place Vendôme.

Through Paris with a darkroom on wheels

Why did André Adolphe Eugène Disdéri photograph the twelve executed Communards? Probably not from 'artistic' motives – nor because he wanted to test the limits of his medium. Disdéri, born in 1819, was above all a businessman – not always a fortunate one, as Helmut Gernsheim points out, but with at least a strong commercial interest and the readiness to seek out his advantage wherever his nose led him. Although he had not invented the *cartes-de-visite*, as is often claimed, he had, more importantly, popularized them. It was his Paris studio that fostered the breakthrough of the aesthetically unambitious portraits that were, however, fast and cheap to produce. "In 1861," writes Gernsheim, "Disdéri was already accounted the richest photographer in the world. In his Paris studio alone, he took in an 1,200,000 francs annually. This means, that at a price of twenty francs for a dozen portraits, his etablissement was serving on average 200 customers per day." Disdéri, who had started as a landscape painter, fabric maker, bookkeeper, and actor, was correspondingly interested in photography as a mass medium. It was he who recognized the wish of the broad majority of the bourgeoisie for portraits, and

knew how to satisfy them. Whereas the Franco-Prussian War of 1870–71 was not of interest to the majority of the studio photographers of Paris (Nadar, Carjat, Reutlinger, Thiébault), Disdéri rode through Paris with a darkroom on wheels, documenting war damage, photographing the destroyed Tuilleries, the burned-out city hall, Thiers' house, destroyed by the Communards, and the Vendôme column. After the end of the riots, he published a book with the title, *Ruines de Paris et de ses environs*. But our picture of the executed Communards does not appear on its pages, nor does a variant (now at the University of Texas in Austin), depicting seven Communards, this time unclothed, in their coffins. Anne McCauley suspects that Disdéri was at the time commissioned by the police to record the faces of the Communards – but evidence is lacking. Later, the picture is said to have been distributed by other studios as a stolen copy, and if so, that is a clue that there was no other picture available that responded to the increased public interest. Disdéri himself seems not to have commercialized the photograph. Or might it be possible that he was not the true creator of the photograph? After all, the modest stamp on the cardboard only indicates that the print had at one point or another passed through Disdéri's studio. "If his studio indeed made these negatives," argues McCauley, "its owner must have either been desperate for money or felt little sympathy for the Commune."

Jacobin dreams of a popular uprising

The photography of the period of the Paris Commune – a still largely un-researched field – was determined by the ideological interests of its photographers. The pictures mirrored the technical possibilities of a medium that hardly allowed instantaneous shots in the sense of today's photojournalism. The photographs of the Commune can be fairly exactly dated between the 18 March and end of May 1871, the beginning and the bloody end of a popular proletarian revolt, whose life span as a social utopia lasted around 70 days. The historical background is well known. The starting point, or rather, the catalyzer of the uprising was the loss of the war against Germany. The Prussians had been occupying Paris since 18 September 1870; capitulation and the conclusion of a peace seemed inevitable. In fact, the National Assembly, dominated by monarchists and clerics, which met together in Bordeaux on 12 February 1871 decided upon an immediate and unlimited peace. Paris flaunted the decision with na-

Emile Robert:
Barricades in front of
the Madeleine, *albu-
min print, 1871*

*A version of this pic-
ture was included in
the* Match *report of
June 1939.*

tionalistic, chauvinistic slogans, and Jacobin dreams of a popular uprising
filled the air. For the first time since 1848 red flags began to appear. On
the night of 17 March, it came to armed conflict when 'regular' troops
attempted to take the approximately one hundred cannons stationed on
the mound of Montmarte under their control at the order of the designa-
ted prime minister Thiers. But the half-hearted raid was foiled by the rebel
troops. Thiers's band was driven from the city as the rebels occupied the
city hall and other public buildings. A municipal council operating out of
Versailles now assumed power as a countergovernment to Thiers. Its pro-
gram included such resolutions as the separation of church and state, the
confiscation of property belonging to religious orders and cloisters, the
official adoption of the red flag, and a law forbidding bakers to bake at
night. Certainly this was no revolution in any real sense of the term, but
rather a pack of Jacobin or Proudon-inspired measures that would serve
to solidify the later reputation of the Commune as a proletarian revolt. Al-
ready on 2 April, conflict exploded again between the followers of Thiers
and the Commune. The Paris Guard behind the ubiquitous barricades
understood well enough how to fight, but problems ranging from quib-
bles over domains of competence, to lack of leadership, military disor-

Franck (François-Marie-Louis-Alexandre Gobinet de Villecholles): The Demolished Vendôme Column, albumin print, 1871

ganization, and to dilettantism soon allowed the superiority of the regular troops to emerge clearly. On 21 May, they succeeded in overcoming the Paris defensive wall at an unguarded point. What followed has gone down in the annals of history as a "semaine sanglante" – a week of denunciations, persecutions, mass executions, and merciless terror such as had not been seen since the Revolution of 1789 (with its 12,000 casualties throughout the entire nation). The estimates for 1871 range between 20,000 and 40,000 Communards killed or executed. We have more precise numbers on the losses at Versailles: official records counted almost 900 dead and 7,000 wounded.

The Commune was a time of many photographs – and few. Many if one looks at the troublesomeness of the then standard wet-collodion process, in which a plate had to be sensitized and developed on location; few, if one considers the number of photographers then active in Paris. Gernsheim speaks of 33,000 persons in 1861 who "earned their living by photography or in businesses that served it." Ten years later, the number certainly would not have been less. But those who remained seem, as Jean-Claude Gautrand has expressed it, to have exchanged "the velvet of the studios" for the street rather unwillingly. The only photographers who

Photo report in
Match, June 1, 1939:
70 years later, the
Commune still occu-
pied the minds of the
French.

stand out for larger collections of pictures are in fact Alphonse Liébert, Hippolyte-Auguste Collard, Eugène Appert, and Bruno Braquehais, whose series of a total of 109 photographs were dutifully handed over to the Bibliothèque nationale in late 1871 and represent the most remarkable contribution to Commune photography.

Meeting of the proletariat and photography

From a Marxist perspective on art history, the photography of the Commune has at times been evaluated as the predecessor of the later development of working-class photography. The days of the Commune had, according to Richard Hiepe, brought about "the first meeting of the proletariat and photography" – which can at most apply to the early pictures of the barricades with posing Communards, although it bears emphasis that those taking the photographs were and remained members of the bourgeoisie. In no sense does the term "proletarian photography" apply to the large majority of the pictures, which range from the innumerable views of war-ravaged Paris (and express a clearly critical position toward the Commune) through to the tendentious photomontages of an Eugène Appert, or to his photographic inventory of the approximately 40,000 imprisoned Communards, which constitutes an early form of the information-gathering approach to photography later refined by Alphonse Bertillon. What is missing, surprisingly enough, between the pictures of the barricades and the ruins, are photographs of the dead; as if they never existed, the twenty to thirty thousand victims left hardly a trace on the photographic plates. For photography, as Christine Lapostolle rightly claims, "there was no *semaine sanglante*, and as a result, no painful pictorial return of the wounded and dead after the battles before the gates

of Paris. Nothing of the misery that tortured the people remained to be seen." Even if there were one or another picture of victims in addition to Disdéri's images of the dead Communards, quantitatively and qualitatively the 'proceeds' would be comparatively modest. And thus it is no accident that precisely this photograph has been able to attain symbolic status in the course of time. Whether Disdéri himself took the photograph or not, this status will not disappear. What is important that the photograph has become an icon, a pictorial metaphor for the end of a short utopia.

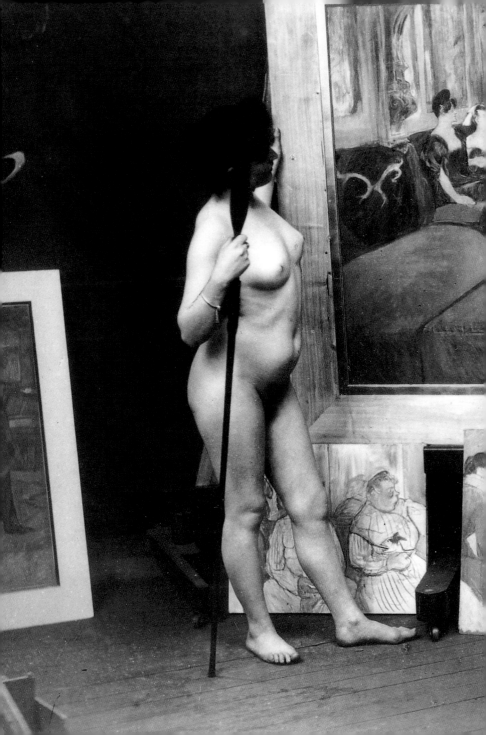

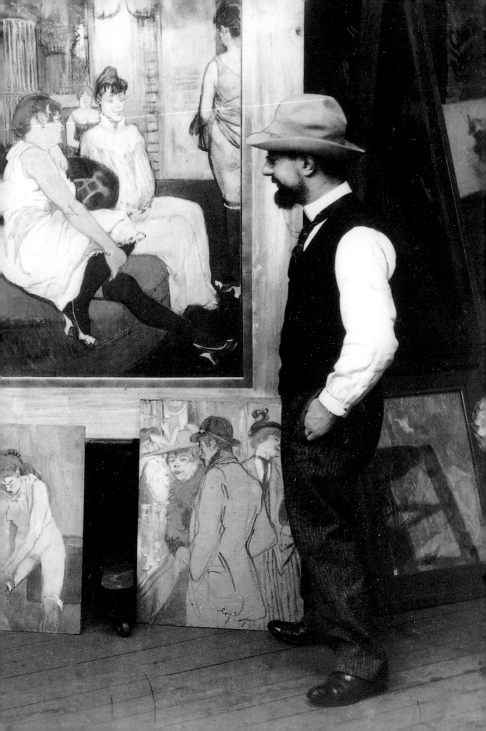

ca. 1894

Maurice Guibert
Toulouse-Lautrec in His Studio

**At some point in the mid-1890s – presumably in 1894 –
Maurice Guibert photographed his friend Toulouse-
Lautrec in the latter's studio. Although the amateur
photographer was simply following one of the common
photographic conventions of the turn of the century,
his ironic perspective on the subject drew emphasis to
the special position of the already internationally
known artist.**

He has laid his brush and palette aside, his hands in the pockets of his
trousers. It's a little as if he is standing there because the director of the
photograph wanted him in the picture only for the sake of a vague sym-
metry. And yet, he is the protagonist of the scene, even if the gaze of the
unprejudiced viewer is caught initially, and is probably held for some
time, by the unclothed woman to the left in the picture. That she is stand-
ing barefoot and completely naked may at first seem rather curious. Her
nudity acquires a 'deeper' significance, however, when one realizes that
around 1900, artists – both painters and sculptors – often had them-
selves photographed with their models in the studio. Usually the camera
'caught' them at their work: the visualization of the breath of genius, a
literal transformation of transitory flesh into 'eternal' art, as it were. But
here, there is no question of work, and furthermore, the studio appears
remarkably orderly. The presentation of what are recognizably seven
panel paintings reminds one rather of a kind of informal vernissage in
which the naked muse, not only unclothed but also holding a lance in her
hand, does not really seem to fit. Even her supposed role as 'model' is
questionable if one looks more closely at the pictures on the floor and on
the easels: there is not a single nude in the academic sense among them.
Further doubts about the role of this 'model' arise when one considers
that this genre did not really constitute the creative center of the work of

our artist, Henri de Toulouse-Lautrec, painter, draftsman, poster artist and, by the time of the photograph, a both celebrated and castigated personality of *fin de siècle* art.

Bourgeois clothing of English cut

Toulouse-Lautrec has donned formal attire, wearing long trousers, a dark vest, a white shirt with stand-up collar and tie. It is rumored that he also owns a suit cut from green billiard-table felt – but this seems rather to be only a gag reserved for special occasions. As a rule, the artist tended toward bourgeois clothing of English cut, irrespective of his affinity for what we would today refer to as the 'subculture'. What his contemporaries may well have found odd, however, was that even in closed rooms, he never removed his hat. The brim, as he took care to explain his foible, eliminated glare when he was painting. In addition, the hat made him appear a little taller – and also covered a deformity in the formation of his head, one that nobody spoke about: a fontanel where the bones had not grown together properly. According to recent medical research, this – together with the many other bodily infirmities that the child born Henri Marie Raymond de Toulouse-Lautrec in the southern French town of Albi in 1864 suffered from in the course of his short life – resulted from the long history of incestuous marriages entered into by his noble ancestors. The artist lisped, was short-sighted, and spoke with a marked stentorian voice – but these were only the smaller problems. He had large and clearly protruding nostrils, a receding chin, and abnormally thick red lips that he concealed behind his dark beard. On a more serious order, he suffered from a generally weak constitution combined with pyknodystosis, a rare from of dwarfism. In addition, two broken legs that he suffered at age thirteen and fourteen ensured that Toulouse-Lautrec would move about only awkwardly and painfully for the rest of his life. "I walk badly," he liked to say, with a touch of self irony, "like a duck – but a runner duck."

Henri de Toulouse-Lautrec was short: five feet in height, to be exact. He was a cripple, fleeing from the many virtues extolled particularly by his father, a passionate rider and huntsman, not to mention lady-killer. The son sought refuge in the bohemian world of Paris during the Belle Epoque, in the demimonde of Montmartre, where he found friends of both sexes, and which became a spiritual home, and almost a family, to

Maurice Guibert

Born **1856**. Active member of the Société française de photographie as well as the Société des excursionnistes photographes. Autodidact, amateur. By profession a representative of the champagne company Moët et Chandon. **1886**–**95** photographic diary entitled *Ma vie photographique*. Becomes acquainted and then friends with Toulouse-Lautrec. The artist's first exposures around **1890**. August **1896** beach holiday in Arcachon together with Toulouse-Lautrec, where he takes snapshots of the latter swimming in a light-hearted mood. **1951** essay by Jean Adhémar on Guibert in the journal *Aesculape*, the first and only work to date on the committed hobby photographer's life and œuvre. Dies **1913**

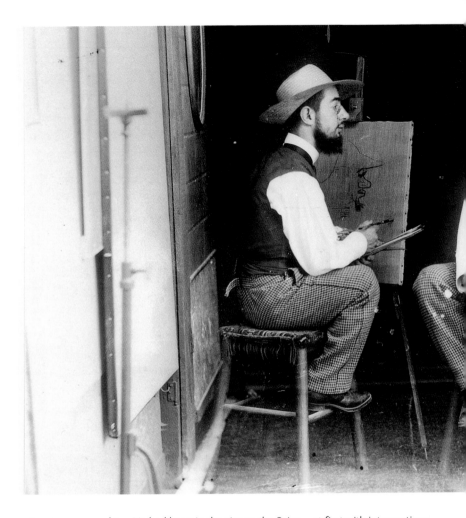

Toulouse-Lautrec,
twice over, photo-
montage, ca. 1892

This picture, now
popularised by post-
cards, was also one of
Maurice Guibert's
ideas.

him. He had been in the city on the Seine – at first with interruptions – since 1878, studying with the animal painter René Princeteau, and later with Léon Bonnat and Fernand Cormon, both of whom were recognized exponents of an academic style. If their salon painting did not really further the talented young man artistically, at the same time neither did it interfere with the development of his free brush strokes – nor does it particularly seem to have placed obstacles in his incipient interest in the world of the bordello, cabaret, and cafe concert. During the same period,

Emile Bernard and Aristide Bruant became his friends and important sources of inspiration for him, as did the ten-year-older Vincent Van Gogh, whom Lautrec immortalized in a remarkable pastel in 1887. A year earlier, in 1886, he had rented a spacious studio on Montmartre at 7 rue Tourlaque at the corner of rue Caulaincourt 27 (today No. 21). It was in this studio, where he stayed approximately ten years, that he probably finished the majority of his œuvre of 737 paintings, 275 watercolors, 5,084 drawings, as well as 364 graphic works and posters. Our photograph, too, bearing the title *Toulouse-Lautrec dans son Atelier*, was certainly taken here, even if we do not know precisely when. But the fact that his large-format painting *Au Salon de la rue des Moulins* (a major work of which several studies and variations exist), which dominates the composition, was completed only in 1894 offers at least a vague reference point for the photograph.

The myth and cliché of the Belle Epoque

To the left in the photograph, although partially cut off, we see the full-length portrait of Georges-Henri Manuel, which has been dated 1891 (today in the Bührle Collection, Zurich). A little further to the right, half visible through the legs of the unclothed young woman, is a sketch titled *Monsieur, Madame et le chien*. The bordello scene *Femme tirant son bas*, painted in 1894 (today in the Musée d'Orsay), constitutes the striking

Guibert took Toulouse-Lautrec's portrait in the most outlandish of costumes: left dressed as a woman, with Jane Avril's famous boa hat on his head (1892), right as Pierrot (1894)

center point of the works displayed on the floor. Finally, to the right, is the last of the identifiable tableaus, *Alfred la Guigne*, painted in 1891 (today in the National Gallery of Art in Washington). Who arranged the pictures for display and why precisely these? Who is the woman with the seemingly meaningless lance? Is she perhaps to be interpreted as a parody of William-Adolphe Bouguereau's painting *Vénus et l'Amour* of 1879: a prostitute who recognizes herself in the large panel painting – an interior of the well-known bordello in the rue des Moulins, in which Lautrec is supposed to have lived for a time? The fact that she presents herself naked before the camera, the manner in which she inspects the painting, as well as her, so to speak, thoroughly non-academic measurements, which do not at all correspond to the ideal of an artist's model, argue for this possibility. Admittedly we don't know the answer, for neither Toulouse-Lautrec nor 'his' photographer, Maurice Guibert, commented on the picture. All we have is a fairly large original print of 9 1/2 x 18 3/4 inches that stems from Guibert's estate and was donated to the Paris National Library by his granddaughter. Art-lovers and visitors to Paris are familiar with the photograph as a postcard, in which format the picture has become a bestseller, effortlessly taking advantage of several clichés: Paris as a city that is both art-minded and generous, lascivious and open to sensual joys – a Paris in which the Belle Epoque has become a myth, a regular ideal of the pleasures of bourgeois life.

Toulouse-Lautrec, like Maurice Guibert, knew nothing of a 'Belle Epoque', a term that arose only in the 1950s. But no one disagrees that before 1900 both were part of the merry and carefree society centered in Montmartre, although Lautrec seems to have maintained a special relationship to Guibert. In letters to his mother, Toulouse-Lautrec is always speaking of his "friend, Maurice Guibert" (July 1891) or the "faithful Guibert" (August 1895), who seems in fact to have been something of an elongated shadow of the artist in the Paris years. There is also evidence of several journeys jointly undertaken, for example, to Nîmes; the castles on the Loire; Malromé, the estate of his mother, located near Bordeaux; Arcachon; or, in 1895, a ship voyage from Le Havre to Bordeaux, during which Guibert was able only with great exertion to restrain the painter, blinded with love for a young beauty, from following her to Africa. Lautrec accorded Guibert no such impressive portrait as the one he painted of another photographer, namely Paul Sescau (1891, now in the Brooklyn Museum, New York), but Guibert appears in no fewer than six other paintings and twenty-five drawings as exactly what he in fact was for Lautrec: a drinking partner, a friend who could hold his alcohol well and who accompanied the artist on nightly romps, a companion on visits to the legendary *maisons closes* – in short, a bon vivant whose stout figure is easy to identify in pictures such as *A la Mie* (With the girlfriend, 1891), and *Au Moulin Rouge* (1892–93). Little more is known about Maurice Guibert, except that he was born in 1856, died in 1913, lived in a handsome inherited estate in the rue de la Tour, was primarily employed as the representative of the champagne firm Moët et Chandon, and indulged in a remarkable hobby in his free time; photography. Guibert was an active member of the Société française de photographie and the Société des excursionnistes photographes, a loose association of amateur photographers with a penchant for hiking, to which the well-known science photographer Albert Londe also belonged. Several albums in the possession of the National Library in Paris, including a volume with the thematic title *Ma vie photographique* (1886–95), provide proof of Guibert's photographic interests, which – remarkably enough – were not at all aimed at ennobling the art of the camera by means of artistic photographic techniques, as the international community of the pictorialists were striving for at the time. Instead, Guibert pursued a kind of privately defined 'snapshot' photography characterized by wit and a sense of fun in setting up scenes. The

dry gelatin plates that came into use in the 1880s, which made amateur photography in our modern sense possible for the first time, proved of course very useful to Guibert and his ultimately artistically unambitious approach.

Costumed in front of the camera

The relevant lexicons remain silent on the photographer Maurice Guibert. And without a doubt he and his small œuvre would have been forgotten, if the playboy and boon companion of Toulouse-Lautrec had not in the course of the years become something of a 'family and court photographer' to the painter. Lautrec himself seems to have taken an interest in photography from early on, although it must be said that his relation to photography on the whole still awaits a proper analysis. What is certain is that Toulouse-Lautrec, like many contemporary painters – one needs only to think of Degas or Bonnard – used photographs as patterns for his painting; in contrast to these other artists, however, Lautrec was himself not an ambitious photographer. In a photograph depicting the tipsy Maurice Guibert at the side of an unknown woman – the pictorial basis of *A la Mie* – Lautrec may have released the shutter of the camera. But basically he seems to have left the medium to Paul Sescau or precisely to Maurice Guibert, who seems to have advanced around 1890 to becoming the private and unofficial pictorial chronicler of Henri de Toulouse-Lautrec. What have survived are photographs of Lautrec swimming naked during a sailing meet on the sea by Arcachon (1896). In a letter to his mother from November 1891, the artist speaks of "wonderfully beautiful photographs of Malromé" that Guibert will send to her. It was above all Guibert who urged his friend to have his portrait taken repeatedly – and in the most ridiculous clothing: Lautrec dressed as a woman, wearing Jane Avril's famous hat decorated with boa on his head (1892); Lautrec as a squinting Japanese in a traditional kimono (also 1892); or as Pierrot (1894) – a sad clown who apparently needed little by way of costuming to create a convincing image. Jean Adhémar has subjected this portfolio to searching analysis: "Thanks to Guibert," writes the former curator of the Bibliothèque nationale, "we accompany Lautrec from 1890 to his death. One sees him in the most various surroundings and in all possible poses. It is particularly striking, however, that we meet a natural Lautrec at most only two or three times. The artist always poses himself; aware that he is

being photographed, he places himself in a scene. he never seeks to hide his deformities. On the contrary, he presents them openly, expressly emphasizing his ugliness and his dwarfish stature." Why does he engage in these travesties? Adhémar finds a logical explanation: "When Lautrec underlines his infirmity to such an extent, then it is very simply because he was suffering from it – more than we realize. In this sense, his form of masochism becomes a distracting maneuver. He would like to laugh about himself before others do so, or rather: to give his audience occasion to make jokes about something that in fact has nothing to do with his physical defects." It would have been very simple for Henri de Toulouse-Lautrec to have visited one of the prominent Paris photography studios to ensure, with the help of a practiced portraitist exploiting the photographic means at his command – lighting, pose, framing, perspective, re-touching of the negative and positive – a pleasing half- or three-quarters portrait. Instead, the artist left in the hands of a friend and amateur the task of creating the photographic witness that still today defines our image of the tragic genius: Toulouse-Lautrec in his studio. Not at work. Not painting before an easel, but in visual dialogue with a naked prostitute(?). In other words, the loner of Montmartre pursued his own course also in his dealings with photography.

Maurice Guibert: Toulouse-Lautrec dressed as a Japanese, 1892

1898

Max Priester/Willy Wilcke
Bismarck on his Deathbed

**The Human-
ization of a
Legend**

**Shortly after Otto von Bismarck's death, a death pho-
tograph that the public had never in fact seen led to a
sensational trial in Hamburg, Germany. The defend-
ants were two photographers who had secretly and illi-
citly captured the deceased founder of the German
Reich on film. Not until years after the end of the Sec-
ond World War was the photograph finally published.**

A great man has died. Think what one may of Bismarck – and historians
are still divided today over whether he was a visionary or reactionary, a
"white revolutionist" (Gall) or a "daemon" (Willms) – there is one thing
certain: he was one of the great figures in nineteenth-century politics,
and for a time he was the most powerful man in Europe. This claim re-
mains true even under the Hegelian understanding of history, in which
even the most influential individuals are at best the 'business managers'
of a predetermined 'purpose', that is, mere assistants in the fulfillment of
the inevitable course of history. The majority of Germans, however, would
have looked at the matter differently around 1890. For them, Bismarck
was the founder of a German Reich with well-defined borders, the creator
of a nation under Prussian leadership. In those days, people still felt unre-
served admiration for the Junker stemming from the lands east of the
Elbe, and throughout the country, Bismarck towers and Bismarck me-
morials made of bronze or stone reinforced the idea. On a popularity
scale, Bismarck surpassed both Wilhelm I and the reigning monarch Wil-
helm II – a fact which the latter realized all too well. In response, the
young kaiser therefore repeatedly sought some kind of reconciliation with
the aged chancellor whom he had disgracefully dismissed from office in
1890. But to no avail. Otto von Bismarck nursed a resentment that might
well be termed hatred and that was to have repercussions even after his
death.

Wilhelm was in no case to be allowed to view Bismarck's mortal remains. By the time the kaiser, who had been intentionally misled by those around him about Bismarck's true condition, finally arrived in Friedrichsruh near Hamburg, the coffin had already been sealed: Bismarck had thus effectively delivered an insult from beyond the grave.

Pictures of the Chancellor produced at assembly line speed

In fact, there were very few who had been allowed to say farewell to Bismarck – family members, house servants, a handful of neighbors from Friedrichsruh. Reinhold Begas was refused permission to make a deathmask, the painter Franz von Lenbach, a death portrait. Similarly, in the beginning, no one seems to have thought about photographing the deceased – understandably from today's point of view, although it must be remarked that the photographing of the dead remained a completely common practice until the end of the nineteenth century. One needs only to think of Ludwig II, whose picture lying in an open coffin provoked almost no interest among the public. After Bismarck's death, however, there was to be no picture that contradicted the official iconography of the chancellor – in particular the image that had been professionally formulated by Lenbach, that Munich-based prince of painters, who had immortalized the Iron Chancellor in a number of oil and chalk works (as if on an assembly line, according to the ironic opinion of the painter's contemporaries). In any case, Lenbach's chancellor was a man of power, determination, and vision: a statesman in uniform, or sometimes in black civilian dress; a great figure in the literal physical sense. And now this travesty: a photograph of the deceased chancellor – the legendary Bismarck – sunk into an unmade bed, the absolute opposite so to speak of the familiar impressive figure exerting a powerful influence on the observer in Lenbach's portraits. To make matters worse, the photograph revealed a veritably shabby ambiance that one would hardly have imagined possible of the former chancellor, with the chamber pot adding an almost vulgar note to the scene. "Pure realism," as the Bismarck scholar Lothar Machtan appropriately pointed out, and thus a possible corrective to the stylized image that had been proffered by Bismarck himself – to the presentation of himself according to the motto "nothing is truer than the appearance" (Willms). For the kaiser, on the other hand, the photograph would have seemed like a belated revenge.

Max Christian Priester

Born 1865 in Altona. Secondary school in Altona. Turns to photography. From 1886 in Hamburg. 1894 opens there his own photography shop. From 1895 photographic reports from Bismarck's home, Friedrichsruh. 1898 takes clandestine photographs together with Wilcke of the deceased Bismarck. This is followed by prosecution and trial for trespassing. Jailed for five months. Dies 1910 in a mental asylum

Willy Wilcke

Born 1864 in Wismar. Apprenticeship in Wismar. Afterwards works as a photographic assistant in Malchin, Lübeck and Chemnitz. 1887 opens a photography shop in Ratzeburg. 1889 moves to Hamburg. There he opens a larger shop with three assistants and three apprentices. 1896 applies for the title of Court Photographer. From 1893 photographs Bismarck receiving homages and audiences in Friedrichsruh. 1898 takes photos of the dead Bismarck with Priester. Jailed for eight months. Stripped of title of Court Photographer. Dies 1945

Er war unser! Mag das stolze Wort den lauten Schmerz gewaltig übertönen.

Bismarck in the eye
of the imagination.
Picture postcards of
this kind went into
circulation shortly
after the death of the
Chancellor.

The photograph had been taken by the professional Hamburg photographers Max Priester and Willy Wilcke the night that Bismarck died – admittedly without the family's permission. The term 'paparazzo' had not yet been coined (Fellini introduced it in his film *La Dolce Vita*), but Priester and Wilcke were consummate paparazzi in the modern sense, motivated neither by personal curiosity nor even by a sense of 'art'. Like the paparazzi of today, what they wanted was money, and the ingredients for success were the same then as now, namely, the interest of the public in the private lives of the prominent. As a vehicle for conveying pictorial information, however, the illustrated press of the day was at best in a relatively archaic state. For technical reasons, photographs often made their way into the press only by way of woodcuts. But in Bismarck's case, the process never got that far. A civil suit, to be discussed below, together with the prior confiscation of all pictures, including "negatives, plates, prints, and other reproductions," by the police – meant that the pictorial material was effectively removed from the public sphere. The picture was in fact not published until approximately two generations later in the *Frankfurter Illustrierte* (No. 50/1952), a German magazine appearing from 1948 to 1962. On another occasion, *Die Welt* (No. 270, 19 November 1974) printed the photograph in connection with a review of a book, *Oevelgönner Nachtwachen*, by the Hamburg author Lovis H. Lorenz, in which he relates his version of the photograph's history. Four years later, the picture appeared once more, this time in the *ZEIT-magazin* (4 August 1978), accompanied by a text from Fritz Kempe. It may be tempting to interpret the publication of the once-taboo picture in a widely-circulated magazine ten years after the student rebellions of the late Sixties as a further station in the process of the Bismarck's demythification process. But in fact, the picture probably contributed even more to the humanizing of Bismarck. The photograph reveals that the circumstances of Prince Otto von Bismarck's death were in fact rather trivial: in death he became one of us.

The air was full of rumors that Bismarck was dying. The old man, increasingly depressed, had been ailing for quite some time. When gangrene set in, it was clear that his days were numbered. In other words, a media event, as we would term it today, was about to occur – and this in turn required the 'right' pictures; that is, the most recent pictures had to be rounded up for publication – and what could be more recent than a picture of the deceased founder of the Reich. Two Hamburg photographers had determined to obtain the necessary image: Max Priester and Willy Wilcke, who had bribed a reliable informant in the person of Bismarck's forester, Louis Spörcke. Now they had only to wait for the moment of death. An hour before midnight on 30 July 1898 Otto von Bismarck died – according to historians, after drinking a glass of lemonade. Then, "with a cry of 'Forward!', he sank back into the pillows and died" (Willms). Spörcke, who had kept the night watch, informed Priester and Wilcke, lodging nearby and fully on the alert: the forester would leave the garden gate and ground-floor window open for them. Toward four in the morning the pair made their way in the house, exposed several plates with the help of the magnesium flashes that were usual at the time. The whole procedure supposedly lasted less than ten minutes, and on the following morning, they returned to Hamburg and attempted to make money as quickly as possible from their – as we would say today – scoop.

"In Remembrance of the Death of the Great Chancellor": picture postcard, pre 1900

The incriminating materials confiscated

They advertised for interested parties with money. "For the sole existing picture of Bismarck on his deathbed, photographs taken a few hours after his death, original images, a buyer or suitable publisher is sought," ran the announcement in the *Tägliche Rundschau* of 2 August 1898. A Dr. Baltz, owner of a German publishing house, replied that he was prepared to pay as much as thirty thousand marks plus twenty percent of the profit for the images. All that was necessary now was for the photographers to obtain the family's permission to publish. In response, Pries-

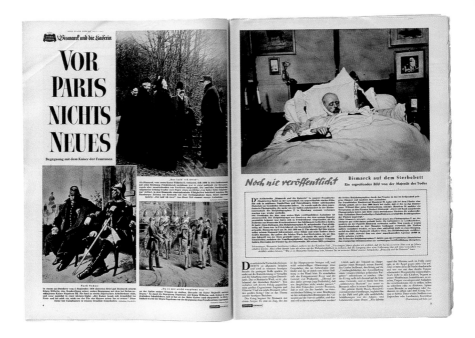

Frankfurter
Illustrierte, no. 50,
1952: the magazine
was the first to pub-
lish the confiscated
Bismarck photo-
graph.

ter and Wilcke quickly produced a retouched version of the picture, show-
ing a clearly younger-looking Bismarck, without headband or patterned
handkerchief. The light-colored chamber pot also fell victim to the prac-
ticed stroke of the retoucher. It is quite possible that the Bismarcks might
have granted permission to publish, but in the meantime, a jealous
competitor, Arthur Mennell, had already stumbled upon the plan, and
denounced Priester and Wilcke to the family. The Bismarcks responded
swiftly. By 4 August they had already managed to have the incriminating
materials confiscated. A civil and criminal court case ensued, today re-
markable in that the crime of trespassing was not the sole charge: the
question of the right to one's own picture was also at issue. The case was
decided in favor of Bismarck; the photographers had not acted for the
sake of the German people, but merely in their own interest. The senten-
ces handed down on 18 March 1899 were correspondingly harsh: five
months for Spörcke, who also lost his position as forester; eight months
for Willy Wilcke along with the loss of his title as court photographer; five
months for Max Priester, who died at age 45 in an institution for the men-

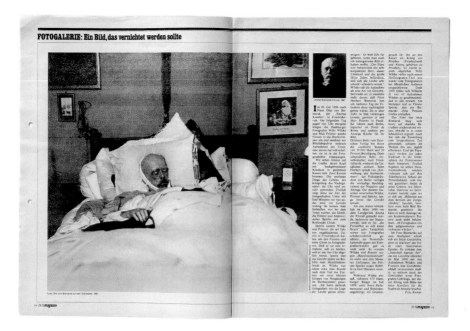

tally ill. The 'evidence' disappeared into the Bismarcks' safe, "never to be turned over to the public," according to the express wish of the family. A clever photography assistant named Otto Reich, however, had already made a print, and from him Lovis H. Lorenz obtained possession of the picture, so he claimed, after the war. Lorenz in turn handed the photograph over to the Hamburg State Educational Institute, which kept the picture in their own collection. What had clearly caused a scandal in 1898 was hardly capable creating a public stir a decade after the Second World War. People had other concerns. Paradoxically, the picture of the dead chancellor helped to keep the otherwise distant and alien Bismarck alive, if not to bring him closer. The photograph proved: Bismarck, too, had died a completely normal, perhaps even trivial, death. A myth had become human.

"A picture that was supposed to be destroyed": Fritz Kempe's analysis of the photograph in ZEIT-magazin, 4.8.1978

Bismarck on his Deathbed **115**

1898 Heinrich Zille
The Wood Gatherers

Heinrich Zille, the well-known graphic artist who depicted proletarian conditions of life around 1900, was also a photographer, but his camera work was not discovered until the mid-1960s. His œuvre of more than 400 photographs is now appreciated as an important contribution to modern photography.

Autumn in Charlottenburg, a small town outside Berlin. Two women, possibly mother and daughter, are pulling a cart loaded high with brushwood across the sandy ground typical of the region, one woman with the right hand, the other with the left clasped around the shafts of the simple vehicle whose left wheel seems to be set none too surely on its axle. The two wood gatherers have in addition yoked themselves with a shoulder band to distribute the load and are literally putting themselves in harness to bring their harvest home quickly. Home – it may be Charlottenburg itself – whose western outskirts are recognizable to the left in the picture as a lightly sloping stripe between the grassy fields and the sky. In 1900, the city with its approximately 190,000 inhabitants is still an independent community; it will not be incorporated into Greater Berlin for another two decades.

The two wood gatherers have already put a few kilometers between themselves and the forest of Grunewald. Their clothing, consisting of skirt, blouse, and apron, indicates their status as peasants. "In Grunewald, in Grunewald there's a wood auction" – the popular old street ditty looks back to the days when the forest, then located far to the west of Berlin, was an important source of natural raw materials for working-class families. Wood was used not only for heating, but also in cooking stoves, for which brushwood and sticks were the cheapest form of fuel – as dramatized by the important role such wood plays in Gerhard Hauptmann's comedy *The Beaver Pelt*.

Eyes to the ground and swinging their arms

Although they constitute the central theme of the picture, which presumably was taken in 1898, the two women are not the only persons in the oblong-format photograph. Between the smaller woman in the background and the wagon with its high load we recognize, half hidden, a baby carriage typical of the times, which is also loaded with wood and a jute sack. And yet a further person intrudes into the picture: the photographer himself, whose long shadow stands out clearly in the bottom right against the bright dune. Somewhere in the background, but not visible in this photograph, there must be the Ringbahn, or circular railway around the city, which in those days more or less functioned as the boundary between city and countryside, that is, between Charlottenburg and Grunewald. Somewhat further to the right, one can imagine today's radio tower and the Berlin exhibition centre. The goal of the two women may well be the Knobelsdorff Bridge. From this point the path leads across the track into the western end of Charlottenburg. It is evident that the photographer is wearing a hat, but whether or not he is using a camera stand for his work cannot be determined. What is certain is that he is looking eastward; the sun must therefore be standing in the west, indicating that the time of the photograph is late afternoon or early evening. The two women are thus making their way back from a daytime outing, which indicates the completely legal nature of their undertaking. In reality, women collecting wood must have been a part of daily life in western Berlin, a situation which explains why none of the court or amateur photographers active in or around the Reich's capital hit upon the idea of capturing a scene such as this, without at least an attempt at idealizing the 'simple life'. But in this picture, there is no trace of romanticism. The women are pulling with their full strength against the harness to keep the wagon rolling, and in the process are swinging their free arms strongly, their eyes to the ground.

Max Liebermann as engaged patron and friend

Heinrich Zille was neither a professional photographer nor an amateur in the sense of being merely a hobby photographer with artistic pretensions, a type that was occasioning much international discussion around 1900. Born in 1858 in Radeburg in Saxony, Zille was primarily a graphic artist known for his tragi-comic sketches of simple people. His work appeared

Heinrich Zille

Born Rudolf Heinrich Zille in **1858** in Radeburg near Dresden. **1872–75** apprenticeship in lithography in Berlin. **1877–1907** works as a lithographer for the Berlin Photographische Gesellschaft. Around **1890** friendship with Max Liebermann. **1892** moves to Charlottenburg. First etchings in the same year under the influence of literary Naturalism. From **1903** member of the Berlin Secession. Published in magazines such as *Simplicissimus, Lustige Blätter, Jugend*. **1907** first illustrated book *Kinder der Straße*. **1924** awarded a professorship. Dies **1929** in Berlin. Photographic estate is in the keeping of the Berlinische Galerie, Berlin

Heinrich Zille:
Third series from
The Wood Gatherers,
5th picture. View
towards Knobelsdorff
Bridge, fall 1898

in various magazines and newspapers beginning in 1903, and five years later, was also published in book form. Zille had already achieved popularity within his own lifetime – but his was a controversial fame. Kaiser Wilhelm II, for example, discredited Zille's work, oriented as it was toward the naturalism of the age, as "gutter art." The Berlin Secessionists on the other hand valued his drawing. Particularly in Max Liebermann the trained lithographer found both a prominent and engaged patron and friend. Zille never made a secret of his photographic activity; at the same time, he did not emphasize it. Like many artists of the turn of the century – Stuck, Lenbach, and Munch are perhaps the best known – Zille also drew from photographs that he had taken himself. Unlike his famous colleagues, however, he seems to have followed this practice, commonly employed by painters and graphic artists of the day, rather rarely. Also of note are the intimacy of Zille's gaze, his particular mode of perception, and his joy in experimentation, all of which are far removed from any kind of commercial photography. One may rest assured that for Zille, the camera served primarily as a means to assimilate reality in a new way.

His contemporaries were aware of Heinrich Zille's work with the camera. Nevertheless, by the time of his death in 1929, this aspect of his work had sunk into oblivion. Not until 1966 was a cache of somewhat more than four hundred glass negatives and approximately one hundred twenty original prints discovered in his estate, out of which a selection was offered to the public for view for the first time by the Berlin Theater critic Friedrich Luft in 1967. The legacy indicates that after 1882, Heinrich Zille photographed exclusively with large-format glass-plate cameras which he may have borrowed from the Photographic Society, his employer of at the time. Surviving are also $4^3/_4$ x $6^1/_4$-inch, $5^1/_2$ x 7-inch, and 7 x $9^1/_2$-inch negatives, along with positives in the form of contact prints.

Interest in banal, everyday life

The spectrum of Zille's themes was remarkably broad, even if the majority of his œuvre, which was largely concerned with the realities of daily life among the simple working class, consists of views of old Berlin – rear courtyards, alleys, narrow houses reached by high staircases, shops and stores. In addition, Zille's legacy contains portraits and self-portraits, family pictures, nudes, scenes of fairgrounds and beaches, and – oddly enough – trash dumps, which Zille photographed a number of times.

Practically absent in Zille's work are panoramic views of the quickly grow-
ing Wilhelmine Berlin, such as those produced by contemporary photo-
graphers such as Max Missmann, Waldemar Titzenthaler, and Hermann
Rückwardt. Similarly, photographs of the German Reichstag, the Victory
Column, or the Brandenburg Gate constitute the exception in an œuvre
centered on paradigms of daily life.

*Heinrich Zille:
Woman with child
pushing a pram
loaded with brush-
wood, with Knobels-
dorff Bridge in the
background, fall 1897*

In keeping with his interest in banal, everyday life, Zille often made wood-
gathering women the object of his lens. All in all, it Is possible to distin-
guish four cycles, in the first of which, taken in 1897, Zille would still have
had to combat the inconveniences that were a part of short-exposure
photography. The pictures are not sharp, and the framing unsatisfactory
– or the women are looking toward the camera, a circumstance that Zille,
who strove for 'discretion', always sought to avoid. In this area, Zille, still
very much the amateur, worked to refine his techniques, rubbing his nose
in his chosen theme, which clearly interested him until 1898.

Precisely why Zille specifically made the theme of daily female labor the
center of his cycle, we don't know. One thing is certain: the wood gather-

Stadtrand
Charlottenburg 1912
(links)

Tippelbruder
im Zentrum

43/44/45

Mein Photo-
Milljöh *(Me photo-
graphic 'nvironment):
the book publication
edited 1967 by the
Berlin theater critic
Friedrich Luft first
drew attention to
Heinrich Zille as a
photographer.*

ers had become a more or less daily sight for Zille after he moved from Rummelsburg to Sophie-Charlotte Street in 1892, where such women passed every evening on their way back from collecting wood. "A tranquil peace settled on the street," according to Zille's son Hans, describing his parents' new apartment. "From the apartment windows, one's gaze ranged into the open land. On the other side of the street, the sandy soil was cultivated; in the middle, there was a large area for drying laundry that was ringed with bushes and trees. Behind the Ringbahn stretched fallow land, partially covered with low-growing pines, and finally came the first trees of the Grunewald and the outskirts of the suburban villas of the West End."

From the open window of his apartment, Heinrich Zille had photographed the grounds of the Ringbahn with the Knobelsdorff Bridge to the southwest as early as 1893. Four years later, he went out into the fields and turned his camera onto the women returning home from picking wood, almost as if looking over the same scene from the other direction. Only a few pictures show them at rest. All his later pictures also avoided the direct gaze into the camera. Zille photographed the women from behind, thus making them 'faceless' but lifting their personal trials and tribulations onto the level of a generalizable condition.

Schatten des Photo-
graphen: Heinrich Zille
photographiert Reisig-
sammlerinnen (oben)

46/47/48

That Heinrich Zille used the photographs from his series on wood gath-
erers as illustration models does not diminish their value as independent
artistic achievements. Already in 1903, his drawing *Wünsche* (Wishes)
appeared in *Simplizissimus*, which an editor, referring to Zille's origin,
probably supplied with a text in pseudo-Saxon dialect: "If ony I hadda
won big time, jist oncet! I woulda had myself a fine cart and then I coulda
carried that brush wood back home right comfortable." Today, the com-
pletely unsentimental directness of the photograph lends it credibility, in
contrast to the drawing. Zille's radical gaze bluntly captures the essential,
and he intuitively applies photography in terms of its intrinsic character-
istics. Decades before the proclamation of the New Objectivity, Heinrich
Zille was pursuing the idea of photography as unembellished documenta-
tion with his *Wood Gatherers*. In this sense, he is properly seen as an an-
cestor of the modern spirit in photography.

Karl Blossfeldt
Maidenhair Fern

ca. 1900

Toward the end of the 1920s, Karl Blossfeldt's plates, published as *Urformen der Kunst*, became one of the most-discussed photographic books of the interval between the wars. His plant studies, originally completed with a view to the commercial art classes, fascinated the contemporary Avant-garde, and still influence both conventional and conceptual photographers today.

A Herbarium from the Darkroom

Occasionally he stood before the camera himself, as in Italy in 1894. Or a year later, still lingering on the peninsula, this time wearing a simple felt hat, a white collarless shirt, and a plain light-colored suit of coarse material. His left hand is resting in his suspenders; his gaze, looking straight and resolutely into the camera. The combination of his wide mustache and a very relaxed posture makes abundantly clear that we are not looking at someone concerned with the socially impressive pose of a bourgeois citizen. This not-quite-middle-aged man is in fact engaged in substantiating himself as an artist. The two portraits have a good deal in common: both were taken out-of-doors with available lighting, and both are close to nature. And something more: the protagonist is always alone – not that he necessarily intended to imply that this solitude was a matter of principle. Nonetheless, the stance is noteworthy in this age during which the Avant-garde was vociferously withdrawing itself from the traditional business of art – and forming itself into secessions, or at least groups, whose members accordingly often posed themselves for group portraits in front of a camera. There can be no doubt about it: Karl Blossfeldt was an isolated figure in the bustling art world of the turn of the twentieth century. But perhaps he was not even this, if one uses the term 'isolated' to designate an individual who is first and foremost devoted to his own artistic will. What was Blossfeldt, then? A sculptor and modeler, a talented artist who primarily wanted to have his work – illustrations, plas-

ter casts, of photographs – comprehended within the context of learning and education. Until the mid-1920s, he was completely unknown as a photographer. In this connection, Gert Mattenklott even speaks of an "odd ball" who attempted to "make porcelain, but accidentally produced gold with his left hand," the porcelain in this case standing for photography and the gold for a book which overnight placed the inconspicuous Blossfeldt on a level with Sander and Renger-Patzsch as the most prominent representative of the New Objectivity in German photography.

Who was this Karl Blossfeldt, whose photographic plant studies, published in book form in 1928, achieved international recognition? We know something of the answer, even if the verifiable data of his active life, spent in the waning years of the Wilhelmine era and the Weimar Republic, are comparatively sparse and leave many questions open. In 1865, Blossfeldt was born into simple family circumstances in the town of Schielo in the Harz Mountains of Germany. He attended secondary school (Realgymnasium) in Harzgerode, and later completed an apprenticeship as a modeler in a foundry for art casting in Selketal. The attentive eye of the local pastor combined with a state scholarship enabled Blossfeldt subsequently to study art in Berlin. In 1884 he transferred to the teaching institute of the Royal Museum of Commercial Art, where Professor Moritz Meurer was particularly impressed with Blossfeldt's talent. Inspired by Semper and the writings of Erich Haeckel, the professor was exploring new paths in art teaching, and placed the replication of biological Urformen, or basic forms, at the center of his practically oriented pedagogy. This approach had its roots in the idea that nature provided important pre-formulated building blocks, so to speak, for architecture and product design. To build up a methodical collection of studies, the professor journeyed to Italy in 1890, accompanied by six graphic artists and modelers, including Karl Blossfeldt.

Purism of design

Their main task was to gather pedagogical material by drawing and modeling plant parts that had been dried or pressed. We may assume that the technical possibilities offered by photography were soon enlisted in the work parallel to more traditional forms of reproducing images from nature. That the task of photography was handed over to Blossfeldt makes two points clear: he was already working with photography at the end of

the nineteenth century, and, more importantly, his photography was not by any means the outgrowth of an autonomous desire to be an artist, but rather stood indisputably in the service of a serious pedagogical project whose scope and content had not yet been formulated. Blossfeldt's inspiration was therefore not the pictorialism that was being vehemently discussed and pursued at the time in contradistinction to commercial photography. If the autodidactic photographer Blossfeldt sought anywhere for inspiration in his work with buds, leaves, and blossoms, then it was in the herbaria and plant books produced from the Middle Ages to the Renaissance. These old illustrations, in their attempt to demonstrate the compatibility of natural forms, evinced a purism of design that may well have pointed Blossfeldt in the direction of a similar photographic direction, which – without his initially desiring it – anticipated the pictorial language of what later came to be called the New Objectivity.

Blossfeldt remained in Italy for six years. Returning to Berlin in 1896, he first worked as an assistant to Professor Ernst Ewald at the Royal Art School and shortly thereafter became a private lecturer at the Museum of Commercial Art, where a course of instruction, "Modeling from Living Plants," had been set up at the initiative of Moritz Meurer. To the fragile preserved specimens and plaster models that were already a part of the program, we may be certain that Blossfeldt soon added photographic studies of the plants. Blossoms, buds, stems, leaves and umbels: Karl Blossfeldt patiently conjured plants and more plants onto the plates, using, it is said, a self-made camera for $2^1/4$ x $3^1/2$-inch, $3^1/2$ x $4^3/4$-inch, $5^1/8$ x 7-inch glass negatives. For Blossfeldt, photographing the plants signified work, and nothing more than work, as Rolf Sachsse has emphasized, for the artist was interested neither in cutting an artistic profile for himself nor in gaining revenue from the project. Only for teaching purposes did he use his pictures, in the form of large-format slides or prints pasted on the classroom walls. In short, until their publication in the middle of the 1920s, Blossfeldt's photographs enjoyed only a very modest and very temporal publicity.

Karl Blossfeldt

Born **1865** in Schielo/ Lower Harz. Apprenticeship as sculptor and modeler. Lives from **1889** in Italy, Greece, North Africa. During this period he commences his systematic documentation of plants. **1896** return to Berlin. **1898** teaches at the Institute of the Arts and Crafts Museum. **1921** appointment as professor. **1926** first exhibition at the Nierendorf Gallery, Berlin. **1928** publication of his book *Urformen der Kunst*. **1929** participates in the "Film und Foto" exhibition in Stuttgart. Dies **1932** in Berlin

A technical herbarium in black-and-white: cool, clear

There is also another sense in which taking the photographs was work, especially when one associates the term with a certain tiresome monotony. From the beginning, Blossfeldt followed a standardized form of ar-

rangement. The plants are always placed against a neutral background and are illuminated by diffuse and evenly directed daylight that brings out their volume and three-dimensionality. He aims the camera directly, that is, vertically, at his subjects, from which he has removed visually disruptive shoots and leaves, as well as the roots. These are the photographic hallmarks that characterize his work: this is how he creates his specimens that are then enlarged between three and fifteen times – forty-five times on occasion, if necessary – to fill the pictorial space. In this manner, between 1890 and 1930, Karl Blossfeldt will complete 6,000 photographs, creating an enormous technical herbarium in black-and-white: cool, clear, and – without the artist realizing it – surrealistic.

Anyone who wishes may claim to find an extrapolation of the Art-Nouveau interest in floral designs in Blossfeldt's eight-fold enlargement of the fronds of a maidenhair fern (scientific name: *Adiantum pedatum*), or in the winding tendrils of a pumpkin, the base of an aristolochia stem, or a forsythia bud. But no interpretation could be more false. Both Blossfeldt and the turn-of-the-century reform movement that he supported were opposed precisely to Art Nouveau's "fashionable playing with mindless curlicues" (Richard Graul, 1904). Although perhaps not so vehement as Adolf Loos, whose equation of "ornamentation and crime" has become a slogan, Blossfeldt desired a turning away from the ubiquitous aestheticizing and decoration of the objects of daily life. If patterns were to be sought in nature, then let it be in the form of basic biological shapes whose tectonics were seen as providing a model for the combination of a 'natural' technology and aesthetics, of economics and material-social justice. This alone was what Blossfeldt attempted to illuminate through his visual researches. Half a century earlier, Semper's *Science, Industry, and Art* (1852) had recommended making the study of nature a duty for design of every sort. Now Blossfeldt was responding to this demand with a unique documentation deriving from possibilities offered by photography – a documentation whose influence is still evident today, perhaps even more in conceptual photography than in commercial art.

In the 1920s, Karl Nierendorf, founder of a Berlin art gallery as well as the "Catacombs" cabaret, became aware of Blossfeldt's work. Just how the clever Nierendorf – who had started his career as a banker in Cologne – discovered Blossfeldt for the realm of art remains hidden in the depths of history. All we know is that the first gallery exhibition of Blossfeldt's plant

Urformen der Kunst, *published in the English-speaking world as* Art Forms in Nature, Examples from the Plant World Photographer Direct from Nature. *Here the cover of the 4th German edition, Berlin 1948*

studies was mounted in April 1926; until that point – and this is worth emphasis – the photographs had never passed beyond the walls of the educational complex located in Berlin's Hardenbergstrasse. Through Nierendorf, Blossfeldt's photographic works appeared for the first time in an artistic context, and in this context they would later be received by the public. Although the response in the popular press ranged from positive to euphoric, the exhibit itself did not yet constitute the great 'breakthrough'. It was not until two years later that the renowned Berlin architectural publisher Ernst Wasmuth brought out Blossfeldt's book *Urformen der Kunst*. The effect was like a "thunderclap," in the words of a contemporary. The book "was to be seen in all the book stores, and the man whom many in the Hardenbergstrasse had looked upon as a friendly specimen of an extinct species – and whom some would gladly have chased out [of the academy] because they thought his two studios were a waste of space – this man had now become famous."

Friends throughout the world

"The first edition," Karl Nierendorf announced proudly in the foreword to the popular edition of *Urformen*, "was taken up by the public in a manner that exceeded all expectation. The German edition was soon succeeded by an English and a French, and throughout the world, the work found so many friends that the publisher has now determined to release a popular edition." This first popular edition appeared in 1935, ironically a year in which important artists of the New Objectivity – a term first used by G. F. Hartlaub in 1925 – had already fallen into disgrace. Nonetheless, this was not to be the last time *Urformen* would be brought to press. After the war, the book was again printed a number of times, and is said to have influenced commercial art teaching in West Germany into the 1950s.

The public's positive reaction to the work found resonance in the nothing less than euphoric reception by the critics, who immediately claimed Blossfeldt as a protagonist of a new manner of perception. Leading the pack of critical reviews was no less a figure than Walter Benjamin, whose critique appeared in the *Literarische Welt* of 23 November 1928, and became "probably the most cited review (J. Wilde). Critics, including such figures as Franz Roh, Julius Meier-Graefe, Max Osborn, and Curt Glaser, as well as authors such as Arnold Zweig and Hans Bethge, also discussed the work. The book, whose first edition moreover had sold out in eight

months, also received some negative criticism, particularly from the political left. Stanislav Kubicki, for example, writing in the *a–z*, a Rhineland magazine that reflected a socially progressive position, identified the basic assumptions behind *Urformen* in an understanding of form that was oriented on supposedly "natural principles of construction"; the truth is, he countered, that "almost all architectonic form derives from practical application...from the materials used, and from the purpose [behind it]. If we today discern a similarity between a Doric column and an enlarged photograph of a segment of horsetail, it is not at all because the horsetail constitutes the basic form of the Doric column. Rather, we have before us an accidental, quite amusing, but insignificant parallelism that tells us absolutely nothing." What Kubicki's commentary overlooks, however, is that Blossfeldt's book with its one hundred twenty full-page plates printed as greenish copper intaglio prints (*Maidenhair Fern* is Plate LV) had long since leapt over the author's initial didactic aim and had become a signal of visual modernity. Moholy-Nagy in particular expressed his reverence for the accomplishment when he presented Blossfeldt's botanic studies in the section of the epochal "Film and Foto" exhibit

Pages from Blossfeldt's Urformen, *1948*

40

41

(1929) in Stuttgart. Whether Blossfeldt himself appreciated the radical
newness of his activity is doubtful, when we look at the foreword he
wrote to his second book, *Nature's Garden of Wonders* (1932), where he
speaks of nature offering a model for the "healthy development of art,"
offering "fruitful inspiration," and providing an "ever-unconquerable
fountain of youth." It is therefore, so to speak, only against the grain of
Blossfeldt's philosophy of nature that postmodern photographers have
adopted his work as a model, whether in terms of his conceptual, accre-
tive, and comparative method of procedure, or in terms of his camera ap-
proach, which unconsciously conforms to the ideals of so-called Straight
Photography. What is certain is that neither the comparative approach of
the Bechers, nor the cool plant studies of Irving Penn, Robert Mapple-
thorpe, Reinhart Wolf, or recently, Kenro Izu, would be conceivable with-
out the creative preliminary groundwork of Karl Blossfeldt. For this
reason, Klaus Honnef has rightly granted him a place in the pantheon of
twentieth-century photography: Karl Blossfeldt, an amateur photo-
grapher, untrammeled by the rules of the craft or the norms of art, was
open to a new kind of perception that corresponded to a rational age.

80

81

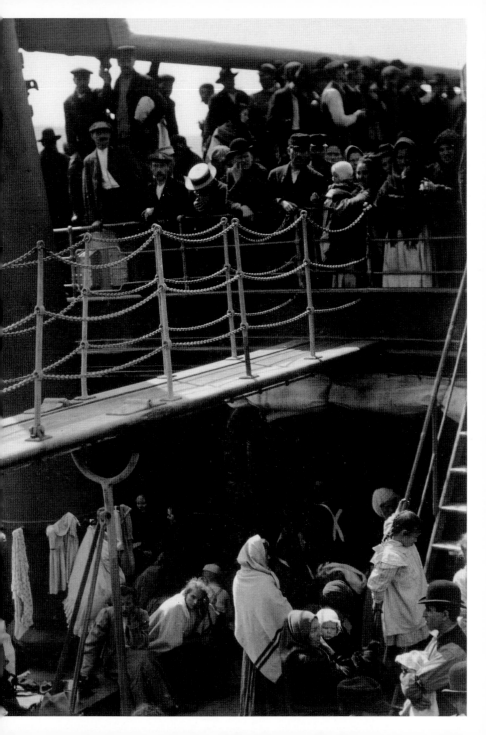

1907 Alfred Stieglitz
The Steerage

It is his most well-known work and, in his opinion, the most important. During a voyage from New York to Le Havre in the spring of 1907, Alfred Stieglitz photographed the steerage deck of the trans-Atlantic steamer Kaiser Wilhelm II. The aesthetic of the picture boldly anticipated what came to be called the New Objectivity in photography.

One gazes at the gentleman wearing the straw hat approximately in the center of the upper third of the picture. This brightly gleaming headgear seems to have functioned as an especially important compositional element for Alfred Stieglitz: after all, he repeatedly made the so-called 'boater', which had become fashionable around 1880, into an unmistakable component of his pictures. One needs only to recall his photograph *The Ferry Boat* of 1910, where an entire group of young hat-wearers perhaps set off his desire to take a picture. Or a more successful variation of the motif, in which the light-colored headgear competes with a row of wooden bollards, painted white. Not that Alfred Stieglitz had any special interest in the hat styles of his age: to the contrary, the material world tended to leave him cold, unless it offered him usable 'raw material' for a photograph he was interested in taking. Stieglitz was no documentarist; the here-and-now had only a limited value for him. And if he once claimed that photography was his passion, and the search for the truth an obsession, then he was certainly not equating 'truth' with the quest after the internal contradictions of an age, society, or political system, such as contemporary photographers such as Jacob Riis or Lewis Hine were concerned with. For Stieglitz, truth implied rather a balance, a rightness, an equanimity within the picture itself; in other words, it was an aesthetic concept. Not that the social aspect failed to move him: according to his own testimony, it was precisely the sense of surfeit inherent in the bored

atmosphere of the First Class that was a part of what moved him during the steamship passage to Europe in 1907 to seek out the tween-decks of the Second and Third Class, where he took what is perhaps his most famous photograph, *The Steerage*. Typically, however, Stieglitz kept his distance, photographed downward from an elevated position. And, decades later, when he provided a remarkably comprehensive commentary to his picture, he was concerned exclusively with compositional, technical, and aesthetic questions. The social extremes evident in the picture in other words were the trigger, but not the goal, of his pictorial exploration. Stieglitz sought not to penetrate, but to aestheticize, the world by means of photography. He understood himself chiefly as an artist, an apologist for an autonomous photography, that served nothing and no one but the duty to be art.

Alfred Stieglitz was born in 1864 in Hoboken, New Jersey, into a German-Jewish family, his father having emigrated from Münden, near Hanover. The son possessed a contradictory spirit. He himself sensed these contradictions, and raised them consciously to the sine qua non of his restless, lifelong devotion to art, specifically, photography. In every person who is truly alive, he once declared, these contradictions are to be found; moreover, "where there are no contradictions, there is no life." In this sense, Stieglitz was an apologist for photography but, as an elitist in thought and deed, he lacked any real desire to popularize it. Stieglitz was an Avant-gardist with an almost nostalgic leaning toward craftsmanship; he was doctrinaire, but without a unified doctrine; he was feared, but ultimately powerless. As a critic, editor, publisher, gallerist, curator, go-between, instigator, impresario, and collector, he was probably the most brilliant figure in American art business in the new twentieth century. His role as a midwife to modern art in the broadest sense of the term is uncontested. In his excellent biography of the photographer, Richard Whelan claims that Stieglitz "is perhaps the most important figure in the history of the visual arts in the USA." Therefore, in the 1950s and 1960s, when New York finally replaced Paris as the world art capital, the revolution unquestionably owed its thanks to Alfred Stieglitz as the long-term result of his influence and effort, so to speak. It was he who introduced America to the European Avant-garde, and in turn fostered and encouraged American artists. But in spite of all this, he understood himself first and foremost to be a photographer. "When I'm finally judged," he once

Alfred Stieglitz

Born **1864** the son of wealthy German immigrants in Hoboken/New Jersey. Studies in Berlin (engineering, photochemistry). **1883** first exposures. **1890** returns to New York. From **1893** editor of the journal *American Amateur Photographer*. **1902** editor of *Camera Notes*. **1902** founding of the Photo Secession. **1903–17** editor of the seminal periodical *Camera Work*. **1905** opening of the Little Galleries. **1907** tours Europe. Meets up with among others Heinrich Kühn. **1925–29** directs the Intimate Gallery. **1929–46** directs the gallery An American Place. Dies **1946** in New York

said, "I should be evaluated primarily in terms of my own photographic work."

In a sense always a pictorialist

As a photographer, Stieglitz is a giant. In today's market; his works easily bring in three hundred thousand dollars – when they come to market at all, that is. His œuvre is discussed in practically every history of the medium. And yet, his photographic creations still stand under the shadow of the artists that he publicized and fostered as his protégés: Edward Steichen, Edward Weston, Paul Strand, to name only three. Stieglitz does not appear in the 'pantheon' of the thirty most important photographers of the twentieth century established in 1992 by Klaus Honnef, who characterizes Stieglitz's work as "commercial photography – though of a high degree": a surprizing evaluation, insofar as Stieglitz succeeded in establishing pictorialism in the USA while he was almost simultaneously anticipating Straight Photography in works like *Winter, Fifth Avenue* (1893), *From the Back-Window, 291* (1915), or – precisely – *The Steerage*. In other words, at least twice Stieglitz was the leading figure in the artistic Avantgarde. Furthermore, it was he who raised the metropolis, modern civilization itself, to an object for art, introducing it into polite company, as it were. Skyscrapers, city canyons, rail and ship traffic all appear as motifs on an equal basis with classical themes such as landscape, genre, and nude photography. Stieglitz's œuvre even comprises examples of conceptual photography, if one considers his portraits of Georgia O'Keeffe, one of his later lovers, shot over a period of years, or his cloud studies, his so-called *Equivalents*, that he pursued almost obsessively. Admittedly absent from Stieglitz's photographs is the radicalism that his contemporaries such as Evans or Strand brought to their work. In a sense, Stieglitz remained a pictorialist, above all interested in adapting the classical rules of art to photography and to creating an elegant print. All of this applies specifically to *The Steerage*, a work at once ambivalently radical and affirmative. Stieglitz published the picture for the first time in 1911 in his magazine *Camera Work*; years later he designated it among his most important works. "If all my photographs were lost, and I were to be remembered only for 'The Steerage'," he once said, "I would be satisfied." In the spring of 1907 Alfred Stieglitz was forty-three years old. We can picture the artist, of whom so many portraits exist, as a respectable middle-

Camera Work, *edition from 1911, in which* The Steerage *was first published*

Edward Streichen did the typography for the cover.

aged gentleman with thick hair and a dark mustache, wire-rimmed glasses, and the skeptical gaze of the restrained misanthrope who has not yet given up the struggle against ignorance and poor taste. Although born in the USA, Stieglitz was strongly influenced by spending a number of school and university years in Germany. In particular, the lectures by Hermann Wilhelm Vogel, the inventor of orthochromatic film, greatly furthered his interest in photography. Stieglitz's first experiments with the camera stem from his Berlin period beginning 1882. He began to submit his work to photography contests and to write knowledgeable essays on the subject for international magazines. Upon his return to the USA, initially as editor of the journal *American Amateur Photographer* and later of *Camera Notes*, he became the apologist of an 'autonomous' photography, free from the service to any particular goals. His association with *Camera Work* (beginning 1903) and the Little Galleries at 291 Fifth Avenue (beginning 1905) provided him with influential forums for broadcasting his ideals. By 1907, he had also opened his doors to the fine arts, in particular to the work of artists like Rodin, Toulouse-Lautrec, Matisse, and Picasso. In the same year, Stieglitz himself undertook a voyage to Europe. In early June, acceding to the wishes of his wife, Emmy, he boarded the Kaiser Wilhelm II, the luxurious flagship of the Norddeutsche Lloyd lines. Along with his wife, daughter Kitty, and a governess, he brought along a Graflex for 4 x 5-inch glass negatives, and a single unexposed plate with which he was later to capture his famous 'tween-decks picture.

For photographers to speak about their individual creations is more the exception than the rule. Nonetheless, in 1942 – four years before his death – Stieglitz provided *The Steerage* with a longish commentary, which Wilfried Wiegand once with justice termed "the most precise description...ever offered on the creation of a masterpiece." Stieglitz begins his discussion with a description of the atmosphere in the First Class, which he hated: faces that "would cause a cold shudder to run down the spine," led him to spend the first few days at sea in a lounge chair on deck with his eyes closed. "On the third day," he continued, "I couldn't take any more. I had to get away from this society."

The artist moved "as far forward as the deck allowed." The sea was calm, the sky clear with a sharp wind blowing. "Reaching the end of the deck, I found myself alone, and looked down. In the steerage were men, women and children. A narrow stairway led up to a small 'tween-deck above,

directly over the prow of the ship. To the left was a slanted chimney, and from the 'tween-deck, a gleaming, freshly painted gangway hung down." Stieglitz noticed a young man with a round straw hat and the funnel leaning left, the stairway leaning right, "the white drawbridge with its railings made of circular chains – white suspenders crossing on the back of a man in the steerage below, round shapes of iron machinery, a mast cutting into the sky, making a triangular shape... For a while I stood there as if rooted, looking and looking. Could I photograph what I was feeling...?" Stieglitz hurried back to his cabin, grabbed his Graflex, and hurried back "out of breath and afraid that the man in the straw hat might have moved. If he had left his place, then I no longer had the picture than I had imagined earlier. The relation between the forms that I wanted to capture would have been destroyed, and the picture would have been gone." But the man was still standing there. Furthermore, neither the man wearing the suspenders nor the woman with her child on her lap had altered their positions. "Apparently," claimed Stieglitz, "no one had changed position. I had only one cassette with a single unexposed plate. Would I be able to capture what I saw and felt? Finally I pressed the button. My heart was pounding. I had never heard my heart beating before. Had I gotten my picture? If the answer was yes, then I knew I had reached a new milestone in photography, similar to *Car Horses* in 1892 or *Hand of Man* in 1902, both of which had introduced a new epoch in photography and perception."

In comparison with the euphoria that he later expressed, Stieglitz seems not to have been so certain in the beginning about the quality of the picture. How else can one explain the fact that the work that he designated as a milestone of photographic art appeared neither in the art photography exhibit in Dresden in 1909, nor in the Albright Gallery in Buffalo a year later. *The Steerage* was published for the first time only in 1911 in the form of a $7^3/_4$ x $6^1/_4$-inch photogravure in Number 36 of the legendary magazine *Camera Work* that Stieglitz edited. Earlier, the photographer thought he recalled showing the photograph to his friend and colleague Joseph T. Keily. "'But Stieglitz,' he protested, 'you took two pictures, one above and one below.'... It became clear to me that he did not rightly see the picture that I had taken." Even today, the photograph is regularly misunderstood as a visual witness to the masses of immigrants that were streaming to the USA around the turn of the twentieth century. In fact,

Alfred Stieglitz: The
Hand of Man, *1902*

however, the ship is cruising in the opposite direction, and the people tra-
veling in steerage were in fact 'migratory birds' – manual workers and
craftspeople who, as Richard Whelan writes, "made the crossing between
Europe and the New World in two-year cycles." Stieglitz himself did not
comment on them – just as he did not seem interested in the entire
social aspect of his photography. He placed forms and structure above
any possible human implications – at any rate, the latter were not the
subject of his reflections. Thus, on the eve of the First World War, 'pure'
art was able to celebrate itself once more. Afterwards, it would be forced
to redefine its role in a new age and a new world.

1908

Lewis Hine
Girl Worker in a Carolina Cotton Mill

Moments of Child-hood

The work of the American photographer Lewis Hine unites moral perspective and social engagement to a media-conscious application of photography. Especially in his cycle on child labor in the USA, he rose beyond pictorial journalism to create an early model for a humane photojournalism.

He is said to have been always extremely exact with the inscriptions on his photographs. For he realized: only when all coordinates passed muster – place, time, situation, etc. – would his photographs be believed, and only then could he defy the skeptics and doubters, of which American politics and economy seemed to provide so many. To undertake all that was necessary so that his work might produce results – this was the so-to-speak motive force behind his at times mortally dangerous, and in any case physically and intellectually grueling, activity. "There were two things I wanted to do," the artist once explained; "I wanted to show the things that had to be corrected. I wanted to show the things that had to be appreciated." In these terms, Lewis Wickes Hine numbers among the leading figures of socially oriented documentary photography.

His vision is always fine and often superb
Girl Worker in a Carolina Cotton Mill, 1908, is the simple authorized title of the original $4^1/_2$ x $6^1/_2$-inch photograph. Specific mention of the name of the factory or the date and hour of the photograph are absent. Hine's concern here is with the condition in general: the presentation of child labor in factories, coal mines, saw mills, southern cotton fields, and northern urban streets and squares. What is most important for him is that the situation appear believable, that the photograph be accepted as evidence, as a document of record – a term that, moreover, first arose in the middle of the 1920s in John Gierson's review of Robert Flaherty's film

Moana in the *New York Sun* of 8 February 1926, in which a similar impulse is termed a 'documentary'. Hine himself never used the expression. "A good photograph," as he once defined it, "is not a mere reproduction of an object or a group of objects, – it is an interpretation of Nature, a reproduction of impressions made upon the photographer which he desires to repeat to others."

With this statement, Hine gives a hint that he was to some extent willing to set up a scene. In the end, he was not simply seeking the naked pictorial evidence, but rather an effect in the sense of a clear, but moving, emphasis. Even in his very first series of photographs of immigrants on Ellis Island he had focused on individuals or couples from the mass of people, arranged them before a neutral background, and – one suspects – asked them to hold still a moment until the heavy Graflex camera was ready for the take and the flash powder was in the pan. Beyond a doubt, the complexity of the equipment itself required a certain level of the photographer's attention. In addition, however, Hine was always concerned also with composition, a fact that is often forgotten in the face of the simplicity of his pictures. "Certainly, Hine was conscious also of the aesthetics of photography," writes Walter Rosenblum, one of the top experts on Hine's work. "His files contain beautiful prints as well as mediocre ones. But when he organized a photograph, the effect was right. Considering the range of subject matter, the difficulties of site and execution, his vision is always fine and often superb."

A girl standing in front of a spinning machine. We can only guess at her age, for Hine did not reveal it, even though he often conducted short interviews with the subjects of his photographs, inquired about their circumstances, and asked their age. Sometimes he measured the size of the children he photographed against the buttons on his vest in order at least to estimate their ages later. This child, whom we could well imagine at a school desk, is probably between eight and ten years old. Technically, she is not alone in the photograph, but the grown woman in the background plays no role in the scene, even if she seems to be attentively watching the process of taking the photograph. The child herself is unselfconsciously working at the so-called ring spinning machine, a device invented in the USA at the beginning of the nineteenth century. The fact that at the moment of the photograph the child has paused in her work deprives the picture of none of its authority. She is hardly looking happily into the cam-

Lewis Wickes Hine

Born **1874** in Oshkosh/Wisconsin. Father dies in an accident during his early childhood. From **1892** various jobs, including heading a team of cleaners. Teacher training at the University of Chicago. Moves to New York. Supply teacher at the Ethical Culture School. **1903** turns to photography. **1904** immigrants on Ellis Island is his first major project with an educational purpose. **1908** quits teaching. A large scale survey commissioned by the National Child Labor Committee on the topic of child labour. **1918** documentation for the Red Cross on the impact of the war on Europe. **1930** photo-reportage on the building of the Empire State Building. **1932** publication of *Men at Work*. Dies **1940** in New York

Lewis W. Hine:
Spinner in New
England Mill, *1913*

From the series
"Child Labor" (Tex-
tiles)

era, nor does the state of her apron indicate any especially blessed living conditions.

In 1907, that is, shortly before Hine made his photograph, a government inquiry reported that there were no fewer than 1,750,178 children between the ages of ten and fifteen years working in American factories, mines, farms, or what we would today designate as service industries (such as shoeshine, newspaper and errand boys). Moreover, sixty-hour weeks were no rarity, in spite of child labor being forbidden by law in many of the states. In Pennsylvania, for example, children under the age of fourteen could not work in the mines, and in other fields, a minimum age of nine years had been set. Such regulations, however, were constantly being evaded, on the one hand because the booming economy required much labor, and on the other because the sheer poverty widespread among urban and city dwellers caused many families to rely on even their youngest members for financial help. For these reasons, proof-of-age certificates were forged, or false information was provided by the parents. Hordes of underage children drudged away as 'breaker boys' in mines where accidents were a common occurrence, and where darkness, cold, wet, and bad air leading to life-long health problems were a certainty; these Hine also addressed in his pictures. "Whatever industry saves by child labor," Hine recognized very early, "society pays over and over."

The worst form of institutions exploiting children

Some of the very worse conditions seem to have existed in the cotton mills of the American South – in North Carolina, South Carolina, and

Georgia – where official statistics record that almost fifty percent of all workers were approximately ten years old. The cotton mills are "the worst form of institutions exploiting children" according to the newspaper *Solidarity*, the "Official Organ of the Worker, Health, and Death Insurance of the United States of America," in 1907. The paper cited also the large rate of illiteracy among the children: 18.8 per cent of all working children between the ages of ten and fourteen were designated as illiterate, that is, they could neither read nor write. "How many of these innocent children, created as human beings in order to populate this planet, cannot attend school because they lack shoes, and above all, enough to eat! Because the mothers must go to work in place of the thousands of fathers who have been killed in the factories, and cannot look to their children's nourishment!"

The problem of child poverty and child labor was known, statistically proven, and the object of public debate. In 1904, the National Child Labor Committee (NCLC) under the direction of Owen R. Lovejoy had formed a private organization with waving banners against the "greatest crime of modern society," the enslavement and exploitation of minors. A jointly issued journal bearing the title *The Survey* was founded to create the necessary publicity, but seems in fact to have drawn little attention to itself before Hine appeared. It was only with the help of his photographic testimony that the opposition to the often-excoriated evil gained the momentum necessary for reforms, new laws, and stricter oversight, and finally the abolition of child labor. "Although we cannot attribute a specific reform to a certain photographic image, the mass of Hine's powerful photographs could not have failed to make an impact." (Stephen Victor) Commissioned by the NCLC, Hine produced more than five thousand photographs between 1906 and 1918. He took his pictures in the factories of Cincinnati and Indianapolis, visited the glass works and mines of West Virginia and the textile mills of North Carolina. He visited homeworkers in New York, and observed the night newspaper-sellers in New England. And this was not his first and largest photographic inquiry. As early as 1904 Hine had documented the arrival of European immigrants on Ellis Island. We can assume that Lewis Wickes Hine, born into modest circumstances in Oshkosh, Wisconsin in 1874, and orphaned at an early age, had refined his self-taught photographic knowledge while attending the New York Ethical Culture School – that is, he learned the use of the

Graflex and Fachkamera for $3^1/_2$ x $4^3/_4$-inch and $5^1/_8$ x 7-inch glass negatives, the handling of the rather dangerous flash powder, and in particular the dialogue with those whom he intended to portray in the midst of the fateful circumstances of their lives. In this effort, his humor, wit, human understanding, and love of mankind undoubtedly aided him – together with his often-noted dramatic talent that is supposed to have gained the versatile Hine entry into factories whose doors were officially closed to outsiders. There are stories that he regularly assumed the role of a Bible salesman, an insurance agent, or an industrial photographer to ease his way around the occasionally militant factory guards. After all, "to most employers, the exploitation of children was so profitable that nothing could be permitted to end it." (Walter Rosenblum)

Hine's photographs appeared in the publications of Hine NCLC, in particular in *The Survey*. They became the motif for posters and appeared in exhibitions and slide-lectures with whose help Hine and the NCLC attempted to reach a broader public. Hine's photographs, in other words, were part of an advanced concept in a double sense: they looked to modern media to effectively raise the desire for social reform.

Photography as a contemporary visual means of communication

More recent photographic criticism customarily poses Hine as the antithesis of Alfred Stieglitz – an opposition that is only partially justified. Stieglitz attempted to create recognition for photography as a modern art form by arguing for elaborate noble-metal processes and an elegant finish. Exactly these qualities seem not to have interested Hine, at least not in the sense of an artful photographic practice. "When he became school photographer in 1905, he didn't know anything about cameras, lenses, technics," according to his biographer Elizabeth McCausland. "Even today, at 64, he will say with a naiveté both lovable and sad: 'How is it that you make so much better prints than I do? Is it because your enlarger is better than mine?'"

To attempt to conclude that Hine was not interested in technical photographic questions would be false, however. What fascinated him was photography as a contemporary visual means of communication; what he ignored was the concept of the 'fine art print' as defended by the photographic community oriented on Stieglitz and his circle. And precisely here may lie the explanation for the low estimation that Hine and his work

have received up to the present time. For example, Edward Steichen, chief curator for photography at the Museum of Modern Art in New York, showed no interest in 1947 in Hine's estate after his death in 1940. And even the evaluation of Susan Sontag, who held Walker Evans to be the most important photographic artist to have concerned himself with America, reveals something of the skepticism that art criticism has shown toward Hine's œuvre primarily directed to social criticism. And yet Hine was in fact interested in formal and aesthetic questions and had, moreover, developed a visual vocabulary that could hold its own at the height of art-photography debates, being wholly based on the qualities intrinsic to the medium. In particular his early workers' portraits, according to Miles Orvell "endow their commonplace subjects with a dignity not in terms of an art-historical tradition, but in terms of a new vocabulary of representation that erased the existing ethnographic and documentary traditions of portraiture and established a new procedure for representing working-class character." But there were very few who recognized this truth during Hine's lifetime, not even a Roy Stryker, who roundly rejected Hine's application for work with the FSA project. Thus Lewis Hine died in 1940, impoverished and forgotten. He who had devoted himself lifelong to the social welfare of others had finally become a welfare case himself.

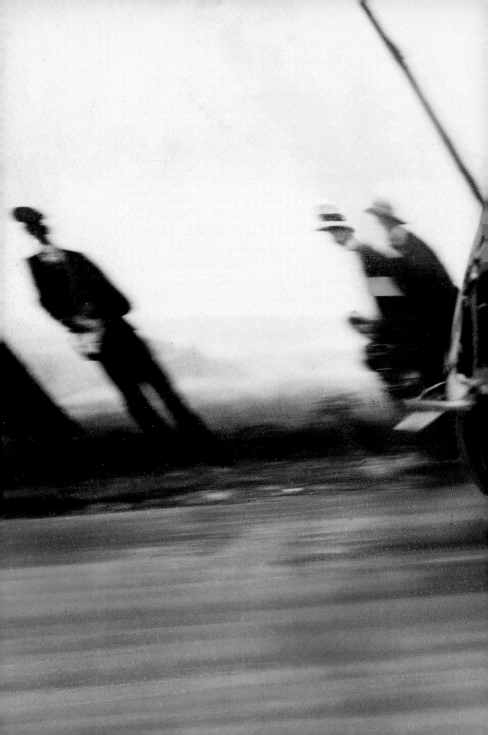

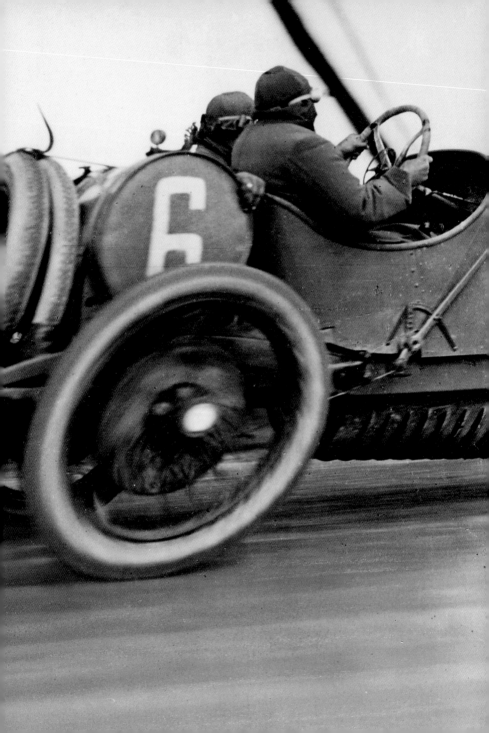

1912

Jacques-Henri Lartigue
Grand Prix de l'A.C.F.

The Tempo of Our Times

Automobile racing was a keenly watched spectacle at the turn of the 20th century. Roaring down the open highways, various makes of autos strove to demonstrate their performance ability. At the Grand Prix of the "Automobile Club of France" in 1912, the young Jacques-Henri Lartigue succeeded taking a photograph that we interpret today above all as a metaphor of the speed of the technological age.

He loved classy automobiles – but what boy of his age isn't? He watched as the first aviators swooped boldly through the skies, witnessed the advent of unheard-of technical innovations, and was fascinated by the age's intoxication with speed. Unlike most of his contemporaries the small Jacques Haguet Henri Lartigue (as he was christened) participated directly in the events. His family was wealthy – for a time, it was accounted the eighth richest in France – and his father, a well-known railroad director, banker, and publisher, exhibited a marked interest in novelty. As early as 1902 the family acquired its first automobile, a Krieger, followed by a Panhard-Levassor designed by Million Guiet. Next came a Peugeot, and finally, as the high point of the private fleet, a Hispano Suiza – before the family's wealth melted away after the First World War. But for now we're looking at a happier age. It was the fabulous era of the Belle Epoque, and the Lartigue family entertained itself with all the diversions appropriate to their class: Sundays spent in the Bois de Boulogne or, often enough, at the auto races conducted on the periphery of Paris. And here, if the enjoyment proved to be fleeting, it could at least be captured on film.

A thing one must love immediately

Père Lartigue himself was apparently an enthusiastic amateur photographer. "Papa makes pictures," wrote Jacques-Henri in his *Mémoires*

sans Mémoire. "Photography is a mysterious affair. A thing with an odd smell, bizarre and peculiar to itself – a thing one must love immediately." In 1901, at age seven, Lartigue received his first camera. "Papa," he noted, "seems like Dear God to me. He says, 'I'll give you a regular photography apparatus as a present.'" This gift proved to be a heavy wooden camera for $5\frac{1}{8}$ x 7-inch glass negatives, a device typical for the times, but in reality much too cumbersome for the slight and delicate Lartigue. But he quickly grasped his new medium as a technical refinement of that "angel trap," as he called it, by which Jacques-Henri, almost as soon as he learned to walk, had begun to record images of the visible world around him: "I blink my eyes quickly three times, spin myself around, and whoosh!, the picture is mine." In this way, photography very soon became an important tool of visual exploration for him; it was not merely a pastime, but the young boy's serious endeavor, which already extended from carefully composed exposures through the development and enlargement processes in the dark room.

With inexhaustible enjoyment and a remarkable eye

Lartigue photographed his own room, his toys, and furniture; then came the house, garden, servants, Mama, Papa, and his older brother Zissou. He broadened his horizons constantly. This is, after all, what he had always sought to do: to stop the process of things, to be able to brake the speed of time, to be allowed to remain a child for whom, so to speak, the world of technology unfolded itself as an over-sized arsenal of toys. Lartigue photographed automobiles – again and again automobiles. He captured airplanes on his plates. And zeppelins. And he did all this with inexhaustible enjoyment and a remarkable eye – but above all with an amazing, seemingly intuitive understanding of the iconographic characteristics of his medium. Decades later, no less a figure than John Szarkowski would claim, ""These pictures are the observations of genius: fresh perceptions, poetically sensed and graphically fixed."

Lartigue was eighteen years old when he succeeded in shooting what has since become his probably most famous photograph. The date is 25 June, 1912. The family has set out to watch the Grand Prix of the Automobile Club de France near Le Tréport. At this time, France was still the leading automobile nation: more than two hundred auto manufacturers courted the favor of prospective customers. In comparison the USA sported

Jacques-Henri Lartigue

Born the scion of a wealthy Parisian family in **1894** at Courbevoie. First camera at age eight, first exposures of his own at age ten. **1915** studies art in Paris. Numerous exhibitions in thirties Paris. Friendship with among others Picasso and Cocteau. **1963** first exhibition of his photography at the Museum of Modern Art, New York. First exhibition in Germany in **1966** at the "photokina". **1970** publication of *Diary of a Century*, edited by Richard Avedon. **1979** he donates his photo archive to the French state. **1984** culture Prize of the DGPh. **1986** officer of the Légion d'Honneur. Dies **1986** in Nice

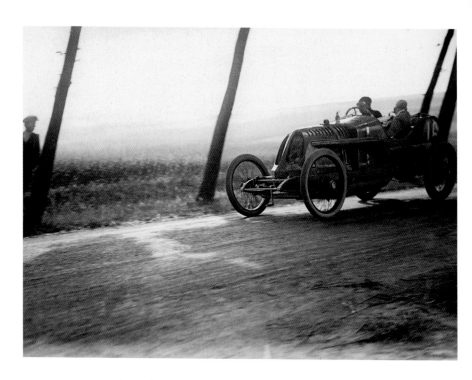

about a hundred such firms, England around sixty, and Imperial Germany
slightly more than thirty. Until the end of the 1920s, France would remain
Europe's largest producer of motorized vehicles and, until the start of the
First World War, its most important exporter. France also presided over
the publication of the first journal devoted to the automobile, *L'Auto* in
October 1900 – a publication to which, one might add, Jacques-Henri
Lartigue held a subscription since 1908. Moreover, it was also in France
that the first highway races took place.

The Paris–Rouen race (1894) is generally accounted as the first of its kind.
Additional races and test runs stretched from Paris to Toulouse, or from
Paris to Ostend and Vienna. The routes were laid out on the dusty, largely
unsurfaced country roads. As a result, flat tires – caused by the horse-
shoe nails that littered the roads – were the norm, and broken axles were
no rare occurrence. Even fatal accidents were often an unavoidable part
of the spectacle that Lartigue – in spite of tragic incidents – could not
tear himself away from. "At 2 p.m.," he confided to his diary under the

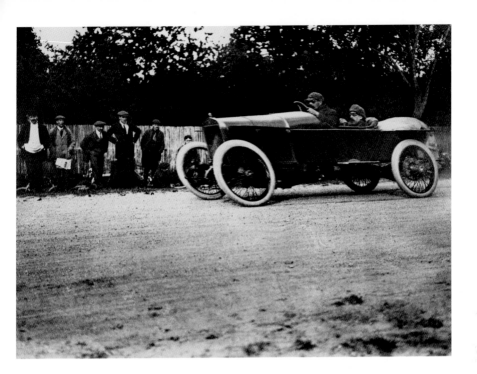

heading of June 25, 1912, "no more cars in sight. The race is over for to-day. In the hotel we were informed that Hemery is alive and well. It got Colinet. He's hurt, his mechanic dead."

Jacques-Henri Lartigue: Course de côte de Gaillon, *October 6, 1912*

A picture accorded no significance for many years

Grand Prix de l'A.C.F. – so the official title of the picture – was taken during the course of 26 June 1912. This was the second day of the Grand Prix, and the photograph is one of a total series of one hundred sixty-nine shots. Lartigue was now photographing with an Ica Reflex for $3^1/_2$ x $4^3/_4$-inch glass negatives. The original camera bears the serial number 489955 and sports a Zeiss Tessar 1:4.5 150 mm objective. The peculiarity of this comparatively large camera with a top-mounted focusing screen is its horizontal focal-plane shutter, which accounts for the elliptical form of the rear wheels in the photograph. Obviously Lartigue followed the motion with his camera. This is why the surroundings are blurry, whereas in contrast the body of the automobile and the two drivers are sharply in

focus. That the entire radiator of the Schneider-made automobile is sacrificed to the framing of the shot can hardly have been the intention of the auto-maniac Lartigue, who otherwise always strove for the total image. It seems that for many years the photographer accorded no significance to the picture. Moreover, he even judged it a mistake. How else can one explain the fact that only a single, badly processed print, which furthermore is strongly clipped on one corner, has survived? The small $4^1/_2$ x $6^3/_4$-inch vintage print is today in the possession of the Gilman Paper Company in the USA. A further, clearly later print is included in an early volume of Lartigue's carefully kept albums. But the years between 1919 and the 1960s were rearranged and expanded in the album: one cannot exclude the possibility that the photographer added the picture in the context of its increasing international fame.

At the beginning of the 60s, Jacques-Henri Lartigue was, true to his philosophy of life, a happy individual – and was utterly unknown. As a photographer, he was an amateur in the literal sense of the word, a person who, without aiming at 'art', explored his personal environment. As a painter, he had won recognition only to the extent that occasionally one of his works found a courageous buyer. An invitation drew Lartigue to the USA in 1962. And what happened here is something that Lartigue's third wife, Florette, would later refer to as a "miracle." She accompanied her twenty-six-year-older spouse on the passage to the USA. And because she understood how boring life can be on board a freighter, Florette Lartigue carried along a stack of photographs in order to retouch them on board. Upon arrival in New York, the couple met with Charles Rado, who had operated a photo agency in France before the war and now worked as an agent in the USA. "In the course of conversation," recalled Florette Lartigue, "the discussion turned to photography, and Jacques mentioned that he himself had been taking photographs since childhood." Charles Rado's interest was piqued; the Lartigue's handed over to him the stack of photographs the couple had brought. And Rado promised to publicize them. In fact, on the very same day, he offered them to the illustrated magazine *Life*. A little later he showed them to John Szarkowski, who had recently stepped into Edward Steichen's shoes as director of the photographic department at the Museum of Modern Art. Looking back, Szarkowski described his first encounter with the works: "What I then thought to be the œuvre consisted of two large scrapbooks and a sheaf

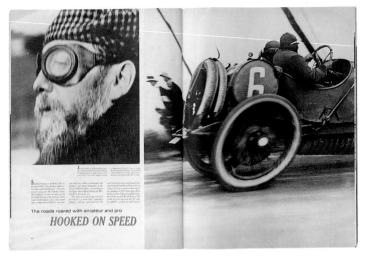

The roads roared with amateur and pro

HOOKED ON SPEED

"Hooked on Speed": Lartigue's Grand Prix de l'A.C.F. *as the lead for the* Life *portfolio, November 29, 1963*

of fifty-two loose prints; the scrapbooks contained a wide variety of prints – little yellowing contacts and bigger prints, including enlargements, on a wide variety of papers... The prints were plunked down on the pages of the album with concern chiefly for the maximum utilization of every square centimeter of the sheet, and with a heartwarming freedom from obedience to any design principle that I knew of, either traditional or modern. The pictures themselves seemed to me astonishing, primarily because of the simplicity and grace of their graphic structure. They seemed – like a fine athlete – to make their point with economy, elegance, and easy precision. It seemed that I might be looking at the early, undiscovered work of Cartier-Bresson's papa...."

Szarkowski was swept away by the material and immediately decided – even though it was the work of an entirely unknown sixty-eight-year-old amateur photographer – to devote a single-man show to Jacques-Henri Lartigue at the Museum of Modern Art. In the first place, Szarkowski reckoned, as a young director he could offer a truly new discovery right from the start. And secondly, Lartigue's photography provided the argumentative groundwork for the development of a new symbolic language for which Szarkowski would later in fact become the apologist. Lartigue, as he reasoned consequently in the catalogue "saw the momentary, never-to-be-repeated images created by the accidents of overlapping

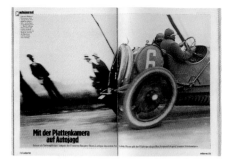

Lartigue's famous picture was used for Stern 52/1979 as both the cover and the lead for a portfolio.

shapes... This is the essence of modern photographic seeing: to see not objects but their projected images."

No end to the accidents or miracles

Lartigue's first exhibition, or, as we would call it today, his coming-out as a photographer, opened on 1 July 1963 at the New York Museum of Modern Art and subsequently went on tour to sixteen other cities in the USA and Canada. The slim exhibition catalogue containing a total of forty-three photographs presented the *Grand Prix de l'A.C.F.* on page twenty-seven. The picture was also featured, although strongly cropped, by the illustrated magazine *Life*, which devoted a comprehensive section to Lartigue in its issue of 29 November. But the end was not yet in sight of the 'accident' – 'miracle' – of Lartigue's equally sudden and world-wide fame as chronicler of the Belle Epoque (as he was initially termed, at any rate). On 22 November 1963, John F. Kennedy was assassinated in Dallas. "We responded to the news with a shock in which there was also a mixture of disappointment," recalled Florette Lartigue. "We were certain that the pages intended for Jacques would now be sacrificed to the dramatic events of this autumn of 1963. In fact, however, photographs of the tragedy in Dallas and Jacques' untroubled pictures shared the pages of *Life*. Precisely because of the title story, this issue now sold like wildfire." Moreover, as Mary Blume underscores, it was one of the highest-selling issues of *Life* ever. Thus Jacques-Henri Lartigue advanced, in a sense overnight, to become "one of the world's most famous photographers, and its best loved." Since then, particularly his photograph *Grand Prix de l'A.C.F.* has been repeatedly reprinted and reproduced. The picture is to

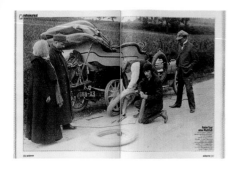 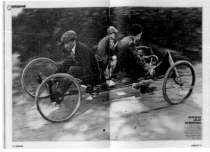

be found in practically every work on Lartigue. Almost as a matter of course it provides the cover motif of the small Lartigue issue in Robert Delpire's paperback edition *Photo Poche*. The German magazine *Stern* (52/1979) selected the picture as the title page to announce a special automobile issue. Recently, the picture has been increasingly in demand by mathematicians, psychologists, and phenomenologists, who have used it to illustrate particular facets in their respective areas. Even company reports have often had recourse to the picture in order to visualize the dynamics of economic life. For Lartigue himself, however, the shot was merely one of approximately one hundred thousand. As a child, he had once complained: "I am sad not to be able to photograph odors." Nonetheless, he succeeded in capturing the times. The *Grand Prix de l'A.C.F.* remains a primary exemple of the power of perception, of our ability to see in an age of supersonic speed: an image for the tempo of our modern technological world.

August Sander
Young Farmers

In 1910, August Sander began a systematic attempt to portray and typologize his fellow countrymen. The project, undertaken wholly at his own initiative and expense, found support only among his painter friends in the Rhineland area of Germany. His book *Antlitz der Zeit* was outlawed and partially destroyed by the Nazis in 1936, but Sander's ambitious undertaking today ranks among the most outstanding contributions to the New Objectivity in photography.

A Profile of the People

The parameters are fairly clear: August Sander titled his picture *Young Farmers*, 1914, thus indicating both the date of the photograph and the social status of the subjects. But whether the picture was made before or after the outbreak of the First World War, felt by many of his contemporaries to mark the end of an epoch, seems not to have been particularly important to Sander. Where the three young men are coming from, or where they are headed, also remains unknown. Are they brothers? friends? neighbors? It has often been claimed that the three are on their way to a dance in town – which at first seems a reasonable assumption. But surely the weekend or even the end of the workday offer additional grounds for 'young farmers' to wash themselves, shave, comb their hair, and draw the dark suit out of the closet. At any rate, we can be sure that the trio have a common goal. But for the moment they let it slip from their minds, as they stop and turn, looking at us directly almost as if on command – and thus make us aware of another person, also present in the photograph without being visible: the man behind the camera.
At the time of the photograph, August Sander was thirty-eight years old. As the Wilhelmine Empire neared its end, he had the reputation – along with Hugo Erfurth and Hugo Schmölz – of being one of the leading pho-

tographers in Cologne. In Bavaria or Prussia, he probably would have sought the status of court photographer; in the bourgeois Rhineland, however, he attempted to prove that he was among the best through the quality of his work and the correspondingly high prices he could ask for it. Was it the loyalty of the Rhineland bourgeoisie to the older, long-established studios, or was it Sander's understanding of the recompense he deserved for his photographs, that soon forced him to look for customers outside of Cologne? In any case, it is certain that Sander increasingly found his clientele in the nearby Westerwald region – a situation that could hardly have displeased him, since Sander, who had come from a simple background himself, had a great understanding and appreciation for the area and undoubtedly struck up a sympathetic relationship with the farmers who lived there.

Whether the negative numbered 2648 was the response to a portrait commission, we do not know. Nonetheless, the name of a certain Family Krieger is known – and nothing else, except that they were to be sent a dozen copies of the photograph: "12 cards" is noted by hand on the negative – probably a reference to printing them in the 4 x 6-inch cabinet format. What might at first glance be misunderstood as 'instantaneous' photography is therefore actually the result of a carefully composed scene, probably preceded by Sander's intensive preparatory conversation with the subjects. In other words, he and the young farmers would have chosen the location of the photograph, decided in favor of a group portrait, and set the specific day and time. Neither the fact that the photograph was made in the open air, nor the make and age of the camera – which first had to be carried to the site, fastened to a stand, and set up for the photograph – probably struck the men, inexperienced as they were with standard photographic practice, as unusual. Sander himself explained nothing: in his remarks and theoretical explanations he was always remarkably reticent. In 1959, however, at an exhibition in the Cologne Rooms of the German Society for Photography, Sander, asked to comment on his picture, offered only technical details about the camera and chemical processes – not at all unusual for the times, but amazing for the "artist" August Sander. "Ernemann portable camera 3/18," he noted about the *Young Farmers*; "built-in Luc-shutter release – time exposure no diaphragm – lens: Dagor, Heliar, Tessar, old lenses – Westendorf-Wehner plates – development meteol-hydrochinon or pyro daylight."

AUGUST SANDER
ANTLITZ DER ZEIT
60 FOTOS DEUTSCHER MENSCHEN
TRANSMARE VERLAG • KURT WOLFF VERLAG • MÜNCHEN

Antlitz der Zeit, in English: Faces of our Time, *featuring "60 German people". Here the cover of this, Sander's first book, as published 1929 by Kurt Wolff in Munich*

Clothes as an expression of social change

Sander's *Young Farmers* (original negative format: $4^3/_4$ x $6^1/_2$ inches) contains a good many oddities and contradictions. But these characteristics are probably precisely what make the picture so interesting and have made it into the most-reproduced and most well-known of Sander's photographs. Sander, it is often said, constructed his pictures in architectonic fashion, giving his subjects sufficient time to present themselves in an arrangement that felt right to them. In fact, the group portrait of the three young farmers oddly creates a simultaneously static and active impression, almost with a trace of the cinematic about it. A cigarette is still hanging loosely from the lips of the young farmer to the left; the one in the center is holding a cigarette in his hand, and the young farmer on the right has possibly already thrown his away. The young man to the left appears as if he had just stepped into the picture, an impression underlined by his walking-stick held at a slant, whereas the young farmer in the background seems petrified into a pillar, his cane boring perpendicularly into the earth, his gaze steadfast, even dogged. Whereas the other two have just arrived, he is already a making a face as if he wants to move on.

Contemporary art critic and theorist John Berger, who has subjected the photograph to a penetrating analysis, points out another peculiarity: the dark suits of the three young men. In terms of cultural history, the suit is an 'invention' of the bourgeois era. The replacement of courtly dress by a special costume developed specifically in England is above all a reflection of deep social changes. With the 'suit', the new bourgeois elite had created an appropriate uniform for itself: simple, practical, and egalitarian. At least for men, what was now important was less social prestige, as signified by an elaborate wardrobe, than economic success in capitalist competition. The suit is, as Berger expresses it, a costume for the "serene exercise of power" in which a man with a powerful build developed through hard bodily labor, appears "as if he is physically deformed." And yet, as Berger correctly emphasizes, "no one had forced the farmers to buy these pieces of clothing, and the trio on their way to a dance are obviously proud of their suits." They are even wearing them with a certain dash in Berger's interpretation – an attitude which nonetheless does not relieve the contradiction, but rather lends an ironic accent to the picture.

August Sander

Born **1876** in Herdorf/Siegerland. **1890–96** works as a pit boy at the Herdorf iron mines. First contact with photography at this time. Works in a photographic studio in Trier. Years of travel. **1910** moves to Cologne. Studio in Cologne-Lindenthal. **1914–18** military service. Contact with the group the Rheinische Progressive. Conceives his long-term project *People of the 20th Century*. **1929** publication of his book *Antlitz der Zeit* (Faces of our Time). His studio in Cologne is destroyed during WWII. **1951** one-man exhibition at the "photokina" in Cologne. **1955** participates in "The Family of Man" exhibition at the Museum of Modern Art, New York. **1961** culture Prize of the DGPh. Dies **1964** in Cologne

August Sander:
Pastry Cook, 1928,
from: People of the
20th Century

The real end of the nineteenth century

The year 1914, when the photograph was made, undoubtedly marks a break in modern history. This was the year in which Sigmund Freud published his outline *On the History of the Psychoanalytic Movement*, Duchamp presented his "ready-mades" for the first time, Walter Gropius designed the Faguswerke that was to be so important for modern architecture, Albert Einstein developed his theory of relativity, and Charlie Chaplin made his first movie. For many historians, the first year of the war marks the real end of the nineteenth century and the beginning of the increasing technological development, rationalization, tempo, and loss of individuality that characterize modernity. August Sander was almost certainly well aware of the change of paradigms – all the more so because leading exponents of what later came to be known as the "Rhine Progressives" – Heinrich Hoerle, Franz Seiwert, Anton Räderscheidt – numbered among his closest friends. Sander was born in 1876 as the son of a mine carpenter and small farmer in Siegerland. Whereas in his early years as a professional photographer he had subscribed entirely to an artistic approach to photography devoted to painterly ideals, by the time he moved to Cologne in 1910, he had transferred his allegiance to what he called "exact photography," without softening effects, retouching, or other manipulations. These principles hold both for his commercial photography and for his ambitious portfolio *Menschen des 20. Jahrhunderts* (*People of the 20th Century*), that has long

been recognized as one of the most significant contributions to the New Objective photography of the 1920s .

The idea of creating a cycle of portraits was not necessarily new. Nadar, Etienne Carjat, and the German photographer Franz Hanfstaengl had already introduced the ancient idea of a pantheon of important contemporaries to photography. At the beginning of the twentieth century, Erna Lendvai-Dircksen and Erich Retzlaff were pursuing 'folk' or pseudo-racial investigations, while their contemporary Helmar Lerski experimented with the formal vocabulary of photographic Expressionism in his *Köpfe des Alltags* (Ordinary heads). August Sander's intentions were considerably more modern that those of his forerunners, in that he not only took notice of the immense social transformations that had occurred during the process of industrialization, but also made them precisely the basis of his social inventory of the German people. Sander has long been criticized for not organizing his work according to the latest knowledge of modern social sciences, but rather arranging his social inventory into seven groups and forty-five folders according to a more or less antiquated model of professional distinctions and hierarchies. The high number of representatives of certain 'types' does not at all correspond to the social reality of the Weimar Republic. In fact, the labor force as such is hardly included in Sander's concept, whereas farmers, taken as a group that the photographer respected as 'fundamental', were clearly overrepresented. The Cologne newspaper *Sozialistische Presse*, for example, apostrophied the figure of a huntsman as "ripe for a museum" and posed the question whether the work really had anything to do with representative examples of the twentieth century. Sander's work, which remained unfinished, may in the end deserve particular criticism in view of the photographer's claim to ('pseudoscientific') neutrality (Susan Sontag). But as a contribution to photography it remains unique.

Approximately as the First World War drew to a close, August Sander turned his attention seriously to his self-appointed task, which he soon provided with the ambitious and encyclopedic title *People of the 20th Century*. Later he explained, "People often ask me how I came up with the idea of creating this work. Seeing, observing, and thinking – that answers the question. Nothing seemed more appropriate to me than to use photography to produce an absolutely true-to-nature picture of our age." Different from the artistic photographic portrait, Sander's work was

not an attempt to visualize inner values, but of interpreting social reality by photographic means. Farmers, craftsmen, laborers, industrialists, officials, aristocrats, politicians, artists, 'travelers', to name a few of Sander's categories, step before the camera. Most of his subjects he found in his immediate Rhineland environment, a fact which today gives his work a slight regional flavor. Formally Sander followed his own, self-determined standards, which do not necessarily make the photographs similar, but lend them a compatibility to each other. That is, he photographed by available light, and usually in a setting in which the subject felt at home. He handled his subjects as complete figures, selected a wide frame, and avoided extreme upward or downward shots that were popular in photography at the time. That in the case of *Young Farmers*, as with the majority of Sander's motifs, only a single negative plate exists indicates that the photographer was relatively self-assured in his visual dialogue with his protagonists.

Commercial harbinger of the larger projected work

August Sander first garnered attention to himself in an exhibition in the Cologne Arts Association in 1927. Whether *Young Farmers* was on display in the show we do not know. But it is certain that older works, originally created as commissioned portraits, were in the meantime being gathered and selected with a view toward the creation of a portfolio that was already in the works. Sander now came to the attention of Kurt Wolff, who had previously published Renger-Patzsch's highly regarded book *Die Welt ist schön* (*The World Is Beautiful*), and in 1929 *Antlitz der Zeit* (*Faces of our Time*) appeared as a first volume, intended as a commercial harbinger of the larger projected work to follow. According to an advertisement sheet included with the work, the volume of selections was able "to convey only a weak idea of the extraordinary size and range of Sander's full achievement. What is does show, however, is the ability of the photographer to get to the core of the people that he places in front of his camera, excluding all poses and masks, and instead fixing them in a completely natural and normal image." In *Antlitz der Zeit*, a full-page print of *Young Farmers* appears as Plate VI. In other words, Sander had already selected the picture to be a part of the core of the œuvre that in the end was supposed to comprise approximately five thousand plates. Exactly what caused the National Socialists to destroy the printing plates and the remainder of

Antlitz in 1936 remains still some-what unclear; similarly, we do not know why, after the war, Sander did not bring his project to a conclusion that would have satisfied him. It is clear that the photographer, now in his seventies, no longer possessed the same energy as earlier. Furthermore, his post-war living quarters in Kuchhausen, with only modest laboratory equipment, were certainly not the ideal place to finish a portrait work of this dimension in an appropriate manner. Nonetheless, Sander continued to work on the project for the rest of his life, taking up old photographs into the collection, and rearranging them all. In the process, he was accompanied by an increasingly interested public. The photo-kina

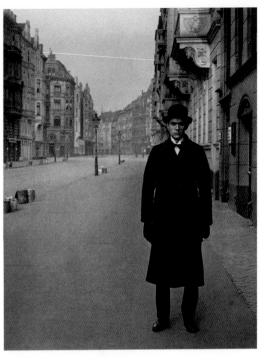

August Sander: The Artist [Anton Räderscheidt], *Cologne, 1926, from:* People of the 20th Century

fair exhibits of 1951 and 1963, as well as Sander's participation in Steichen's "The Family of Man" project (1955), were important early stations in his more recent reception. That the world had changed since the conception of the project can hardly have missed Sander's notice. Where youthful gestures of protest might express themselves in 1914 through cigarettes and a hat askew, the world after 1945 sported chewing gum, rock and roll, jeans, and petticoats as signs of the modern spirit. In a certain sense, August Sander had lost hold of 'his' people.

Paul Strand
Blind Woman

"Strand is simply the biggest, widest, most commanding talent in the history of American photography" — thus has Susan Sontag described her countryman Paul Strand. Especially in his early work, he transcended the limits of pictorialism and thus prepared the way for modern photography in the USA.

Manhattan
People

New York, autumn 1915. A young man enters Gallery 291 on Fifth Avenue. This is not his first visit: he had become acquainted with the legendary gallery while he was a student at the Ethical Culture School, and perhaps even now he might have been thinking of his former teacher, Lewis Hine, who had initiated the class excursion of young amateur photographers to the gallery. Decades later, Paul Strand would report that Hine: "took us all down to a place called the Photo-Secession Gallery at 291 Fifth Avenue, where there was an exhibition of photographs. I walked out of that place that day feeling, This is what I want to do in my life... That was a decisive day."

In 1915, Paul Strand was twenty-six years old. He had graduated from the Ethical Culture School, and was earning a living in his father's import business. In addition, he already spent a Wanderjahr in Europe and was now a member of the New York Camera Club. He was sure of his goal, but he had not succeeded in establishing himself as a commercial photographer or through his free-lance work. He had returned from Europe with well-composed landscapes in the painterly tradition of pictorialist photography. With his *Garden of Dreams/Temple of Love* (1911) he had won praise from fellow amateurs at exhibits in New York and London. Realizing that such artistic ventures were hardly sufficient, the self-critical Strand sought advice from recognized exponents of artistic photography such as Clarence H. White and Gertrude Käsebier. "They were very sweet to me as a young fellow, but not very helpful." It was in fact Alfred Stieglitz himself, the



great apologist of artistic photography in the USA, who became an important mentor and helpful adviser to the young man. "I used to go and see Stieglitz about once every two years. I did not go there to bother him unless I had something to show. He was a great critic for me."

In this autumn of 1915, Strand had reached that point once again. He selected a number of more recent works to show Stieglitz. Since his last visit, the young photographer had visited the path-breaking Armory Show with works representing the European modern and had furthermore acquainted himself with the art of van Gogh, Cézanne, Picasso, and Braque. Influenced by Cubism as well as the documentary projects of Lewis Hine and the advice of Alfred Stieglitz, who was himself coming ever nearer to a straight photography, Strand had turned to urban themes and a more rigorous way of seeing. Of course, by this time, cityscapes were nothing new to photography; one has only to look as the works of Karl Struss (*New York*, 1912), for example, or Alvin Langdon Coburn (*House of a Thousand Windows*, 1912), or Alfred Stieglitz (*The City of Ambition*, 1910). Strand, however, was the first to create a valid synthesis of contemporary themes and artistically mature vision appropriate to the photographic medium. His pictures, as Maria Morris Hambourg once stated: "were tough, surprising, and had intimate weight." We have a pretty clear idea just which motifs Paul Strand presented to his mentor on this autumn day in 1915: *Fifth Avenue and 42nd Street*, *City Hall Park*, and *Wall Street*. And we also know Stieglitz's reaction. "We were alone in the Gallery," recalled Paul Strand. "He was very enthusiastic and said: 'You've done something new for photography and I want to show these.'" Stieglitz kept his word; shortly thereafter, in March 1916, Paul Strand had his first exhibit at 291 – the gallery that one can justly claim to be the most important forum of the Avant-garde in the USA. For Strand, it was, so to speak, the breakthrough. For the art of the camera in the USA, in the words of Helmut Gernsheim, it was the beginning of a new epoch: the "era of modern photography."

The search for the greatest degree of objectivity

Europe was already caught in the throes of the war in which the USA became an active participant in 1917. The mood of the country had already begun to change: out of the dismay, there emerged a growing self-confidence. "In the ferment of World War I, there was also a great deal of unrest

in America," recalled Paul Strand. "It was a time of new thinking and new feeling about various forms of culture, sharpened later by the catastrophic Crash of 1929." We can only speculate about what might have inspired Strand in this age of intellectual upheaval to begin portraying anonymous people in the streets of New York. He himself always defended the series, which many consider his best work, with the desire to photograph people "without their being aware of it." But it is hardly imaginable, according to the critic Milton W. Brown "that this series of memorable and psychologically probing studies could have been the by-product of a technical gimmick." Are these photographs indeed concerned merely with a cheap effect? Insofar as Strand in a sense "stole" his portraits, had he not freed himself from traditional portrait standards: interaction, visual dialogue, the possibility of setting one's own scene? What is certain is that Strand, with the help of specially fitted cameras (initially with a side-mounted objective, later with a prism lens) was largely able to photograph without being noticed. And this anonymity also became the guarantee of what he was meanwhile striving for: the greatest possible degree of objectivity. But Strand was neither concerned with creating a sociogram of New York society (the series is too small in scope), nor did he make a claim to journalism (for this, the images are too indefinite in their historical context). Strand sought and found characters of everyday life, drew simple people into the center of his photographic attention, thus making them the unconscious 'object' of a psychological investigation.

Strand opened his cycle in Five Points, the slum where Jacob Riis had also worked. He photographed on the Lower East Side and around Washington Square. Seventeen of Strand's portraits have survived, including *Man in a Derby* and, precisely, *Blind Woman*, a picture that Walker Evans termed brutal, but in a positive, cathartic sense: Nothing, according to Evans, had as great an influence on his own photography as Paul Strand's work. In a somewhat exaggerated comparison, one might say that just as the First World War caused a break in painting – a turning away from the pictorial aesthetic that had exhausted itself in formalism – Strand singlehandedly brought about a new era in the USA with the Cubist-inspired structure of his photographs: machines pulled into the frame, unposed portraits. Strand's work, according to Alfred Stieglitz, is 'pure': "It does not reply upon tricks of process... The work is brutally direct. Devoid of all flim-flam; devoid of trickery and of any 'ism'; devoid of all attempt to

Paul Strand

Born **1890** in New York as the son of Bohemian immigrants. Works till **1911** in his parents' shop. During this time devotes his attention to photography. **1909–22** member of the Camera Club. **1916** first exhibition in Stieglitz's Gallery 291. **1917** major presentation of his photos in *Camera Work* (in its last issue). **1920** experimental film *Manhatta*. **1922–32** works chiefly as a freelance camera man. **1932–34** Mexico. **1935** Moscow. *Time in New England* as his last photographic project in the USA. **1950** moves to France. **1952–54** Italy. **1954** Hebrides. Devotes especial attention during his later years to nature studies around his home in Orgeval. Dies there **1976**

mystify an ignorant public, including the photographers themselves. These photographs are the direct expression of today."

Excluding all situational or anecdotal perspective

A blind woman with a cardboard sign hanging from her neck. What is more disturbing here – the obvious physical deficit, or the written notice calling attention to it? In one sense, the picture is tautological, but there is a system to the tautology. In a hectic age, and specifically in a metropolis, anyone wanting to call attention to her infirmity must provide it with an exclamation point. Cynical as that may sound, the cynicism redounds upon the head of the society that gives the handicapped no other choice but to assure survival through public demonstration of her 'fault' – in other words, to make capital out of the infirmity. Stanley Burns in *A Morning's Work* calls attention to the dramatic situation of amputees and other cripples – for example all those injured in work-related accidents – in America at the turn of the twentieth century. Many of these people were forced to earn their income by selling their own photographic portraits, the public always took an interest, according to Burns, in the misfortune of others. Whether the blind woman is in fact selling something or only holding her hand out we don't know. The photographer intentionally kept the frame of the photograph small, thus excluding all situational or anecdotal perspective – an approach which at the same time eliminates any feel of pity such as otherwise might be aroused by the sight of a forlorn blind soul amid the stone canyons of New York. The photograph decisively turns its back on all that is sentimental or maudlin. The picture is also 'straight' in its reduction to only a few determining formal elements. There is for example the simple sign, dominating the composition like a title added to the photograph and reminiscent of the denunciatory 'INRI' hung over Christ in the Christian topos. Similarly, there is the comparatively modest oval of the metal license tag bearing the number 2622, which was issued by the City of New York, and gave the recipient the right to sell door-to-door. And finally there is the fleshy, clearly asymmetric face, darkly vignetted by some sort of shawl, and the lifeless eyes. These elements, in combination with the photograph's directness, without any attempt at photographic beautification, constitute a drastic presentation that would have shocked contemporaries viewers, accustomed as they were to non-committal pictorialism, Decades later, Strand remained

Paul Strand:
Man in a Derby,
1917

Paul Strand:
The Fense, 1917

impressed by the woman's dignity and recalled that she had "an abso-
lutely unforgettable and noble face." He did not inquire after her name
or story.

It is doubtful that Strand – in contrast to Lewis Hine, for example – inten-
ded to make a symbolic gesture for social reform. Although the artist
always understood himself to be a politically thinking man, open toward
movements of the times (it is well known that he later took an interest in
Communism), the context in which the picture first appeared, in the form
of a 13³/8 x 10¹/8-inch platinum print (today in the Metropolitan Museum,
New York), suggests that Strand's only interest in revolt was in the realm
of art. The *Blind Woman* was not a part of the first Paul Strand exhibit
organized by Stieglitz at his 291 gallery in 1916; but in the following year
the picture already reached a broader international public when Stieglitz
devoted the entire final double edition of his influential journal *Camera
Work* to Paul Strand. In addition to *Blind Woman*, the final Number 49/50

presented five further street portraits, views of New York, graphically conceived object studies, and an essay in which the photographer formulated his aesthetic credo. Strand's belief in an unfalsified, unmanipulated straight photography was not necessarily new, for the art critic Marius de Zayas had argued in 1913 for a use of the camera composed for "the objective condition of the facts". But Strand's explanations and arguments were delivered simultaneously with convincingly believable pictorial evidence.

Since its first publication in *Camera Work* in 1917, *Blind Woman*, together with the photographer's other street portraits have been accounted as "Strand's most exciting work," in the words of Alan Trachtenberg. Helmut Gernsheim called them "living fragments from the great kaleidoscope of everyday life." Similarly, in his history of street photography, Colin Westerbeck claimed that every street photographer surely knows *Blind Woman* and has learned from it. The question arises then, why the young Paul Strand gave up this kind of photography as early as 1916, never to return in later years. Did working with a 'hidden camera' suddenly seem immoral to him, as one critic surmises? One thing is certain: "His later images are magnificent," according to Milton Brown, "yet they don't have the journalistic quality that the early ones have."

1926

Man Ray
Noire et blanche

Painter, graphic artist, writer, experimenter with 'ready-made' art – throughout his life, the American artist Man Ray oscillated among various disciplines. Nonetheless it was primarily as a photographer that he achieved fame as creator of a richly varied œuvre in which the photograph serves less to illustrate reality than to express the artist's surrealistically inspired images, fantasies, and visions.

This picture is found in every catalogue, every exhibition of Man Ray's work. In addition to *La Prière, Violon d'Ingres, Les Larmes*, and a series of more-or-less experimental portraits of Ray's Paris artist friends, the image is among his best-known photographs. The picture was already included in the catalogue of 1934, Man Ray's first programmatic summary in book form. The artist himself accounted the originally square photograph, cropped into various formats, as one of the core works of his photographic production of the 1920s and early 1930s – an evaluation still shared today by exhibition organizers, writers, as well as art dealers and gallery owners. When Klaus Honnef put together his *Pantheon of Photography in the Twentieth Century*, Man Ray was represented by *Noire et blanche* as a matter of course; similarly in the catalogue to the large and highly respected Man Ray retrospective in 1998 in the Grand Palais in Paris, where *Kiki with the Mask* formed the upstroke as it were to a discriminating aesthetic discussion of his photographic œuvre. And as far as the international art market is concerned, by the middle to end of the 1990s, *Noire et blanche* had turned up at auctions on three occasions, making the headlines every time. In the process, that had undergone fairly minor cropping print brought in a prodigious $206,000 at Christie's in 1995, just as the year earlier an unnamed buyer had paid $320,000 for Man Ray's probably most prominent photograph as a vintage print. Last

but not lease, in 1998, a collector – once again at Christie's – was pre-pared to pay no less than $550,000 for the motif in the form of a diptych, making *Noire et Blanche* into one of the most sought-after treasures in the international photographic trade.

The same sleep and the same dream

About the picture itself and its creation we know little. Man Ray, born Emmanuel Radnitzky in 1890 in Philadelphia, was by no means an artist who spoke willingly about his work. Even his comprehensive autobio-graphy published in 1963 avoided discussing concrete pieces. It is clear, however, that the photograph was made at the beginning of 1926 in Man Ray's studio at 31 rue Campagne Première, which the now-successful por-trait artist had opened four years earlier in Paris, his adopted city of resid-ence. The photograph was first published on 1 May 1926 in the French magazine *Vogue* under the title *Visage de nacre et masque d'ébène* (Pearl face and ebony mask). The picture appeared again two months later in the Belgian Surrealist magazine *Variétés* (No. 3, 15 July 1928), now under the title *Noire et blanche* (Black and White), and once more, in November of the same year, in *Art et décoration*, this time with a text by Pierre Migennes: "The same sleep and the same dream, the same mysterious magic seem to unite across time and space these two female masks with closed eyes: one of which was created at some point in time by an African sculptor in black ebony, the other, no less perfect, made up yesterday in Paris."

The opposite of a rapid-fire shooter

Man Ray was in the habit of giving his photographic and all other cre-ations ringing titles ever since he had visited the legendary New York Armory Show in 1913. Á propos Marcel Duchamp's *Nude Descending a Staircase*, Man Ray had concluded that without its provocative title, the picture would hardly have received all the attention that the press and public paid it. Whereas *L'enigme d'Isidore Ducasse*, *Retour à la raison*, and *À l'heure de l'observatoire* belong in this sense to the most striking and in-ventive of Man Ray's titles, at first glance *Noire et blanche* seems in con-trast to be hardly more than a simple description, even if, from the per-spective of Western culture, which normally 'reads' from left to right, the correct reference would have to be *Blanche et noire* – a title valid in fact

Man Ray

Born Emmanuel Radnitzky **1890** in Philadelphia/Penn-sylvania. **1911** moves to New York. Friend-ship with Stieglitz and Duchamp. First photographic repro-ductions of his art works. **1916** first por-traits. **1921** moves to Paris. **1922** opens a studio in Montpar-nasse. First Rayo-graphs. **1929** first solarisations. **1934** publication of his book *Man Ray: Pho-tographies*. **1935–44** fashion shots for *Harper's Bazaar*. **1940** return to the USA. Waning interest in photography. From **1951** back in Paris. **1966** culture Prize of the DGPh. Dies **1976** in Paris

Noire et blanche, *1926: interestingly Man Ray also produced a reverse print from the negative.*

for the negative of the picture (which of course presents the image in reverse).

Man Ray, who began photographing as an autodidact in 1914, was initially concerned with achieving an adequate reproduction of his own painting and art objects. As a photographer, he was cautious – the opposite of a 'rapid-fire shooter', as Emmanuelle de l'Ecotais points out. Even his preference for working with a $3^1/_2$ x $4^3/_4$-inch plate camera required a carefully thought-out and economical method of procedure. Especially in the face of these hindrances, May Ray must be accounted an extraordinarily productive photographer: no fewer than twelve thousand negatives and contact prints were turned over alone by Man Ray's last wife, Juliet, to the French nation. Among them were several variations of *Kiki with the Mask* – pictures that prove that Man Ray had in this case been initially unsure of the valid formulation of his pictorial idea and that he reached the final composition only after passing several stages.

This was not the first time that Man Ray gave West African art a determinant role in his work. As early as 1924 in the creation of *La lune brille sur l'île de Nias*, he had photographed an unidentified young woman next to a sculpture of a Black African, admittedly without reaching a convincing formulation of an image that barely arose above the illustrative. Two years later, *Noire et blanche* confirmed his continuing interest in the art of 'primitive' peoples, which in fact had had an extremely great influence

precisely on the Avant-garde after 1900 (Expressionists, Fauvists, Cubists). Ray himself had first become acquainted with African art around 1910 in Alfred Stieglitz's New York gallery 291, and in his autobiography, African art is significantly mentioned in the same breath as the artistic expressions of Cézanne, Picasso, and Brancusi. The mask in this case, moreover, is a work in the Baule style, supposedly one of those cheap replicas which even in those days were available everywhere.

In the studio, Man gave form to his dialogue between 'white' and 'black', between an inanimate object and a supposedly sleeping female model (Kiki, in reality Alice Prin, once more taking on the role), in front of a neutral background. Shortly after moving from New York to Paris in 1921, Ray had become acquainted with the young woman, a favorite nude model in artistic circles, whose defiant charm was precisely such as to appeal to Man Ray. In his memoirs, the photographer described at length his first meeting with 'Kiki de Montparnasse': "One day I was sitting in a café Soon the waiter appeared to take our order. Then he turned to the table of girls, but refused to serve them: they weren't wearing hats. A violent argument arose. Kiki screamed a few words in a patois I didn't understand, but which must have been rather insulting, and then added that a cafe is after all not a church, and anyway the American women all came without hats... Then she climbed onto the chair, from there onto the table, and leapt with the grace of a gazelle down onto the floor. Marie invited her and her friends to sit with us; I called the waiter and in an empathic tone ordered something for the girls to drink."

First lover during the years in Paris

Before long Kiki became the first of Man Ray's lovers during his early years in Paris. For him she was a model, a source of inspiration, and also an antagonist in turbulent scenes. In ever-new portraits and nude photographs, Man succeeded after 1922 in capturing something of the irascible spirit of this legendary artists' sweetheart. Perhaps the most famous of these photographs is a portrait from 1926, which may have been made on the same day as *Noire et blanche*. In any case, the pale complexion, clearly contoured lips, and the pomaded, tightly combed-back short hair suggest the proximity.

Kiki is holding the mask to her cheek, supporting it with both hands and casting a dreamy look sideways toward the art object – a shot in vertical

format, which apparently satisfied the artist just as little as the symmetrically composed, markedly static version in which Kiki's chin is set against that of the mask as a so-to-speak mirror image. Numerous details in the photograph – clothing, jewelry, Kiki's naked bust – distract from the real intention. Only the addition of the table as a stable, space-defining horizontal element, combined with narrower framing, provided a formally convincing solution. Now the horizontal stands unmistakably against the vertical, black against white, living against lifeless, European against African: the equality of the cultures is underlined by the negative print. Moreover, the subtle use of light, which emphasizes the strong geometry of the composition, plays a convincing role.

Man Ray had already published a photo titled *Black and White* on the cover of the magazine *391*, edited by Francis Picabia, in 1924. In that work, a classical statuette contrasted with an African sculpture; now, as if in a further development of the same concept, Man Ray set a human face against a 'primitive' mask. In the earlier work, Man's English title implied no reference to the sex of the subjects. With *Noire et blanche*, on the other hand, there can be no doubt: what is portrayed is, so to speak, a purely feminine dialogue that, in best Surrealist tradition, well understands how to remain somewhat mysterious. There can be no doubt that *Noire et blanche* is more than a merely formal game. At the very least, according to Emmanuelle de l'Ecotais, the work is exemplary for one of Man Ray's fundamental dictates: provoquer la réflexion.

Noire et blanche:
a rarely reproduced
and thus little known
variant from the
cycle

Bibliography

General historical overviews of photography

Auer, Michèle and Michel: *Encyclopédie internationale des photographes de 1839 à nos jours.* Geneva, 1985

Baier, Wolfgang: *Geschichte der Fotografie.* Leipzig, 1980

Baier, Wolfgang: *Quellendarstellungen zur Geschichte der Fotografie.* Leipzig, 1980

Barthes, Roland: *Camera Lucida: Reflections on Photography.* London, 1982

Benjamin, Walter: "A Small History of Photography". In: *One Way Street and Other Writings.* London, 1979

Daval, Jean-Luc: *Die Photographie. Geschichte einer Kunst.* Aarau/Stuttgart, 1983

Van Deren Coke, Frank: *The Painter and the Photograph from Delacroix to Warhol.* Second edition. Albuquerque, 1972

von Dewitz, Bodo (ed.): *Alles Wahrheit! Alles Lüge! Photographie und Wirklichkeit im 19. Jahrhundert. Die Sammlung Robert Lebeck.* Cat. Agfa Foto-Historama/Museum Ludwig Köln, Dresden, 1997

Frizot, Michel (ed.): *Nouvelle Histoire de la Photographie.* Paris, 1994

Gernsheim, Helmut: *Geschichte der Photographie. Die ersten hundert Jahre.* Frankfurt on the Main/Berlin/Vienna, 1983

Hambourg, Maria Morris/Pierre Apraxine/Malcom Daniel/Jeff L. Rosenheim/Virginia Heckert: *The Waking Dream. Photography's First Century. Selections from the Gilman Paper Company Collection.* Cat. The Metropolitan Museum of Art, New York, 1993

Hiepe, Richard: *Riese Proletariat und große Maschinerie. Zur Darstellung der Arbeiterklasse in der Fotografie von den Anfängen bis zur Gegenwart.* Cat. Städtische Galerie Erlangen, Erlangen, 1983

Hochreiter, Otto/Timm Starl: *Geschichte der Fotografie in Österreich.* Bad Ischgl, 1983

Honnef, Klaus: *Pantheon der Photographie im XX. Jahrhundert.* Cat. Kunst- und Ausstellungshalle der Bundesrepublik Deutschland, Bonn, Stuttgart, 1992

Kemp, Wolfgang: *Theorie der Fotografie I. 1839–1912.* Munich, 1980

Köhler, Michael/Gisela Barche: *Das Aktfoto. Geschichte, Ästhetik, Ideologie.* Cat. Münchner Stadtmuseum, Munich, 1985

Sontag, Susan: *On photography.* London, 1978

Newhall, Beaumont: *History of photography.* New York, 1982

Weiermair, Peter: *Das Verborgene Bild. Geschichte des männlichen Akts in der Fotografie des 19. und 20. Jahrhunderts.* Vienna, 1987

About the photographers

Aubert, François
 Reinke, Jutta/Wolfgang Stemmer (ed.): *Pioniere der Kamera. Das erste Jahrhundert der Fotografie 1840–1900.* Cat. Fotoforum Bremen, Bremen, 1987

Bayard, Hippolyte
 Duca, Lo: *Bayard.* Paris, 1943
 Frizot, Michel: "La parole des primitifs. À propos des calotypistes français". In: *Études photographiques,* no. 3, November 1997, pp. 43–63
 Gautrand, Jean-Claude/Michel Frizot: *Hippolyte Bayard – naissance de l'image photographique.* Amiens, 1986
 Jammes, André: *Hippolyte Bayard. Ein verkannter Erfinder und Meister der Photographie.* Lucerne/Frankfurt on the Main, 1975

Potonniée, Georges: *Histoire de la Découverte de la Photographie.* Paris, 1925
 Steinert, Otto: *Hippolyte Bayard. Ein Erfinder der Photographie.* Cat. Museum Folkwang Essen, Essen, 1959

Bisson, Auguste Rosalie
 Die Brüder Bisson. Aufstieg und Fall eines Fotografenunternehmens. Cat. Museum Folkwang Essen, Essen, 1999
 Leroy, Marie-Noelle: "Le monument photographique des frères Bisson". In: *Études photographiques,* no. 2, 1997, pp. 82–95
 Stenger, Erich: *Die beginnende Photographie im Spiegel von Tageszeitungen und Tagebüchern.* Würzburg, 1943

Blossfeldt, Karl
Blossfeldt, Karl: *Photographien*. Munich, 1991
Blossfeldt, Karl: *Photographs 1865–1932*.
Cologne, 1993
Blossfeldt, Karl: *Art forms in Nature*. Munich,
1999
Van Deren Coke, Frank: *Avantgarde-Fotografie
in Deutschland 1919–1939*. Munich, 1982
Ewing, William A.: *Flora Photographica*.
*Masterpieces of Flower Photography from 1835
to the Present*. London, 1991
Herzog, Hans-Michael (ed.): *Blumenstücke –
Kunststücke. Vom 17. Jahrhundert bis in die
Gegenwart*. Cat. Kunsthalle Bielefeld, 1995
Nierendorf, Karl (ed.): *Urformen der Kunst*.
Berlin, 1928
**Photographische Sammlung/SK Stiftung
Kultur** (ed.): *August Sander, Karl Blossfeldt,
Albert Renger-Patzsch, Bernd und Hilla Becher
– Vergleichende Konzeptionen*. Cologne, 1997
Wilde, Ann and Jürgen (ed.): *Karl Blossfeldt –
Photographien*. Munich, 1991
Wilde, Ann and Jürgen (ed.): *Fotografie*. Cat.
Kunstmuseum Bonn, Ostfildern, 1994

Daguerre, Louis-Jacques-Mandé
Gernsheim, Helmut and Alison: *L. J. M.
Daguerre. The History of the Diorama and the
Daguerreotype*. New York, 1956
Gunthert, André: "Daguerre ou la prompti-
tude. Archéologie de la réduction du temps de
pose". In: *Études photographiques*, no. 5, 1998,
pp. 4–25
Haugsted, Ida: "Berichte aus Paris, 1839. Zu
den Briefen Christian Falbes an den dänischen
Kronprinzen". In: *Fotogeschichte*, no. 31, 1989,
pp. 3–14
Pohlmann, Ulrich/Marjen Schmidt: "Das
Münchner Daguerre-Triptychon. Ein Protokoll
zur Geschichte seiner Präsentation, Aufbe-
wahrung und Restaurierung". In: *Fotoge-
schichte*, no. 52, 1994, pp. 3–13
Reynaud, Françoise: *Paris et le Daguerréotype*.
Cat. Musée Carnavalet, Paris, 1989
Starl, Timm: *Ein Blick auf die Straße. Die foto-
grafische Sicht auf ein städtisches Motiv*.
Berlin, 1988
Starl, Timm: "Sicht und Aussicht. Zu den Auf-
nahmen Pariser Boulevards von Daguerre und
Talbot". In: *Camera Austria*, no. 24, 1987,
pp. 81–86

Stenger, Erich: *Die beginnende Photographie
im Spiegel von Tageszeitungen und Tage-
büchern*. Würzburg, 1943

Disdéri, André Adolphe Eugène
Barret, A.: *Die ersten Fotoreporter 1848–1914*.
Frankfurt on the Main, 1978
La Commune photographiée: Cat. Musée
d'Orsay, Paris, 2000
*Le Corps et son Image. Photographies du dix-
neuvième siècle*. Cat. Bibliothèque nationale,
Paris, 1986
McCauley, Elizabeth Anne: *André Adolphe
Disdéri and the Carte de Visite Portrait Photo-
graph*. New Haven/London, 1985
Neumann, Thomas: "Fotografie zur Zeit der
Pariser Kommune". In: *Pariser Kommune 1871*.
Cat. Neue Gesellschaft für Bildende Kunst,
Berlin, 1971, pp. 152–159

Duchenne de Boulogne
*À corps et à raison. Photographies médicales
1840–1920*. Cat. Mission du Patrimoine photo-
graphique, Paris, 1995
Burns, Stanley B.: *A Morning's Work. Medical
Photographs from The Burns Archive & Collec-
tion 1843–1939*. Santa Fe, 1998
Ewing, William A.: *The Body*. London, 1994
Guilly, Paul: *Duchenne de Boulogne*. Paris,
1936
**Hambourg, Maria Morris/Françoise Heil-
brun/Philippe Néagu**: *Nadar*. New York, 1995
Marbot, Bernard/André Rouillé: *Le Corps et
son image. Photographies du dix-neuvième
siècle*. Bibliothèque nationale, Paris, 1986
Mathon, Catherine: *Duchenne de Boulogne
1806–1875*. Cat. École nationale supérieure
des beaux-arts, Paris, 1998

Durieu, Eugène/Delacroix, Eugène
*L'art du nu au XIXe siècle. Le photographe et
son modèle*. Cat. Bibliothèque nationale de
France, Paris, 1999
Aubenas, Sylvie: "La collection de photogra-
phies d'Eugène Delacroix". In: *La Revue de
l'Art*, 1999
Heiting, Manfred: *At the Still Point. Photogra-
phs from the Manfred Heiting Collection*.
vol. I, 1840–1916. Los Angeles/Amsterdam,
1995
Jobert, Barthélémy: *Delacroix. Le trait roman-*

tique. Cat. Bibliothèque nationale de France, Paris, 1998

Koetzle, Michael/Uwe Scheid: *1000 Nudes. Uwe Scheid Collection.* Cologne, 1994

Paviot, Alain: *Le Cliché-Verre. Corot, Delacroix, Millet, Rousseau, Daubigny.* Cat. Musée de la vie romantique, Paris, 1994

Sagne, Jean: *Delacroix et la photographie.* Paris, 1982

Vaisse, Pierre: "Delacroix et la photographie, un livre de Jean Sagne". In: *Photographies,* no. 3, December 1983, pp. 96–101

Zerner, Henri: "Delacroix, la photographie, le dessin". In: *La revue du musée d'Orsay,* no. 4, 1992, pp. 83–87

Guibert, Maurice

Adhémar, Jean: "Toulouse-Lautrec et son photographe habituel". In: *Aesculape,* no. 12, December 1951, pp. 229–234.

L'art du Nu au XIXᵉ siècle. Le photographe et son modèle. Cat. Bibliothèque nationale de France, Paris, 1997

Schimmel, Herbert D.: *The Letters of Henri de Toulouse-Lautrec.* Oxford, 1991

Toulouse-Lautrec. Cat. Galeries nationales du Grand Palais, Paris, 1992

Hine, Lewis

America & Lewis Hine. Photographs 1904–1940. Millerton, New York, 1977

Doherty, R. J.: *Social-Documentary Photography in the USA.* New York, 1976

George Eastman House (ed.): *Portfolio.* Rochester, New York, 1970

Gutmann, Judith Mara: *Lewis W. Hine and the American Social Conscience.* New York, 1967

History of Photography, no. 2, 1992 (special number about Lewis Hine)

Kaplan, Daile: *Lewis Hine in Europe: the lost photographs.* New York, 1988

Kemp, John R. (ed.): *Lewis Hine: Photographs of Child Labor in the New South.* Jackson, 1986

Lunn Gallery (ed.): *Lewis W. Hine. Child Labor Photographs.* Washington, D. C., 1980

Orvell, Miles: "Lewis Hine. The Art of the Commonplace". In: *History of Photography,* vol. 16, no. 2, 1992, p. 87f.

Rosenblum, Naomi: *The Lewis Hine Document.* Brooklyn, 1977

Rosenblum, Naomi/Walter Rosenblum: *Lewis W. Hine.* Paris, 1992

Steinorth, Karl (ed.): *Lewis Hine. Die Kamera als Zeuge. Fotografien 1905–1937.* Kilchberg, 1996

Victor, Stephen: *Lewis Hine's Photography and Reform in Rhode Island.* Providence, 1982

Howlett, Robert

Buckland, Gail: *Reality Recorded – Early Documentary Photography.* London, 1974

Haworth-Booth, Mark: *The Golden Age of British Photography 1839–1900.* New York, 1984

Haworth-Booth, Mark: *The Origins of British Photography.* London, 1991

Hiepe, Richard: "Industrie und Maschine in der Weltanschauung der Fotografie". In: *Tendenzen,* nos. 106 and 107, 1976

Naef, Weston: *The J. Paul Getty Museum Handbook of the Photographs Collection.* Malibu, 1995

A Personal View. Photography in the Collection of Paul F. Walter. Cat. The Museum of Modern Art, New York, 1985

The Waking Dream. Photography's First Century. Selections from the Gilman Paper Company Collection. Cat. The Metropolitan Museum of Art, New York, 1993

Lartigue, Jacques-Henri

Astier, Martine/Mary Blume: *Lartigue's Riviera.* Paris/New York, 1998

Avedon, Richard: *Diary of a Century.* New York, 1971

Chapier, Henry: *Jacques-Henri Lartigue.* Paris, 1981

Lartigue, Florette: *Jacques-Henri Lartigue. La Traversée du siècle.* Paris, 1990

Lartigue, Jacques-Henri: *Jacques-Henri Lartigue et les autos.* Paris, 1974

Lartigue, Jacques-Henri: *Mémoires sans mémoire.* Paris, 1975

Lartigue, Jacques-Henri: *The Photographs of J.H. Lartigue.* New York, 1963

Lartigue, Jacques-Henri. Munich, 1984

Lartigue, Jacques-Henri: Album. Cat. der Stiftung für die Photographie, Berne, 1986

Life. 29 November 1963

Sprung in die Zeit. Bewegung und Zeit als Gestaltungsprinzipien in der Photographie von den Anfängen bis zur Gegenwart. Cat. Berlinische Galerie, Berlin, 1992

Szarkowski, John: *The Photographs of Jacques-Henri Lartigue*. New York, 1963
Szarkowski, John: *The debut of Jacques-Henri Lartigue*. New York 1991 (unpublished typescript, archive Association des Amis de Jacques-Henri Lartigue)

Man Ray
Billeter, Erika (ed.): *Skulptur im Licht der Fotografie. Von Bayard bis Mapplethorpe*. Cat. Wilhelm Lehmbruck Museum Duisburg, Berne, 1998
l'Ecotais, Emmanuelle de/Alain Sayag: *Man Ray. La photographie à l'envers*. Cat. Centre Georges Pompidou, Paris, 1998
Jaguer, Edouard: *Surrealistische Photographie. Zwischen Traum und Wirklichkeit*. Cologne, 1984
Krauss, Rosalind/Jane Livingston/Dawn Ades: *Explosante-Fixe. Photographie & Surréalisme*. Cat. Centre Georges Pompidou, Paris, 1985
Man Ray. Cat. Galerie der Stadt Stuttgart, Ostfildern, 1998
Man Ray: Photographs. London, 1987
Man Ray: La photographie à l'envers. Album de l'exposition. Cat. Centre Pompidou, Paris, 1998
Man Ray: Photographs 1920–1934. New York, 1975
Man Ray: Sein Gesamtwerk 1890–1976. Schaffhausen, 1989
Man Ray: Self Portrait. Boston, 1963

Nadar
Barret, André: *Nadar. 50 photographies de ses contemporains*. Paris, 1994
Gosling, Nigel: *Nadar*. New York, 1976
Hambourg, Maria Morris/Françoise Heilbrun/Philippe Néagu: *Nadar*. New York, 1995
Honnef, Klaus (ed.): *Lichtbildnisse. Das Porträt in der Fotografie*. Cat. Rheinisches Landesmuseum Bonn, Cologne, 1982

Niépce, Nicéphore
Fage, Jean: *La Vie de Nicéphore Niépce*. Bièvre, 1983
Harmant, Pierre.-G./Paul Marillier: "Some Thoughts on the World's First Photograph". In: *The Photographic Journal*, no. 107, April 1967, pp. 130–140
Jay, Paul: *Nicéphore Niépce. Lettres et documents choisis par P. J.* Paris, 1983

Jay, Paul: *Niépce. Genèse d'une Invention*. Chalon-sur-Saône, 1988
Jay, Paul: *Niépce. Premiers outils – Pemiers résultats*. Chalon-sur-Saône, 1978

Priester, Max/Wilcke, Willy
Anon.: "Bismarck auf dem Sterbelager". In: *Die Welt*, no. 270, 19. 11. 1974
Kempe, Fritz: "Ein Bild, das vernichtet werden sollte". In: *Zeit-magazin*, no. 32, 4. 8. 1978
Franz von Lenbach. Cat. Städtische Galerie im Lenbachhaus, Munich, 1987
Lorenz, Lovis H.: *Oevelgönner Nachtwachen*. Hamburg, 1974
Machtan, Lothar: *Bismarcks Tod und Deutschlands Tränen. Reportage einer Tragödie*. Munich, 1998
Ruby, Jay: *Secure the Shadow. Death and Photography in America*. Cambridge Mass./London, 1995

Sander, August
Berger, John: *Das Leben der Bilder oder die Kunst des Sehens*. Berlin, 1989
Keller, Ulrich/Gunther Sander: *August Sander – Menschen des 20. Jahrhunderts. Portraitphotographien 1892–1952*. Munich, 1980
Molderings, Herbert: *Fotografie in der Weimarer Republik*. Berlin, 1988
Photographische Sammlung/SK Stiftung Kultur (ed.): *August Sander, Karl Blossfeldt, Albert Renger-Patzsch, Bernd und Hilla Becher – Vergleichende Konzeptionen*. Cologne, 1997
Powers, Richard: *Three Farmers on Their Way to a Dance*. London, 1989
Sander, August: "In der Photographie gibt es keine ungeklärten Schatten!" Cat. August Sander Archiv Köln, Berlin, 1994
Scholz, Christian: "August Sander, Photograph aus Deutschland". In: *Neue Züricher Zeitung*, no. 159, 12./13. 7. 1997, pp. 57–59

Stieglitz, Alfred
Eisler, Benita: *O'Keeffe & Stieglitz. An American Romance*. New York, 1991
Finsler, Hans: "Das Bild der Photographie". In: *Du*, no. 3/1964
Greenough, Sarah/Juan Hamilton: *Alfred Stieglitz. Photographs & Writings*. Cat. National Gallery of Art, Washington, 1983

Stieglitz, Alfred: *Aperture Masters of Photography*. New York, 1989
Stieglitz, Alfred: *Camera Work. The Complete Illustrations 1903–1917*. Cologne, 1997
"Stieglitz, Alfred: Wie es zu 'The Steerage' kam". In: **Wilfried Wiegand** (ed.): *Die Wahrheit der Photographie. Klassische Bekenntnisse zu einer neuen Kunst*. Frankfurt on the Main, 1981, pp. 173–177
Whelan, Richard: *Alfred Stieglitz*. New York, 1996

Strand, Paul
Burns, Stanley B.: *A Morning's Work. Medical Photography from the Burns Archive & Collection 1843–1939*. Santa Fe, 1998
Fleischmann, Kaspar (ed.): *Paul Strand*. vol. I. Zurich, 1987
Fleischmann, Kaspar (ed.): *Paul Strand*. vol. II. Zurich, 1990
Hambourg, Maria Morris: *Paul Strand circa 1916*. Cat. Metropolitan Museum of Art New York, New York, 1998
Haworth-Booth, Mark: *Paul Strand*. New York, 1987
Hill, Paul/Thomas Cooper: *Dialogue with Photography*. New York, 1979
Lyons, Nathan: *Photographers on photography*. Prentice-Hall, 1966
Stieglitz, Alfred: *Camera Work. The Complete Illustrations 1903–1917*. Cologne, 1997
Strand, Paul: *An American Vision*. New York, 1990
Strand, Paul: *Circa 1916*. Cat. Metropolitan Museum of Art, New York, 1998
Strand, Paul: *Essays on his Life and Work*. New York, 1990
Strand, Paul: *Photographs 1915–1945*. Cat. Museum of Modern Art, New York, 1945
Strand, Paul: *A Retrospective Monograph. The Years 1915–1946*. New York, 1971
Strand, Paul: *Sixty Years of Photographs*. New York, 1976
Strand, Paul: *The World on My Doorstep*. New York, 1994
Tucker, Ann W.: *Five American Photographers*. Cat. Museum of Fine Arts, Houston, 1981

Zille, Heinrich
Bohne, Friedrich: *Heinrich Zille als Fotograf*. Cat. Wolfgang-Gurlitt-Museum, Linz, 1968

Brost, Harald/Laurenz Demps: *Berlin wird Weltstadt*. With 277 photographs by F. Albert Schwartz, Hof-Photograph. Stuttgart, 1981
Van Deren Coke, Frank: *The Painter and the Photograph from Delacroix to Warhol*. Second edition. Albuquerque, 1972
Fischer, Lothar: *Heinrich Zille*. Reinbek bei Hamburg, 1979
Flügge, Gerhard: *Mein Vater Heinrich Zille*. Berlin, 1955
Flügge, Matthias: *Heinrich Zille. Fotografien von Berlin um 1900*. Leipzig, 1987
Flügge, Matthias: *Heinrich Zille. Berliner Photographien*. Munich, 1993
Kaufhold, Enno: *Heinrich Zille. Photograph der Moderne*. Munich, 1995
Luft, Friedrich: *Mein Photo Milljöh. 100 x Alt-Berlin aufgenommen von Heinrich Zille selber*. Hannover, 1967
Photographie als Photographie. Zehn Jahre Photographische Sammlung 1979–1989. Cat. Berlinische Galerie, Berlin, 1989
Ranke, Winfried: *Draughtsman and Photographer*. Cat. Goethe Institute, Munich, 1982
Ranke, Winfried: *Heinrich Zille. Photographien Berlin 1890–1910*. Munich, 1975. Second edition. Munich, 1979. Third (revised and relithographed) edition. Munich, 1985
Ranke, Winfried: *Vom Milljöh ins Milieu. Heinrich Zilles Aufstieg in der Berliner Gesellschaft*. Hannover, 1979

Photo Credits

Despite extensive research, we have been unable to locate the holders of the rights to some of the photographs. We extend our apologies and ask that they contact us.

Agfa Foto-Historama, Cologne: 62–63, 67, 68, 80, 85, 94, 95

© akg-images/Erich Lessing: 86

Aperture Foundation Inc., © 1971, Aperture Foundation Inc., Paul Strand Archive: 168

Archiv Fotomagazin, Munich: 14

Association des Amis de J.H. Lartigue: © Ministère de la Culture, France/A.A.J.H.L.: 150–151, 154, 155

Bayerische Staatsbibliothek, Munich: 104 left, 104 right, 107,

BBC Hulton Picture Library, London: 137

© Berlinische Galerie, Photographische Sammlung/VG Bild-Kunst Bonn, 2002: 116–117, 120–121, 123

Bibliothèque Nationale de France, Paris: 34, 41, 42 left, 72, 98–99

Karl Blossfeldt-Archiv/Ann und Jürgen Wilde/VG Bild-Kunst Bonn, 2002: 126, 129, 130, 132, 133

Caisse nationale des Monuments historiques et des sites; Félix Nadar © Arch. Phot. Paris: 77

© Coll. Musée de la Photographie à Charleroi: 82

© École nationale supérieure des beaux-arts, Paris: 44, 49, 50

Fotomuseum im Münchner Stadtmuseum: 16–17, 19, 23,

George Eastman House, Rochester, © Lewis W. Hine/Courtesy George Eastman House: 142–143, 146

© Gernsheim Collection, Harry Ransom Humanities Research Center, The University of Texas at Austin: 8–9, 92

Howard Greenberg Gallery, New York: © Alfred Stieglitz/Courtesy Howard Greenberg Gallery, NYC: 135

Manfred Heiting Collection, Amsterdam: 42 right, 52

Hans-Michael Koetzle Collection/Archive, Munich; repro photographs: Hans Döring, Munich: 13, 54, 74, 96 left, 96 right, 97 left, 97 right, 112, 113, 115, 124, 125, 130, 132, 133, 162

© Landesmedienzentrum Hamburg: 108–109

Horst Moser Collection, Munich; repro photographs: Hans Döring, Munich: 157, 158 left, 158 right, 159 left, 159 right

Musée Carnavalet, Paris; © Photothèque des Musées de la Ville de Paris: 88–89

Musée Toulouse-Lautrec, Albi-Tarn, France (all rights reserved): 102

© Die Photographische Sammlung/SK Stiftung Kultur – August Sander Archiv, Cologne/VG Bild-Kunst, Bonn: 160, 163, 164, 167

Les Publications Condé Nast Paris S. A., Paris: 182

© Man Ray Trust, Paris /VG Bild-Kunst Bonn, 2002/Telimage, 2002: 176–177, 180–181, 185

© Royal Photographic Society, Bath: 138, 141, 173, 174

© Uwe Scheid Collection: 36, 37, 38

© Société Française de Photographie, Paris: 26–27, 29

© Sotheby's, London: 32

Universität München, Institut für Kommunikationswissenschaft: 114

© V&A Picture Library, London: 56–57, 59, 60

"Buy them all and add some pleasure to your life."

www.taschen.com